POCKETS OF PRETTY

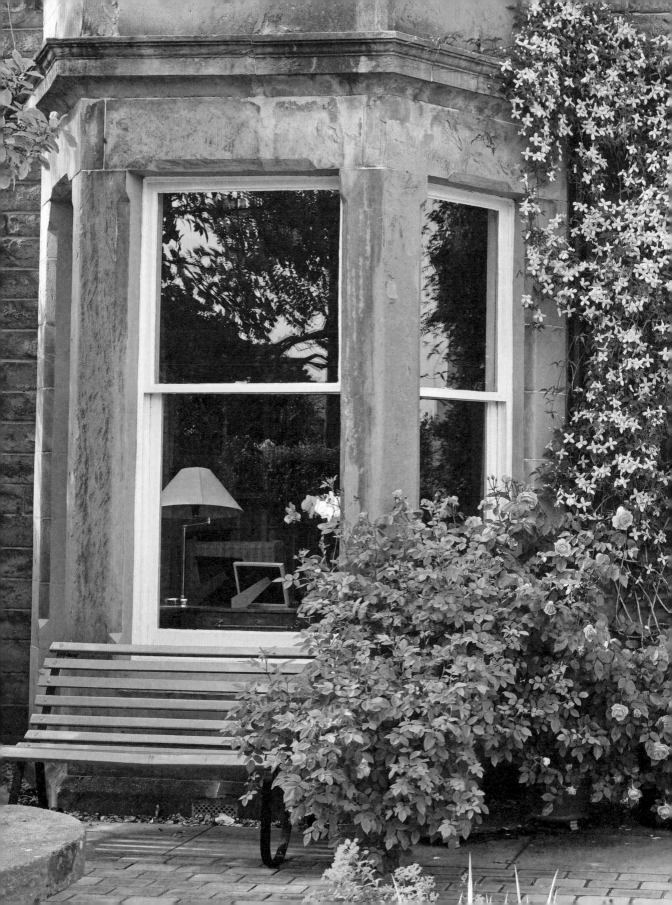

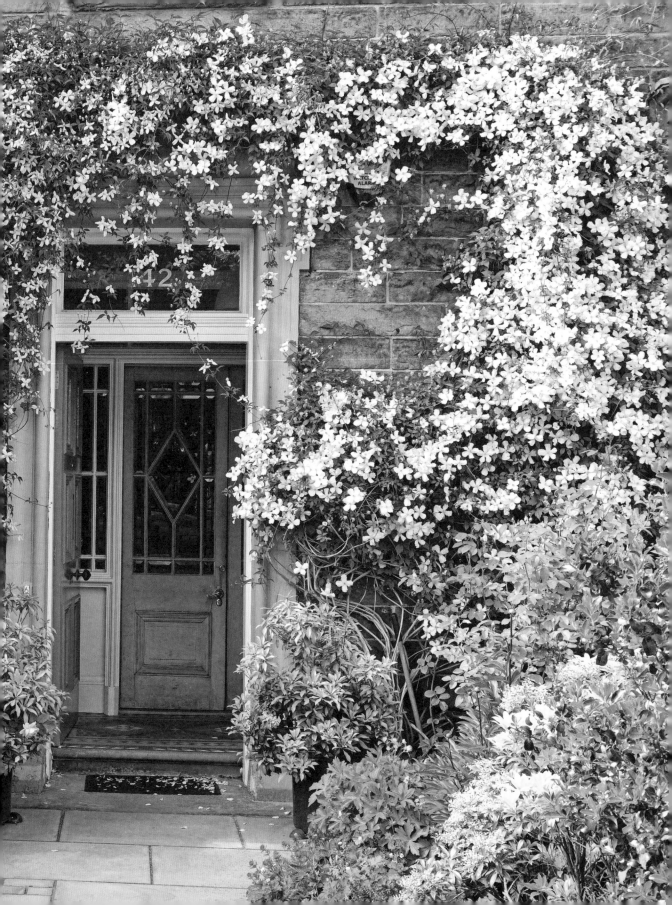

POCKETS OF PRETTY
AN INSTAGRAMMER'S EDINBURGH

SHAWNA LAW

BLACK & WHITE PUBLISHING

First published 2019
by Black & White Publishing Ltd
Nautical House, 104 Commercial Street,
Edinburgh, EH6 6NF

1 3 5 7 9 10 8 6 4 2 19 20 21 22

ISBN: 978 1 78530 262 6

Author photos on back cover, pages 2 and 244 © Alex Hamilton

Illustrations by Helen C. Stark

Design by Black & White
Printed and bound in Croatia by Grafički Zavod Hrvatske

To Edinburgh
for the endless inspiration you
gave me for this book

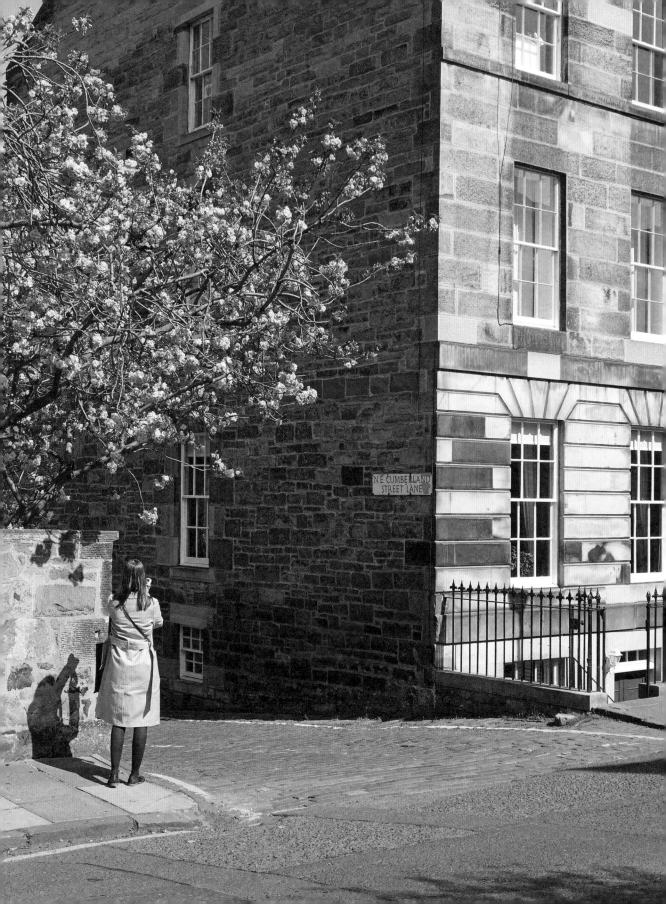

CONTENTS

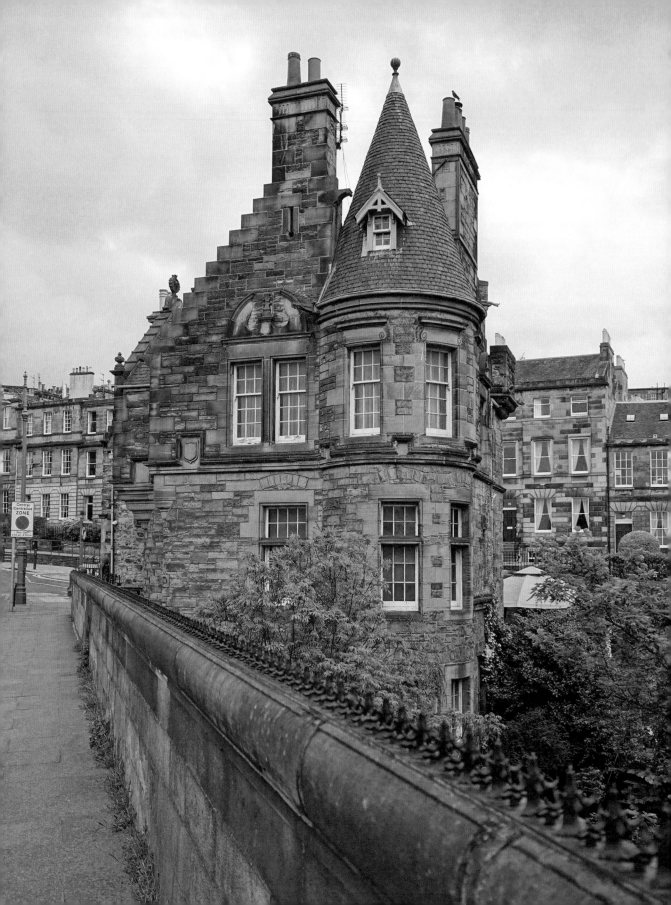

POCKETS OF PRETTY

DEFINITION: Those small patches or areas of the cityscape, which one finds attractive in a delicate way; something that is admirable, pleasing and lovely to behold.

HOW TO USE THIS BOOK

Beauty is in the eye of the beholder and I'm a strong believer in being mindful of your surroundings and actively seeking out beauty in all forms wherever you are. Personally, I haven't come across anywhere without a pocket of pretty worth photographing or appreciating; sometimes it just takes a closer inspection. And so, this book, which started as a visual exploration of Edinburgh, has also turned into what I hope will be an encouragement to set out and explore your neighbourhood to find its own particular pockets of pretty. To help you do this, I have divided this book into four main sections.

NEIGHBOURHOOD GUIDES I've had a lot of fun exploring and putting together the neighbourhood guides which focus on Edinburgh's 'villages'. The chapters highlight the main pockets of pretty to look out for in each area as well as interviews with lovely independent business owners and plenty of local suggestions.

EDINBURGH'S LITTLE GEMS As I explored the city, it became apparent that there are several smaller, often overlooked, neighbourhoods of Edinburgh. These areas are not without their charm, and so I felt it only right to shine a light on them. I've suggested short walks to guide you around these tiny pockets of pretty.

ESCAPE THE CITY CENTRE Edinburgh is by no means a large and bustling city. However, it's still nice to take a break from the city centre by heading out on a day trip. The city is a great jumping-off place to visit other parts of Scotland, but I wanted to show how you don't have to leave Edinburgh to enjoy a day out.

THE LIFE OF A CITY It wasn't until I began exploring Edinburgh that I truly began to appreciate and look forward to the changing seasons. Now I can't help but notice and marvel at the beautiful pink blossoms of spring or the crimson and gold tones of autumn – and just when I think Edinburgh couldn't get any prettier, the city dons a new seasonal coat.

AN INSTAGRAMMER'S CHECKLIST

Most (if not all) of my favourite Instagram accounts are those who have discovered their niche and love what they photograph: their passion really shines through and compels me to keep following their adventures! I stumbled across my never-ending inspiration as I began to explore the streets of Edinburgh five years ago. Along the way I've picked up a few little habits and small nuggets of Instagram wisdom, which I've gathered together in a handy Instagram checklist.

DON'T FORGET A CAMERA Over the years, my camera has become my trusty sidekick and I've developed a form of FOMO (fear of missing out) when I leave the house without it. My tip would be to use whatever you're most comfortable with, whether that be your smartphone or a professional camera. I've found that often it's the spontaneous shot-on-a-phone photo that does the best on Instagram as it evokes a mood or feeling that a staged shot doesn't always capture.

Tip If you're using your smartphone, don't forget to give its lens a wipe for the best quality of photo.

EMBRACE THE WEATHER It's not unheard of for us to experience four seasons in one day in Scotland, so don't be put off by the weather.

I prefer slightly overcast days or the atmosphere provided by a light rain shower, a smattering of snow, or a misty day. Perhaps counterintuitively, I tend to head indoors on sunny days to capture interior scenes as there's a good chance you'll have plenty of natural light. Of course, this is all a matter of personal preference, and it's all about finding out what conditions you enjoy taking photos in or which results you're happiest with.

HEAD OFF THE BEATEN PATH I've always had explorer tendencies. To me, there's something thrilling about heading down a mysterious path and not knowing where it'll lead. I think that's one of the best ways to get to know Edinburgh and understand how the city fits together.

Tip Always remember to occasionally look up or turn around, as you'll be surprised by how often you could have missed a hidden gem!

LOOK OUT FOR NATURAL FRAMES Having explored Edinburgh for several years, I'm always on the look out for different angles or unique ways to frame a shot – whether that be through a window or framed with autumn foliage. For instance, my good friend and fellow Edinburgh Instagrammer, @edienthusiast is brilliant at finding a pocket of flowers to use as a frame for her photos.

BE RESPECTFUL I'm going to use a phrase my friend always says, 'Take only photos, leave only footprints.' Just a friendly reminder, that no matter where you are, try and be mindful when you're taking your Instagram photos. An adorable Instagrammable mews house on Circus Lane is first and foremost someone's home.

THE JOYS OF EDITING I must admit I do enjoy a little editing. A few of my go-to apps are Snapseed, VSCO, and occasionally Lightroom for mobiles. Snapseed is a wonderful little app bursting with potential. For the most part, I use it for correcting brightness and ambiance, perspective, and removing the odd bin or ugly lamppost using the 'healing' tool. Occasionally, if I have taken a photo with an odd hue, I'll also head over to Lightroom and reduce the specific colour. Usually my last step is to apply my favourite filter in VSCO. There's an extensive collection of filter packs to choose from but my most used filter is A6. I tend to stick to the same filter or a few similar ones to create a cohesive style.

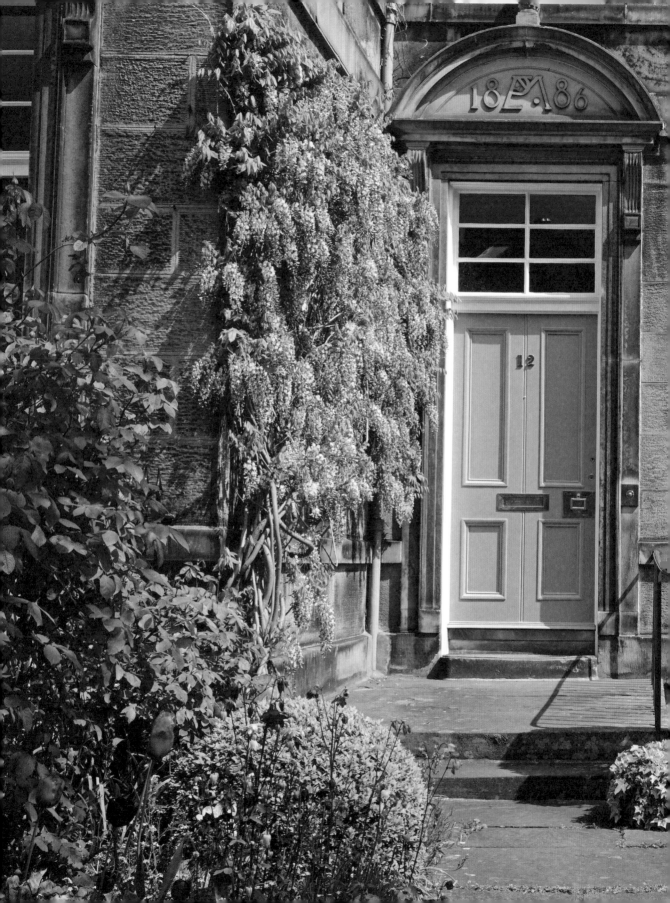

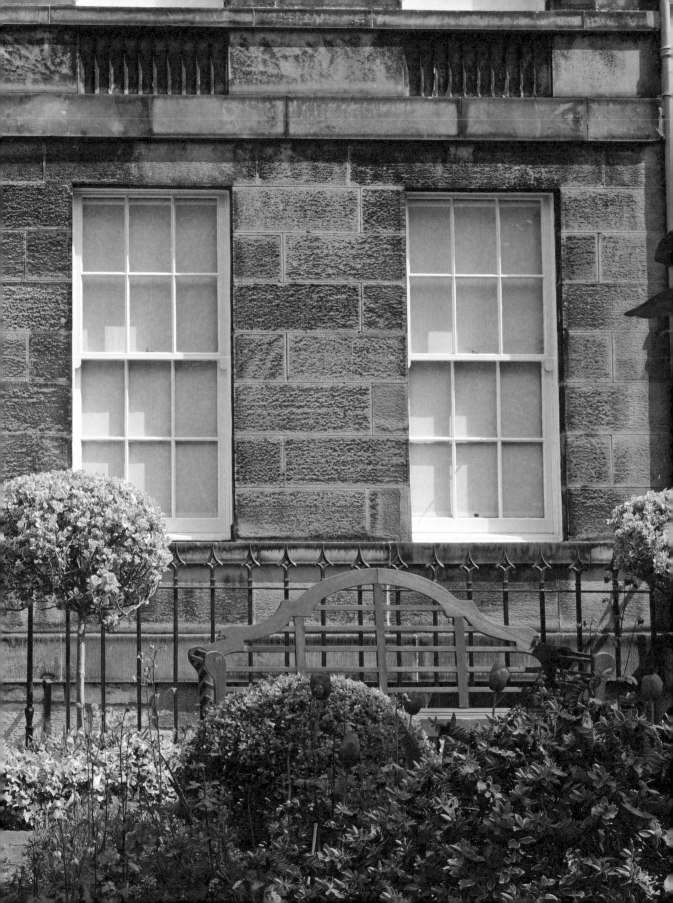

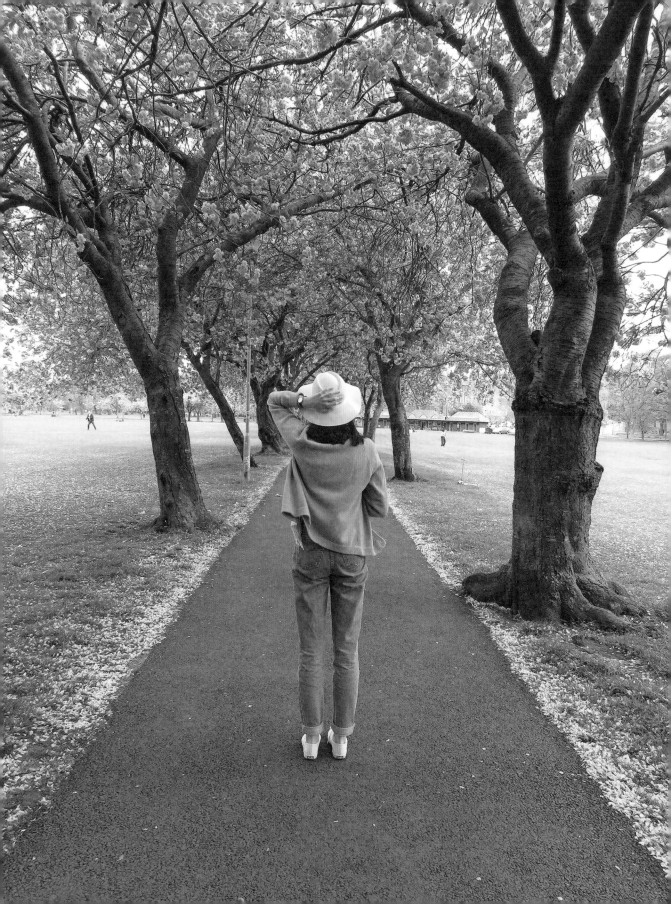

POCKETS OF PRETTY

Neighbourhood Guides

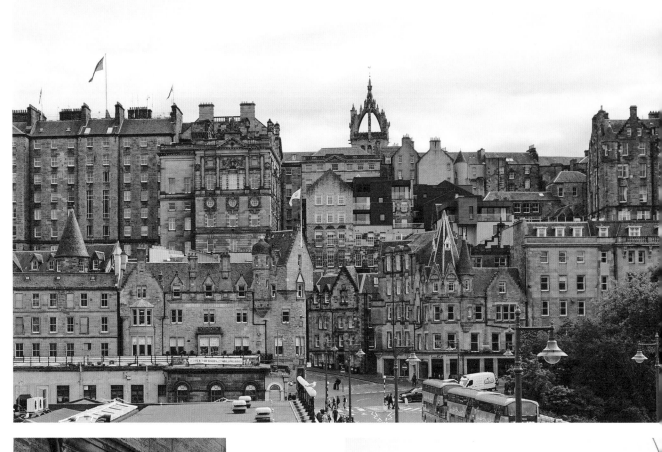

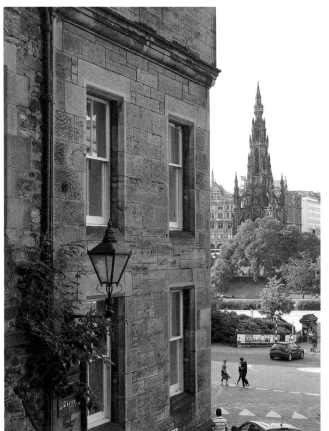

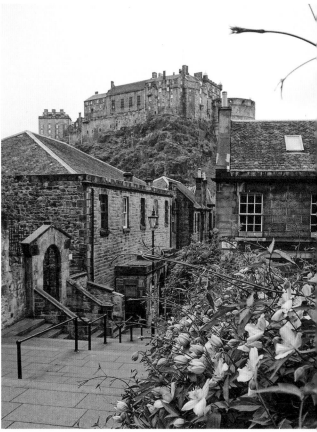

OLD TOWN

'It seems like a city built on precipices, a perilous city. Great roads rush downhill like rivers in spate. Great buildings rush up like rockets.' – **G.K. CHESTERTON, 1905**

To me, Edinburgh's Old Town is unlike anywhere in the world. Early examples of skyscrapers rise in a disordered, jumbled fashion to create the magnificent cityscape that so many recognise and love. Edinburgh Castle towering majestically over the city and the extinct volcano of Arthur's Seat looming like a sleeping lion in the distance, the skyline of Edinburgh's Old Town is quite a sight to behold and hints at the rich complexity of its history. From its very origins, the area has had royal connections as King David I established it as a Royal Burgh in the 12th century. The Royal Mile itself runs the length of the Old Town with the imposing shapes of Edinburgh Castle and Holyrood Palace acting as regal bookends.

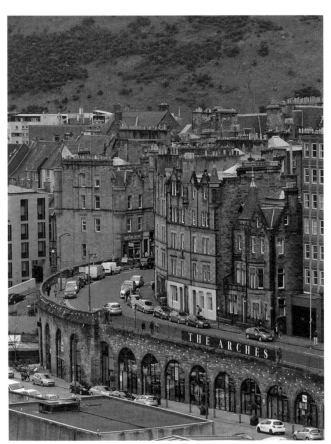
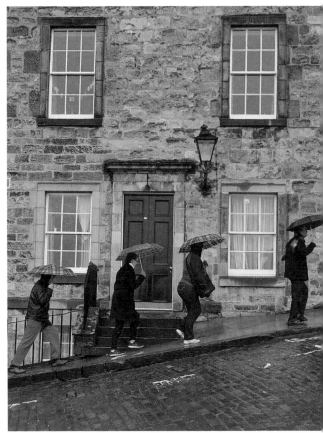
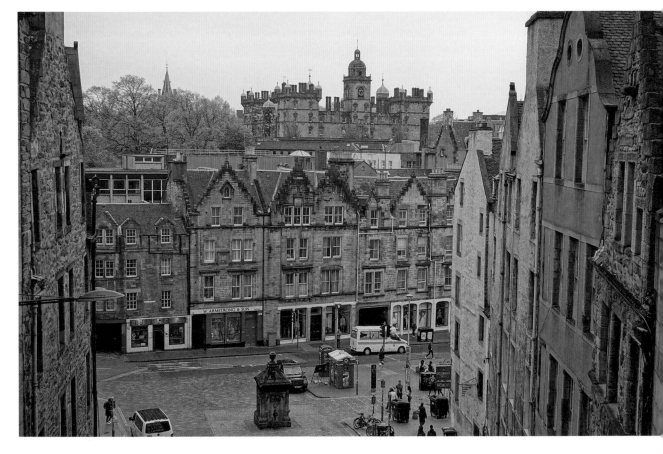

Pockets of Pretty in the Old Town

THE VENNEL

Every time I mention the Vennel to someone, I feel I'm letting that person in on a little secret. Tucked away in the south-west corner of the Grassmarket, this unassuming set of steps holds a picturesque secret. Its old-fashioned streetlamps, dramatic vista, and worn stone steps, all complement one of the best views of Edinburgh Castle you can find.

VICTORIA STREET & VICTORIA TERRACE

Victoria Street is one of Edinburgh's most beloved and most-photographed streets. The curved, sweeping street links the Grassmarket to George IV bridge, and has become one of the Old Town's main attractions. What sets this street apart from any in the city is its terrace balcony which overlooks the street. If you walk to the very end, you'll be greeted with splendid views of George Heriot's School and a slice of the Grassmarket.

THE NATIONAL MUSEUM OF SCOTLAND & ROOFTOP TERRACE

I've visited the National Museum of Scotland ever since I was young – this was before its out-standing refurbishment – and it's a landmark that holds many memories for me. It's a brilliant place to spend a rainy day in Edinburgh. The rooftop terrace boasts nearly 360-degree views of the city and is the perfect way to revel in the cityscape if you don't have time to climb Arthur's Seat. It can be rather tricky to find if it's your first visit to the museum; perhaps that's why it remains something of a hidden gem.

COCKBURN STREET

Cockburn (pronounced Coburn) Street is one of the many entrances into Edinburgh's Old Town. The steeply curved street wraps around early examples of skyscrapers and eventually inter-sects with the Royal Mile. The Royal Mile may be the main reason visitors head up this street, but Cockburn Street is an architectural feast for the eyes and filled with lovely independent cafés and quirky shops offering everything from retro dresses to bohemian homewares.

RAMSAY GARDEN

These remarkable homes are an iconic part of Edinburgh's Old Town landscape. The distinctive red and white buildings with their castle-esque features sit proudly on Castlehill and was originally part of renowned Edinburgh town planner Sir Patrick Geddes's vision to improve the living conditions of the Old Town. I can't imagine any buildings more fitting to sit next to Edinburgh Castle. In recent years, Ramsay Garden has become a bit of an Instagram hotspot in the Old Town and I can see why.

EAST MARKET STREET ARCHES

The Arches is a recent addition to Edinburgh's Old Town. What was once a row of abandoned Victorian brickwork arches have now been transformed into cool contemporary retail units. I think the Arches are one of the city's more appealing modern developments. Only a few moments' walk up the hill from Waverley station, these eclectic boutiques are definitely worth visiting.

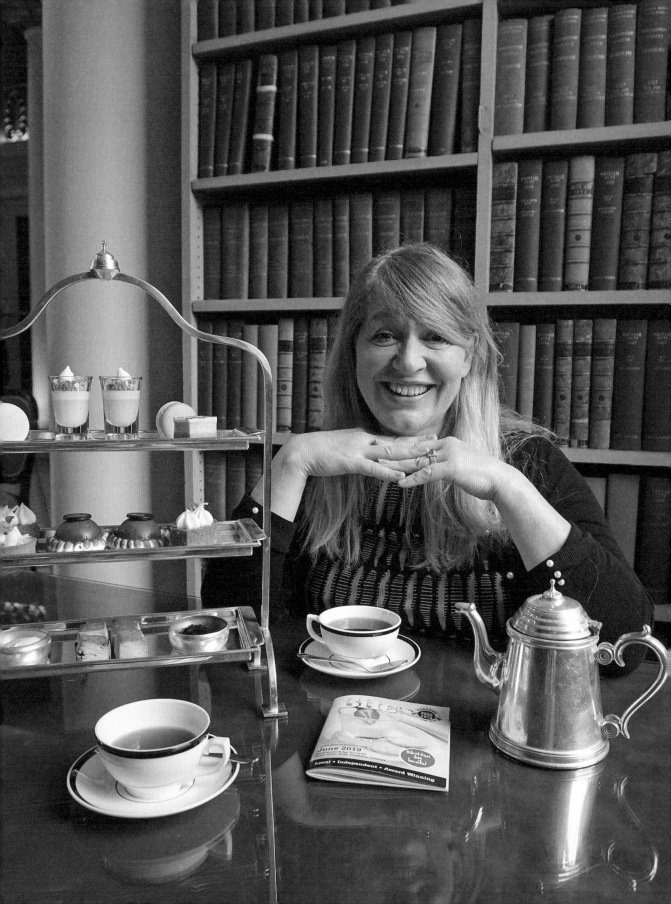

Afternoon Tea with Mrs Bite

Bite is a bit of a locals' secret. The 'bite-sized' publication is a monthly food magazine written by locals and comes in a handy pocket-size format which is free to pick up in various shops and restaurants in Edinburgh. To find out a little more about the magazine's beginnings and to chat all things food, I've sat down for afternoon tea with Sharon Wilson, known locally as 'Mrs Bite' (founder and all-rounder at *Bite Magazine*) at the Colonnades at the Signet Library.

How did your adventure with *Bite Magazine* begin?

When I started in 2003 Edinburgh's foodie culture was only just starting to simmer. Scotland's natural larder and eating locally were key concepts that underpinned our early issues, but which were not as widely accepted as now. I thought food was going to become part of a Scottish cultural renaissance that had already seen music, fashion, fiction and film gain worldwide recognition. This was inspiration enough to start *Bite*.

What do you love most about your job?

My life revolves around food and I can hand-on-heart say I love my job. Who wouldn't! Working on a food magazine means that every day brings new people, fresh ideas and endless foodie 'happenings'. I can't do it all myself of course and rely heavily on the team behind *Bite*. They roam the closes and cobbled streets of Edinburgh, noses poised for a whiff of some new gastro adventure.

What does a typical day with *Bite Magazine* look like?

I get up about 6 a.m. and the first thing I do is feed my cat Hobnob who is as greedy as me. When I work from home, I start my day with good coffee and sourdough which I get every Saturday from Woodlea Stables in Fife. I also buy freshly laid organic eggs from them. After breakfast I read through social media and emails. Some days I have appointments with restaurants, otherwise I am writing restaurant reviews, updating the website and doing social media, organising foodie visits for the team, editing, deciding on a front cover, running competitions and a whole host of exciting everyday jobs that keep *Bite* ticking along.

Could you recommend a few places to eat in Edinburgh for different occasions?

BEST BRUNCH SPOTS Nobles and Roseleaf, which are both in Leith, have good brunch menus made using local produce. Expect dishes such as Eggs Benedict, Bloody Marys, good coffee and juices. They are traditional pubs that

have been given contemporary twists in terms of décor. Also, the Edinburgh Larder Café in Blackfriars Street has delicious bacon butties, brownies and scones.

ROMANTIC MEAL OUT Romantic for me means pushing the boat out, so that's somewhere with good Scottish seafood and steak. I like the Dining Room at the Scotch Malt Whisky Society on Queen Street and the White Horse on the Royal Mile.

RESTAURANTS WITH A VIEW The Lookout by Gardener's Cottage on Calton Hill definitely has one of the best views in Edinburgh. I also like the Secret Herb Garden just outside the city in Lothianburn. It's a nursery, which houses over 600 different types of herbs, plus beehives, rose garden, café, gin distillery. Sit in the glass houses with coffee and cake and enjoy a sylvan countryside setting.

BEST AFTERNOON TEA SPOTS So many – and I do love an Afternoon Tea! Definitely jam first on those scones, please. If pushed for one particular place I would say the Colonnades at The Signet Library. It has an elegant 'tea salon' vibe and is just off the bustle of the Royal Mile. A beautiful building and the food is top drawer.

BEST PLACES FOR A PINT OR COCKTAIL Head to a traditional pub with a good range of Scottish and local beers such as Teuchters

Landing in Leith, Teuchters bar in the West End, the Guildford Arms at the East End of Princes Street or the Cumberland Bar in the New Town for its beer garden.

There are loads of cocktail bars in Edinburgh. Harvey Nichols has a smart bar with views of the Firth of Forth and good service, Bramble is recognised worldwide and the Voodoo Rooms is award-winning but to be honest throw a stone and you will find one. Edinburghers love their cocktails.

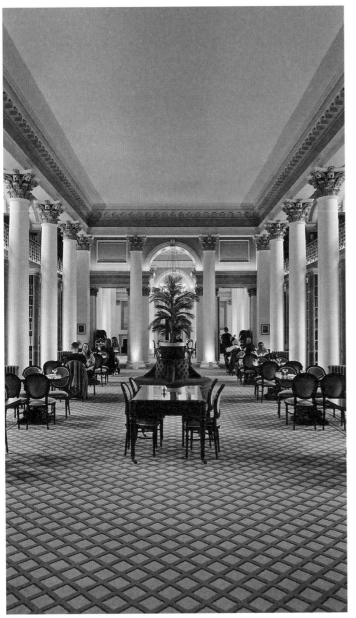

Coffee Shop Corner

Scottish weather can be fairly temperamental and if you're out exploring the Old Town, you may need a cosy café to nip into. Thankfully there are plenty to choose from and here are just a few of my favourites.

As their name suggests, LOVECRUMBS (155 West Port) specialises in delectable cakes. Anything from pear and cardamom to bramble and vanilla and, most importantly, they also serve up a great cuppa to go with the treat of your choice.

THE MILKMAN (7 Cockburn Street) has to be one of the most characterful coffee shops in the

Old Town. Albeit rather small, the coffee shop has embraced its original stone walls making stepping inside feel like stepping into a slice of history. If you manage to sneak the coveted window seat, I can guarantee you'll feel pretty smug sipping your coffee and watching life on Cockburn Street pass by.

Hidden away within one of the East Market Arches is BABA BUDAN (19 East Market Street) which has managed to blend the character of the Old Town with a stylish modern interior. They specialise in coffee and doughnuts – need I say more?

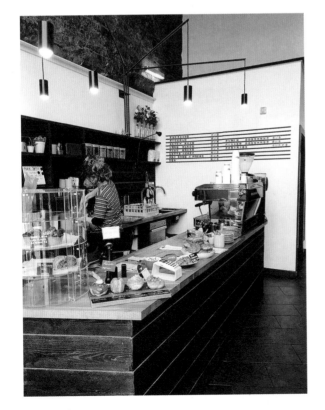

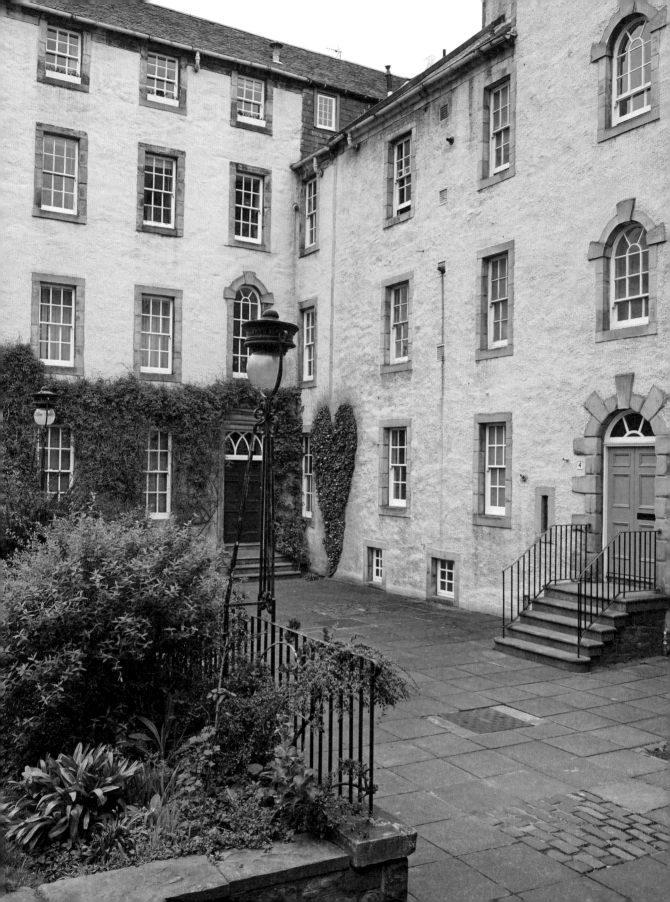

A Closer Inspection of the Royal Mile

As you walk down the Royal Mile and branch off down its closes, you'll breathe in the atmosphere of the area's history, shrouded in mystery and folklore. For those of you who aren't familiar with a 'close', it's a Scottish term for a narrow alleyway, these glimpses into the past are one of my favourite aspects of Edinburgh's Old Town. Hidden down these closes were once bustling communities, with more upper-class residents residing on the top floors away from the inevitable squalor of the street. Concealed within a select few of these unassuming closes are beautiful little squares and gardens, full to bursting with photo opportunities. Look out, too, for the intriguing arches and decorative signs that sometimes mark the entry to the closes!

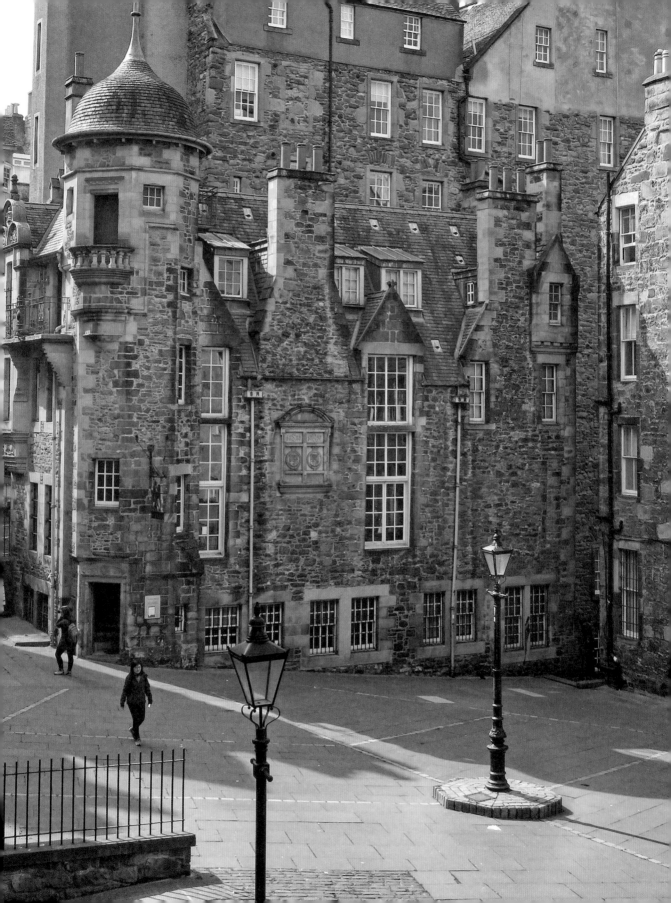

BOSWELL COURT

Hidden within Boswell Court is the Witchery Restaurant and Secret Garden. The exquisite ivy-covered close is brimming with photo opportunities. During autumn, you'll likely see a collection of pumpkins and, at Christmas, you'll be greeted by twinkly lights and a splendid Christmas tree.

LADY STAIR'S CLOSE

There are moments in Edinburgh where I must remind myself I'm not in a fairy-tale land but a modern city – and entering Lady Stair's Close is one such moment. The close brings you to a courtyard with a 17th-century townhouse, home to the Writers Museum. The Writers Museum is an architecturally exquisite building that celebrates the lives of Scottish literary legends. It is free to visit and a perfect place to escape the rain while soaking up a bit of Scottish history! When you're in the courtyard, don't forget to look down: the flagstones are beautifully inscribed with thought-provoking quotes to celebrate Scottish authors.

ADVOCATE'S CLOSE

Located directly opposite St Giles' Cathedral, the High Kirk of Edinburgh, lies one of the most well-known closes on the Royal Mile, yet it can be easy to miss if you're not looking for it. Advocate's Close offers its visitors a magnificent view of the Scott Monument, which is perhaps why it's the subject of many photographs and paintings!

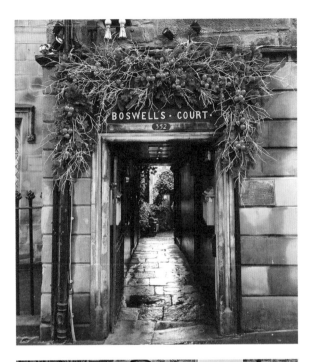

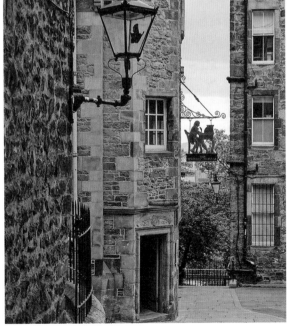

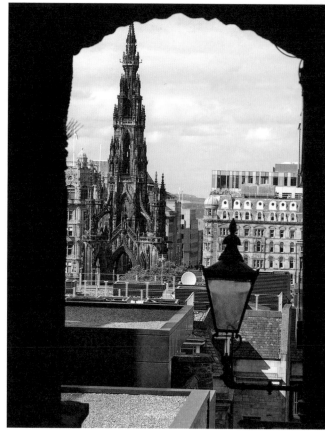

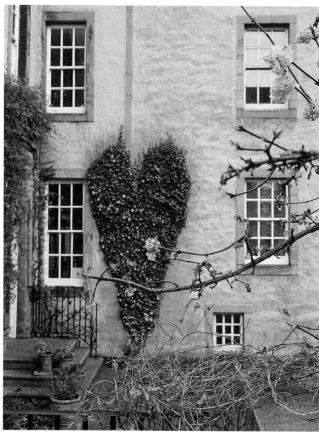

CHESSEL'S COURT

Once you step off the bustling street and pass through the arches which lead to the court-yard, you're greeted by a pocket of greenery and tranquillity. The court is home to a beautiful example of mansion flats. The heart-shaped ivy which grows up the wall of the mansion flats is surely another reason why Chessel's Court has become a firm favourite.

DUNBAR'S CLOSE

Once inside Dunbar's Close, there is little in-dication that you are still standing in a city centre. It is characterful, secluded, stunning in the springtime and, to top it off, Robert Burns was known to be a regular visitor! The garden is laid out in the clipped and elegant style of the 17th century and was donated to the City of Edinburgh by the Mushroom Trust. It's the ideal place for a picnic or for reading a book during the spring or summer.

WHITE HORSE CLOSE

At the foot of the Royal Mile, lies the eternal-ly charming White Horse Close. As you walk through the close it opens up into a surprising collection of quaint buildings, which have been beautifully restored. Make sure you walk inside the courtyard, where you'll be rewarded with the sight of a beautiful ivy-covered home with quirky decorations.

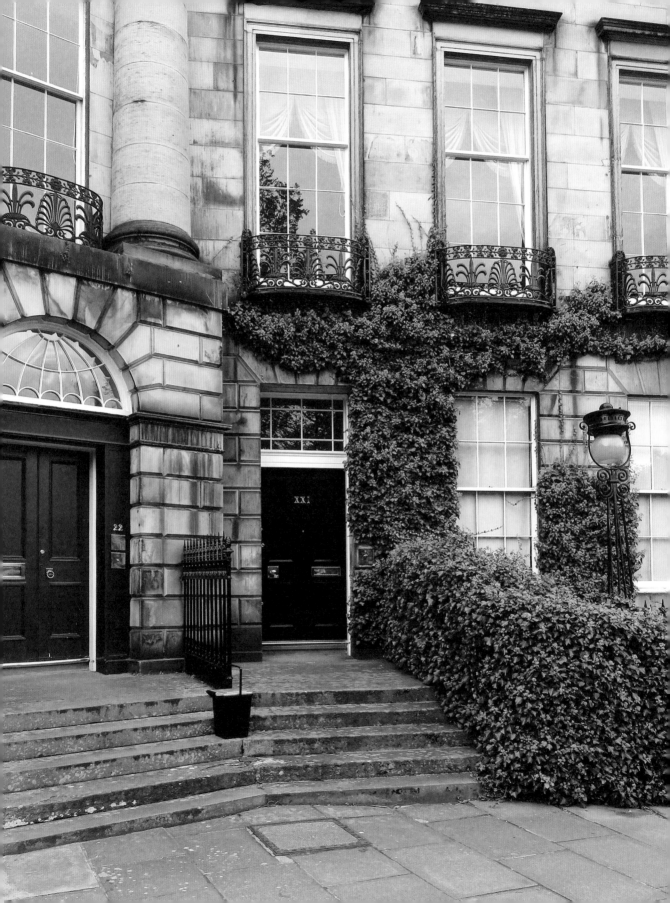

NEW TOWN

'The New Town arose, growing from day to day until Edinburgh became one of the most handsome and picturesque cities in Europe.' – **JAMES NASMYTH**

One of the things I love most about Edinburgh is the variety. The city keeps you on your toes as it doesn't have one clear identity, which is shown brilliantly in the contrast between the Old Town and New Town. As you leave behind the higgledy-piggledy charm of the Old Town and cross over into Princes Street Gardens, you step into the uniformity and elegance of the New Town. It's regarded as a Georgian masterpiece and is one of the largest complete examples of town planning from the Georgian period anywhere in the world. To me, the New Town is one remarkable pocket of pretty consisting of wonderful art galleries, stately rows of elegant Georgian homes with adjacent private gardens, and a diverse shopping scene. It's a lovely place to simply wander and admire your surroundings.

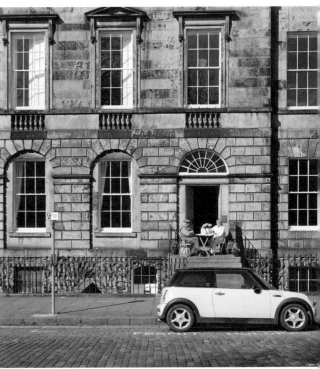

Pockets of Pretty in the New Town

PRINCES STREET GARDENS

Quite frankly, we're fairly spoilt when it comes to green outdoor spaces in Edinburgh, but one of the most well-loved is Princes Street Gardens. The garden sits in a valley between the Old and New Town and is split into East and West Princes Street Gardens, both with their own distinct personalities. East Princes Gardens is easy to identity thanks to the Scott Monument, a towering Gothic rocket-shaped structure, which you can climb for magnificent views over Edinburgh. I'm not great with heights, so I admit I've only made it up halfway but even then the views were stunning. Sitting proudly between the two gardens are two fantastic galleries, the National Gallery of Scotland and the Royal Scottish Academy, both of which are well worth a visit.

West Princes Street Gardens is a personal favourite of mine. It's considerably larger than its neighbour, full of intriguing statues, and often quieter than East Princes Street Gardens. There are also several hidden pockets of pretty within it. From July to October, you can visit Edinburgh's famous floral clock, a working clock laid out in flowers. Another hidden gem to look for is the Gardener's Cottage; quaint and picture perfect, it's nestled away in the east corner of the garden. There's also the recently restored Ross Fountain, where you can take the iconic Instagram photo of it with Edinburgh Castle, framed with greenery.

MORAY PLACE

Moray Estate was originally a country estate before it was incorporated, as an impressive extension, into the New Town plan. The jewel in its crown is the circular Moray Place, considered one of the grandest streets in Scotland thanks to the scrupulous planning that went into the aesthetics and building of these pristine properties. It is quite delightful to stroll around, camera at the ready.

DUNDAS HOUSE, ROYAL BANK OF SCOTLAND, ST ANDREW SQUARE

You may be suitably impressed by the exterior of Dundas House, but nothing can prepare you for its magnificent interior. The building was once the grand home of Sir Lawrence Dundas who cheekily claimed the plot of land which was laid aside for a grand church in James Craig's original New Town plan. Since 1825, the remarkable town house has been the registered office of the Royal Bank of Scotland. As you walk through the front entrance, you enter the beautifully restored house, but it isn't until you reach the Royal Bank of Scotland's extension that you'll be truly astounded by the stunning domed ceiling punctuated by stars which let in the sunshine.

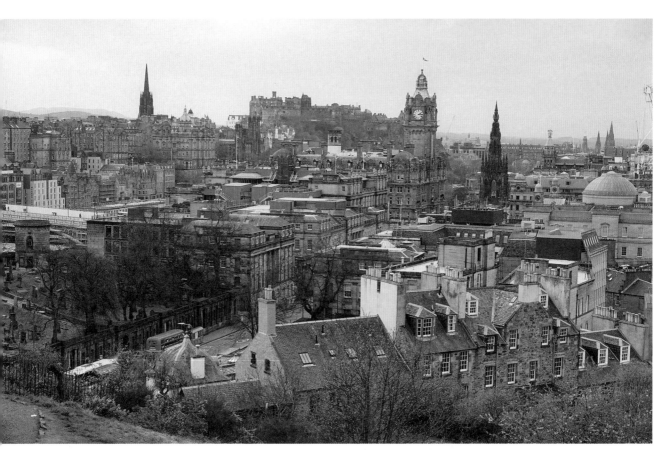

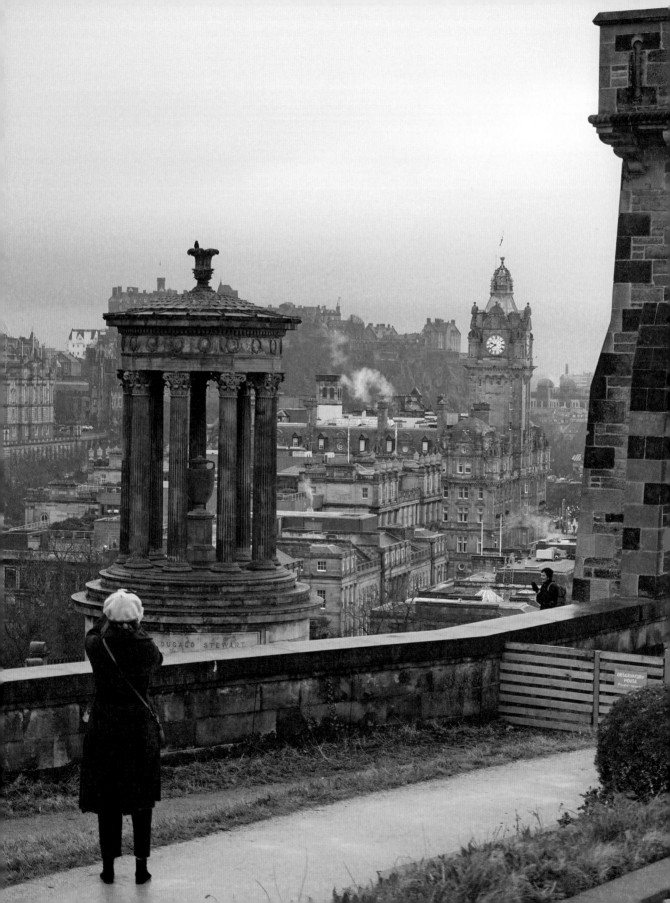

SCOTTISH NATIONAL PORTRAIT GALLERY

At the east end of Queen Street, a red sandstone neo-gothic building stands out among the grey sandstone Georgian homes. The Scottish National Portrait Gallery is a feat of architectural design and a literal shrine for Scotland's heroes and heroines. It's quite possibly one of my favourite buildings in Edinburgh. The grand hall is particularly enchanting during the festive period when the gallery is decked with garlands and a Christmas tree stands proudly in the centre. The café is an aesthetic haven too!

CALTON HILL

The humble-in-size hill boasts spectacular 360-degree views over the city and out to the Firth of Forth which rival its considerably taller neighbour, Arthur's Seat. A few Instagram photo opportunities are the view along Princes Street and a snapshot of 'Edinburgh's disgrace', the National Monument of Scotland. If views aren't enough to tempt you, Calton Hill is also home to the Collective Art Gallery, a beautiful contemporary art gallery which has sympathetically incorporated itself into the historic City Observatory and City Dome. Adjoining the Collective is the Lookout by the Gardener's Cottage. This small restaurant makes the most of its fantastic surroundings with floor-to-ceiling windows looking out over Edinburgh.

If you thought the views from Calton Hill couldn't get any better, you'll be in for a treat. The Nelson Monument is often overlooked, as many visitors flock to the Scott Monument, but for a small entrance fee you can gain access to the tower's magnificent views. It also has a small museum on the ground floor which is free to visit but donations are welcome. As you ascend the spiral staircase, you'll have a chance to peek at the city out of the old windows. However, a word to the wise, it's perhaps best to avoid it on windy days. I can tell you from experience that it gets pretty blustery up there!

BROUGHTON STREET

This is one of the select few streets in Edinburgh which has become a thriving melting pot for brilliant independent businesses. It's a street with a strong personality and a fierce community spirit among the shop owners, hosting annual events like 'Midsummer on Broughton Street' or celebratory events like 'Broughton Street Lives', which marked the end of roadworks along the street. As you leave behind York Place, and wander into Broughton Street, you're met with a colourful selection of places to eat. Try popping down Barony Street to the Broughton Deli or pick up a hot drink to-go from coffee aficionados Artisan Roast and enjoy it with a fresh cinnamon bun from the Söderberg bakery.

Broughton Street is also one of the best places to visit if you're looking for a gift or to treat yourself. Scandinavian lifestyle store, Lifestory, will have you coveting a new addition for your home; Curiouser & Curiouser will tempt you with quirky items you didn't realise you needed, and Narcissus Flowers will entice you into their store with the sweet scent of fresh flowers.

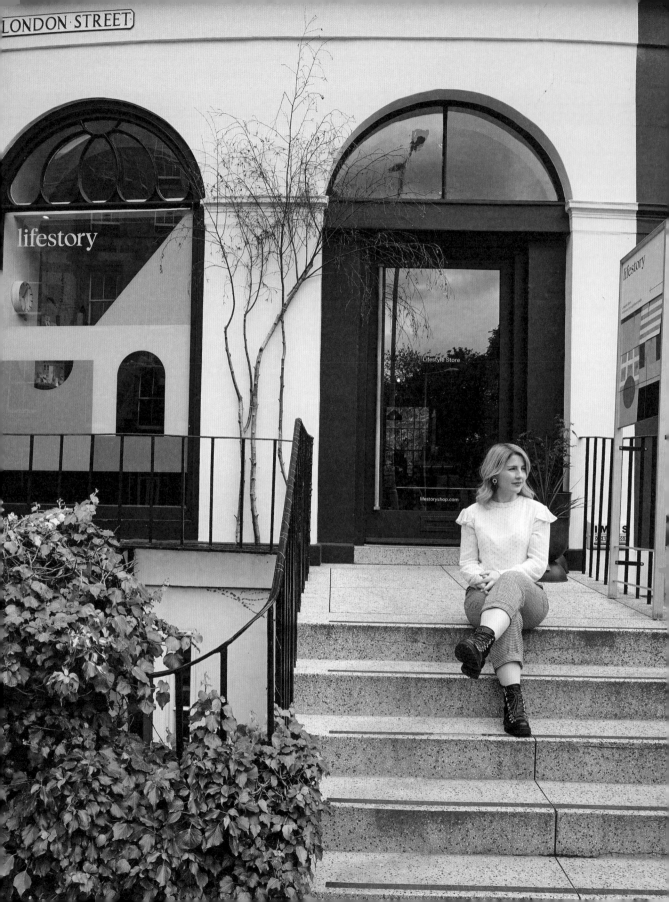

A Coffee Date with Susan from Lifestory

Anyone who knows me, knows how fond I am of Lifestory and I have Instagram to thank for introducing me to this brilliant store. Tucked away at the bottom of Broughton Street, Lifestory is a beautifully curated Scandinavian-led design store with a small coffee bar nestled at the back. Over the years, I have come to know its owner, Susan, who is not only one of the loveliest of people I know but also a brilliant businesswoman. As well as successfully running Lifestory, Susan started out in Edinburgh by founding the hugely popular Hula Juice Bar which she owned for ten years. Despite her Irish roots, Susan considers Edinburgh her home, and lives in Edinburgh's seaside village of Portobello with her partner and their adorable dog Rufus.

I've met up with Susan at one of her favourite coffee shops, Thomas J. Walls, to chat all things Lifestory and Edinburgh.

How did your journey with Lifestory begin?

In 2013, while I was running Hula Juice Bar, a new store opened in Edinburgh called Lifestory. It had been set up by two creatives, a husband and wife team, and they had created this beautiful concept store with a minimal aesthetic and a Scandinavian focus. I had visited it a few times and found it to be a very inspirational place.

After a year or so Lifestory was put up for sale, and despite it not being the best timing for me, it was just too tempting an opportunity to turn down and here we are four years later!

What was your vision for Lifestory?

For a while I had been developing an idea to create a hybrid lifestyle store, with a Scandinavian influence and a combined coffee bar area. I was looking to create the kind of shopping experience I love when I go to other cities. So, I kept the name but changed the layout by opening up the storeroom to create one large space with a seating area at the back of the store which overlooks an urban garden. I sold Hula Juice Bar last year to focus on this full time and rebranded with a beautiful new identity and logo for Lifestory to start the year off!

Lifestory has a wonderful collection of brands, how have you discovered them?

Over the years, I've developed the product range and we now stock over a hundred brands including ferm LIVING, HAY, and house doctor, as well as stocking at least thirty or more UK-based brands. Sometimes I go to trade shows, it's really nice to meet makers in person, but a lot of the time I discover new brands through Instagram. My aim was to make sure everything we stock in the shop flows together well. Two of

the questions we get asked a lot are 'Is it all by the same maker?' or 'Do you make everything yourself?', which is actually a huge compliment and great feedback because people are picking up on that continuity.

Do you have any tips for visitors to Edinburgh?
Edinburgh is an incredible place to live. One of the best things about the city is it's so easy to get around. I always suggest visitors visit the Broughton Street area, which is full of independent businesses including Lifestory, then climb the nearby Calton Hill, which gives you the perfect vantage point to get an understanding of how the city is laid out. As well as the views, there's a modern art gallery you can visit, or the option to have lunch at the Lookout which boasts fantastic views over the city. Then you can take Jacob's Ladder down towards the Arches where there's a row of lovely independent businesses which brings you to the Old Town.

Coffee Shop Corner

The New Town is full of wonderful independent coffee shops. If you're enjoying a spot of shopping along Princes Street or George Street there are plenty of independent coffee shops to slake your thirst, including Burr & Co, Lowdown Coffee and William & Johnson Coffee Co. However, I can't go into detail about them all or we'd be here all day! So here are a few of my personal favourites.

I find LEO'S BEANERY (23A Howe Street) to be one of the homeliest cafés in Edinburgh, perhaps because it's a family-run business. When I worked nearby, I used to enjoy sitting in one of their window seats with a hot chocolate and a book while on my break. It's also a wonderful spot to enjoy lunch with friends.

Entering DOOR 127 (127 George Street) is like stepping into the pages of a glossy home décor magazine. The coffee shop resides in the lobby of Eden Locke's aparthotel, but unless you spotted someone checking in, you'd be none the wiser. Keep an eye on their social media channels as they also host regular events, such as flower arranging and calligraphy workshops.

The tiny yet well-loved WELLINGTON COFFEE, perches on the corner of George and Hanover Street. Sitting just below the pavement, the coffee shop has at most four tables, meaning it can get rather busy in there. But if you're seeking for a cosy nook and a great cup of coffee, look no further.

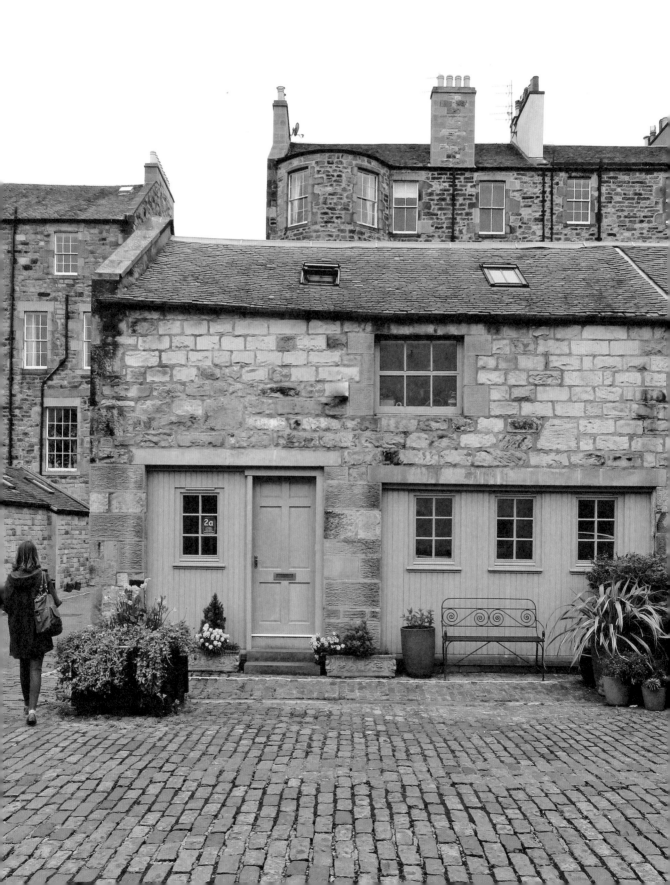

MEWSING AROUND THE NEW TOWN

While many get excited about the splendour of grand properties, I'm more intrigued by the possibility of a mews lane lurking behind.

There are few things that delight me more than the sight of a row of mews houses. Edinburgh may have few and far between in comparison to London, but that makes coming across them all the more exciting. These humble homes started out life in the most practical sense: the ground floor would stable horses, and the upper floor accommodated servants. And this is why you'll often find mews behind a row of grand houses. However, how times have changed! These compact homes are now some of the most sought-after and come with a pretty price tag.

GLOUCESTER LANE

A lovely little lane lined on either side with mews houses, Gloucester Lane leads from New Town down towards Stockbridge.

REGENT TERRACE & CARLTON TERRACE MEWS

Tucked away behind Calton Hill are two charming mews lanes. Carlton Terrace Mews is particularly interesting as its mews houses curve around the cul-de-sac with a lovely patch of greenery in the centre. The mews is often patrolled by the odd neighbourhood cat.

DUBLIN MEUSE

One of my favourite shortcuts from Northumberland Street to Dublin Street is Dublin Meuse. The mews lane has a few delightful homes, including an ivy-covered house which I always stop to admire.

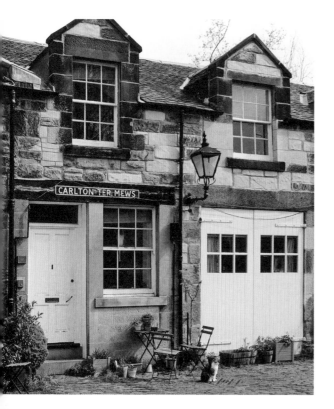

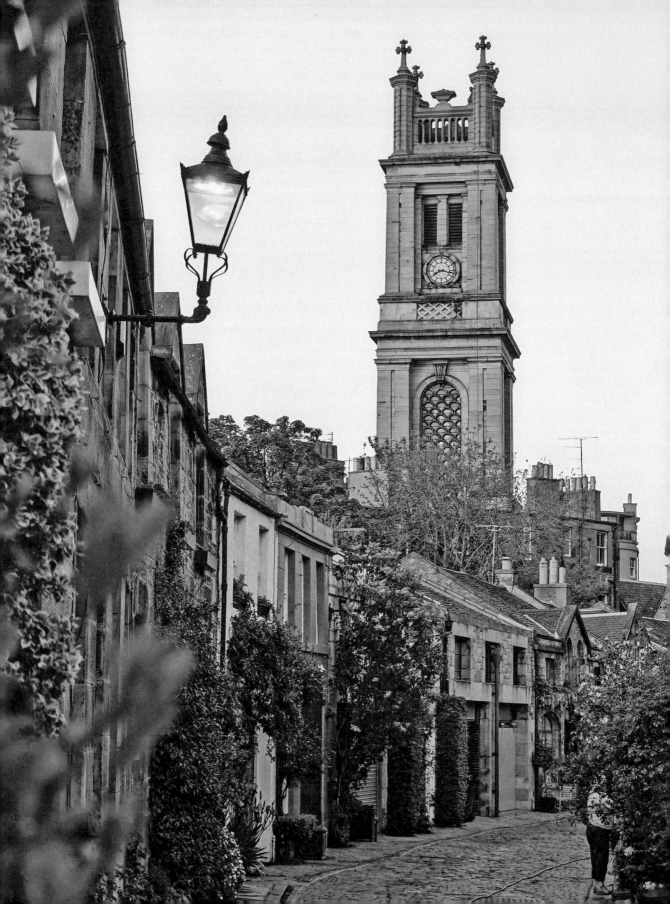

STOCKBRIDGE

'I like this place and could willingly waste my time in it.' – **WILLIAM SHAKESPEARE**

Just a short walk north of Princes Street, Stockbridge has a drastically different feel from its close neighbours. Originally a small village outwith Edinburgh, Stockbridge has kept lots of its village-like characteristics – and those who love the area are quite fierce about protecting its independent atmosphere. One of Stockbridge's many charms is its high street, where you can buy meat from the local butchers, flowers from the florist, cheese from the cheesemonger – I could go on – but you get the idea. In an age where we do most of our shopping at the supermarkets, these distinct specialist shops seem rather lovely to me. As well as an enticing collection of independent shops and cafés, Stockbridge also has a reputation as a haven for charity shoppers.

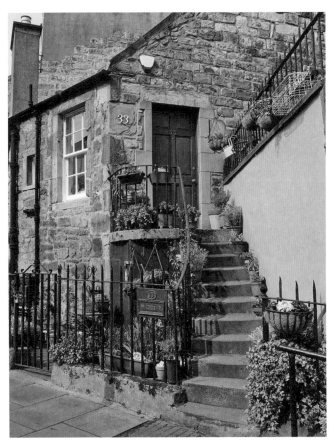

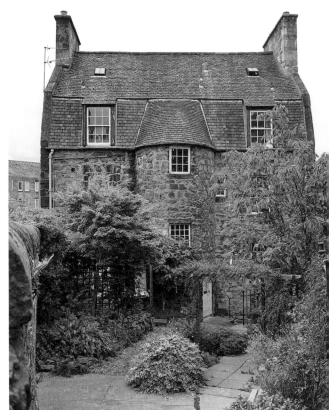

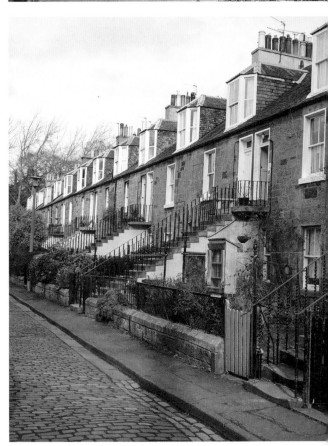

Pockets of Pretty in Stockbridge

THE STOCKBRIDGE COLONIES –
GLENOGLE ROAD

The Colonies started off life in Edinburgh as a social housing experiment for working-class families. However, the homes that were once an affordable housing scheme are now some of the most sought-after properties in the city. What makes them so unique is their unusual layout. The housing project set out to offer an alternative to traditional tenement accommodation, so the homes were designed to be flats that felt like houses. And so, each home has its own front door and garden. The Stockbridge Colonies are in a beautiful location, sandwiched snugly between the Water of Leith and the Glenogle swimming baths, with its sauna, steam room and tranquil pool. As well as being extremely charming to look at, these colonies have fostered an amazing community spirit and host regular open gardens, yard sales, art events, a choir and more!

THE POTTED GARDEN IN THE CITY &
DUNCAN'S LAND

The Potted Garden, as it has become known owing to a small sign hanging in its garden, could easily be overlooked if you were simply walking down Kerr Street with your eyes fixed forward – but that would be an awful shame! It may not be the largest front garden in Stockbridge, but what it lacks in space it makes up for in an abundance of plants. The quirky house has

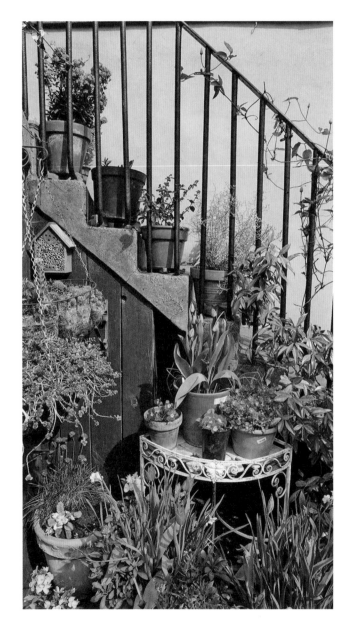

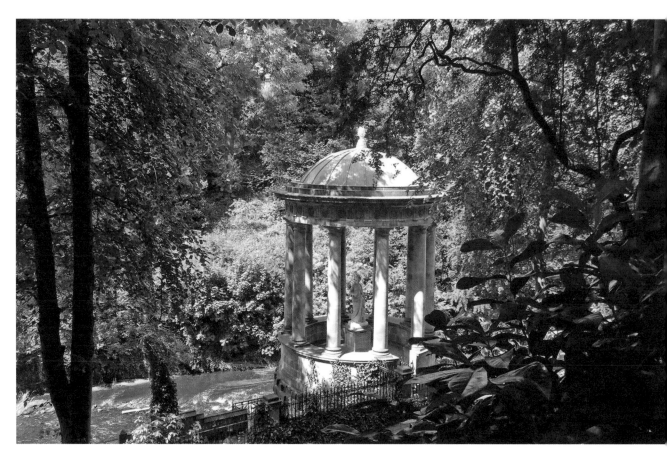

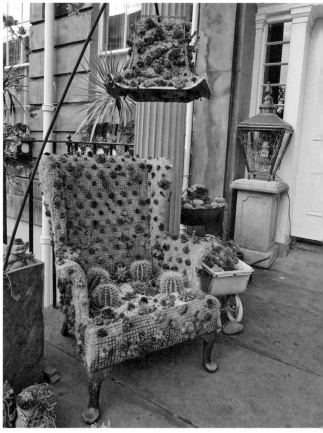

oodles of charm and is further enhanced by the assortment of plant pots proudly displayed on the stone staircase leading up to the front door and the collection of plants decorating the modest front garden. It's become a firm favourite among locals. Before you leave, take a few steps along India Place, and pop your head over the stone wall for a brilliant photo opportunity of Duncan's Land, one Stockbridge's oldest surviving buildings that dates back to 1790.

WATER OF LEITH & ST BERNARD'S WELL

Hidden amid the foliage along the Water of Leith walkway, halfway between Stockbridge and Dean Village, you might be surprised to find a neoclassical temple structure called St Bernard's Well. The circular well was designed by Scottish painter, Alexander Nasmyth, and the waters were once famed for their healing powers. Nowadays, you'll only get the chance to glimpse inside St Bernard's Well a few times a year when the Dean Village Association fling the doors open to the public. I was stunned the first time I entered. The space may be small but it's beautifully decorated. There are gloriously patterned floor-to-ceiling mosaic tiles, with the ornate well standing proudly in the centre.

A SUCCULENT GARDEN IN THE CITY

Edinburgh is widely known as a historic and awe-inspiring city (and quite rightly so), but it's also a city filled with creative and vibrant individuals. As you walk past the impressive Edinburgh Academy and Georgian façades on Henderson Row, the last thing you would expect to come upon is a collection of antique

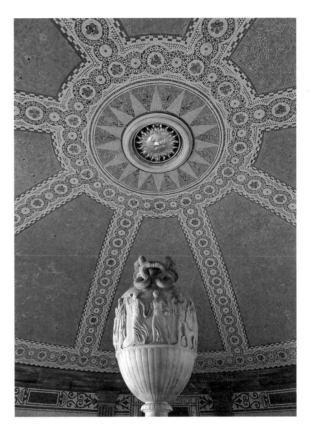

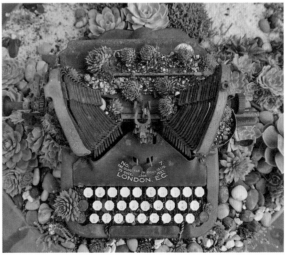

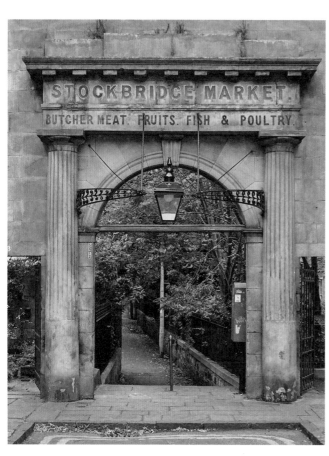

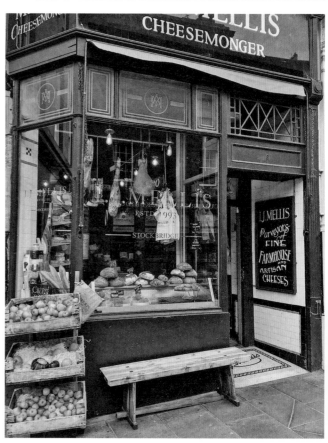

furniture, old wellies and teapots congregating at the entrance of one of these Georgian homes. If you pause to take a closer look at the hodgepodge of furniture and antiques, you'll soon realise that out of every crevice a quite frankly astonishing array of succulents and cacti are thriving.

ST STEPHEN STREET

The street has become a haven for independent shops of all shapes and sizes. It's encouraging to watch them flourish and fight off competition from large chains. The shops all have their own unique purpose and personality, from one of the best independent bookshops in Edinburgh, Golden Hare Books, to the beautiful lifestyle store, The Method, and Space at Seventeen a pop-up venue. It's only fair to take a moment to appreciate this wonderful little street. There's also a hidden gem tucked away halfway down this street, at St Stephen Place, where you'll spot the picturesque Georgian archway heralding the entrance to Stockbridge's old meat market.

ANN STREET

Named after Sir Henry Raeburn's wife, Ann Street is simply stunning; nestled next to Dean private gardens, it consists of Georgian garden villas. The street has become known locally as Millionaires Row, as it's one of Edinburgh's most expensive residential addresses. As you enter, you'll be greeted by a narrow cobbled street with rows of Georgian townhouses flanked on either side. The homes' generous front gardens are immaculately tended and it's an absolute delight to walk along Ann Street in spring when the wisteria is in bloom.

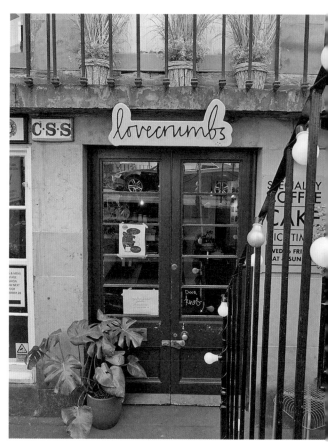

Coffee Shop Corner

Tucked away down little side streets and sitting proudly on the high street, there are various cafés to visit when you're in Stockbridge. I've selected a few of my favourite spots to sit back with a cuppa and observe the world go by.

If the mere mention of *kanelbulle* (cinnamon buns) or seasonal *semla* (cardamom buns filled with almond paste and whipped cream) has you drooling, SÖDERBERG is a must-visit when you're in Stockbridge. The Swedish independent café chain has won over locals and gained a whole army of loyal fans. Their bread is a dream, too!

THE PASTRY SECTION's a relatively new addition to Stockbridge yet within a short space of time they have become an integral part of the high street. All their baked goods are lovingly baked on their premises daily, so the trickiest part is deciding what you'll have.

If you enjoy something different, GAMMA is quite possibly the quirkiest café I've set foot in. Primarily a bike shop, it has a few tables at the front where you can sip a coffee, admire the cycling paraphernalia and have a chat with Gamma's friendly owner, Gavin.

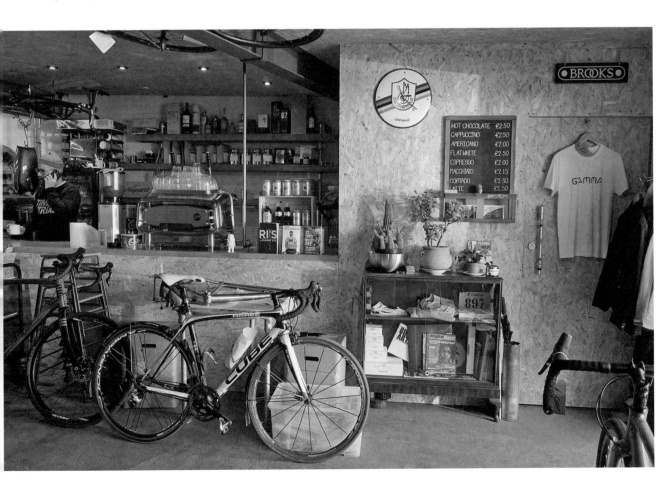

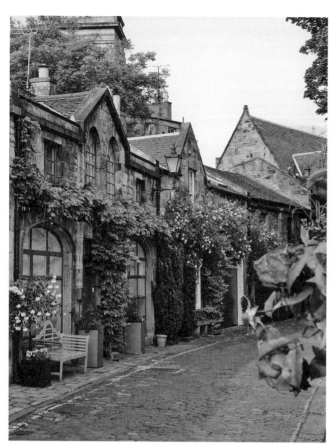

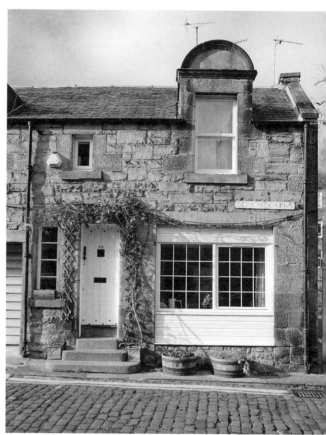

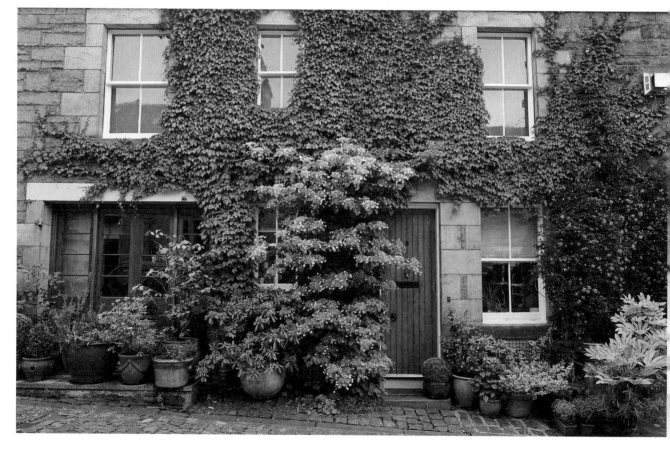

MEWSING AROUND STOCKBRIDGE

CIRCUS LANE Although, technically in the New Town, Circus Lane is often synonymous with Stockbridge. I remember only a few short years ago, Circus Lane was admired by locals but remained a relatively hidden gem. However, word is out (largely thanks to social media) and I'll often come across visitors lining up to take the iconic Circus Lane shot with St Stephen's Church towering in the background. The presence of other admirers has not affected my love for the little lane; it remains one of my favourite places to visit and photograph as the seasons change throughout the year.

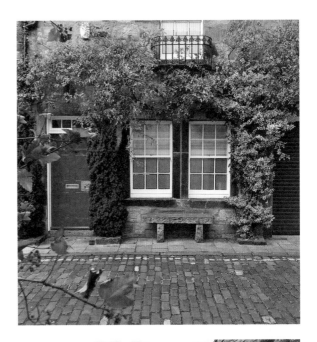

DEAN PARK MEWS Stockbridge's lesser-known mews, Dean Park Mews, may not draw the crowds like its popular neighbour Circus Lane, but it's most certainly not lacking in picturesque charm. Dean Park Mews has a sleepier countenance. Whenever I visit, I often pass locals pottering away in their garages or tinkering with their cars. You're almost certain to spot a feline prowling around observing the goings-on in this peaceful city sanctuary.

LEARMONTH GARDEN MEWS If you thought Dean Park Mews was a hidden gem, chances are you may not be aware of Learmonth Garden Mews. I confess, despite living in Edinburgh for about five years, I only happened across this delightful mews at the beginning of 2019. It may not be as picturesque as Circus Lane or as large as Dean Park Mews, but you can still capture some beautiful detail shots!

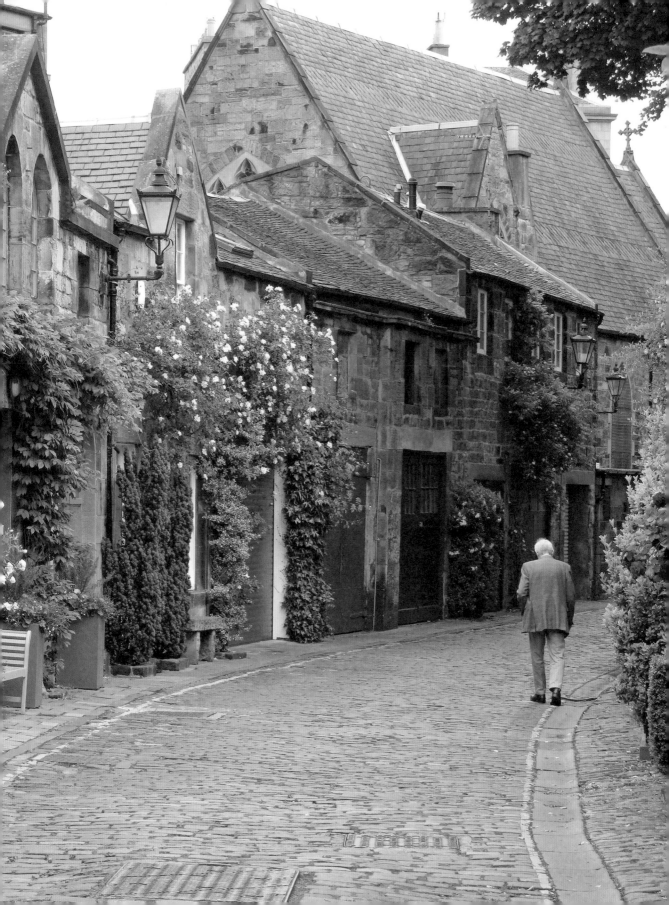

The Gentleman of Circus Lane

A few years ago, I was walking through one of my favourite Edinburgh lanes, when an older gentleman came up to me and asked, 'Why do people always photograph this street? Is it in a guidebook or something?' I remember looking at him and then laughing gently. Our conversation continued as follows:

'I think it's because we all love how beautiful it is.'
'Well, it didn't used to be!'

We walked through Circus Lane together and he chatted about what the lane used to be like when he was young. Apparently, there once was a cat shelter! He told me how, when this street was first being renovated into private homes, his mum mentioned to his father that she thought how nice they looked. His father's response was:

'Never will you catch me living in one of those houses, I worked hard to get out of places like that!'

Truly, times have changed. As we parted ways, I managed to snap a photo of him as he was walking away.

A Morning with Lesley at the Pastry Section

I can't think of a better way to end a day of wandering around Stockbridge, than with a cup of tea and a sweet treat, and that's how I came across the Pastry Section. It only took one bite of their raspberry and white chocolate tart for me to know that the Pastry Section would become a firm favourite. Sitting at the north end of Stockbridge's high street, the Pastry Section has become something of a local institution in the short time it's been open. Its success is most definitely attributed to its delightful owner, Lesley, who's not only a wonderful baker but also one of the sweetest people I've had the pleasure of coming across.

I wanted to find out more about Lesley and how the Pastry Section began, so we met at the store one morning and sat in the window seats with a pastry and a hot drink for a good old natter.

Where did your love for baking stem from?
My grandma was a great cook and I have inherited some of that. I've always baked at home and enjoyed baking for friends. People always said that I should open a store but, for me, it was more of a hobby and I didn't really think anything of it.

What was your background before the Pastry Section?
I was originally a nurse, and in the latter part of my career, I worked in ITU. I had a run of three young men tragically pass away, who were all about thirty years old, very successful and going in the right direction. It made me re-evaluate my life, and I realised I had fallen out of love with nursing, not the physical job of looking after somebody, but the general politics. That's when I decided I would go back to college to do a professional cooking course because I really wanted to have a certificate to prove to myself that I was good enough to do this.

The Pastry Section is two years old and from the outside it looks like you've gone from strength to strength. Has it all been smooth sailing?
No, not at all! For two years, I was in full-time college, working two shifts nursing, baking at a café in Newhaven, as well as looking after my two children. It was tough. Once I graduated, I began the process of opening a store, we put in offers for lots of spaces, but we didn't get any of them. Then our current space came up for let. I thought it was a lovely space but told myself if I didn't get this one, that's it. Thankfully,

we got it! Over the two years, we've found that the Pastry Section has become more than just a shop; over coffee and cake we have evoked memories, conversations have been initiated and friendships have emerged.

There's such an array of different sweet treats on the Pastry Section's counter. Where do you find your inspiration?

We work very organically. I don't make a weekly plan of what we're going to do, we have a day plan. The seasons plays a major role and it also comes down to what we're in the mood for, too. One time we went out for drinks which came with pretzels and peanuts, so I had the idea to do a 'Bar Snack Brownie'. There are also certain things everyone loves, and we call them 'The Favourites'. So, we always try to rotate those in. We also try to theme it if there's a holiday coming up. For instance, for Valentine's Day this year, our hot chocolate came with a heart-shaped marshmallow and we put on all 'The Favourites' – and we sold out of everything!

The shop must keep you really busy! How do like to spend your time off?

In the beginning, I used to be in the shop every day, but now I let myself have a day off on Mondays and a half-day on Sundays. On my days off I enjoy getting out into the fresh air, so we tend to head out of Edinburgh for a day trip to places like East Neuk in Fife. I like how it's easy to visit different parts of Scotland from Edinburgh by train, you can get on the new Borders Railway or spend the day in North Berwick or head up to Dundee and visit the new V&A – which is amazing! When I'm in Edinburgh I enjoy spending time going to galleries and visiting exhibitions. Last Monday, we went to the City Art Centre's Robert Bloomfield exhibition and I loved it.

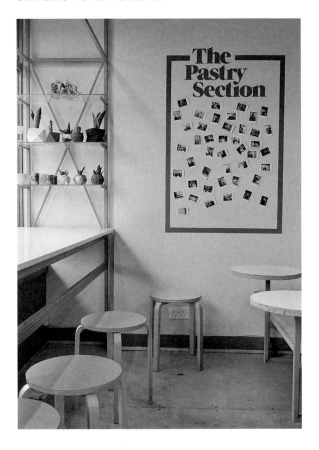

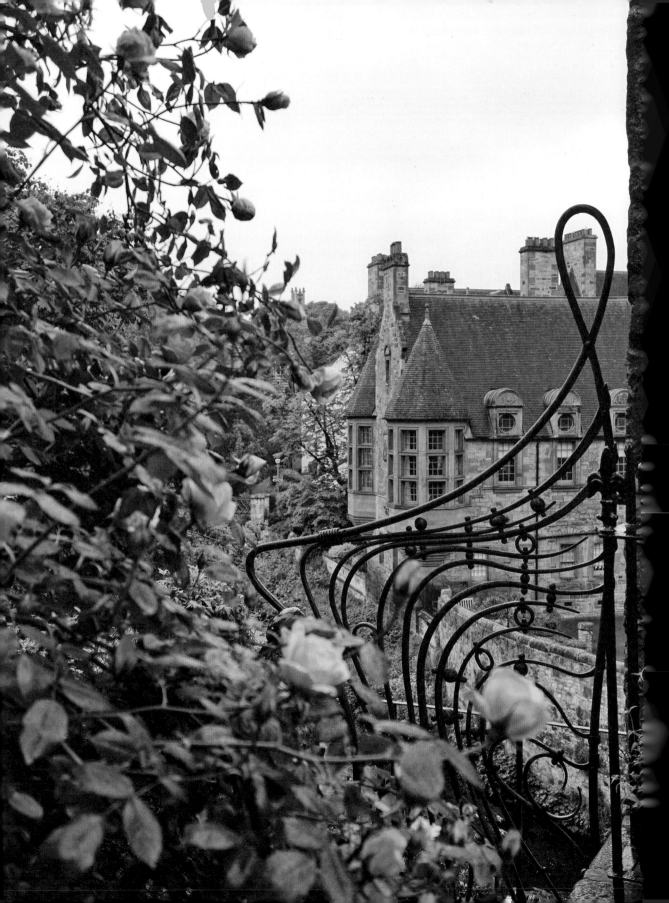

WEST END & DEAN VILLAGE

'Everything you look at can become a fairy tale
and you can get a story from everything you touch.'
– HANS CHRISTIAN ANDERSEN

Edinburgh's West End is quite possibly one of my favourite neighbourhoods and somewhere I think is often overlooked. It has a strong identity and sense of community spirit, and hosts regular events including the West End Classic Vehicle Show (a fantastic event to stock up on #asundaycarpic photos). Keep an eye out on the @edinwestend Instagram account to ensure you don't miss out. At first glance the area is fairly unassuming, with bustling Queensferry Road lined with a wealth of fabulous places to dine taking centre stage. However, if you wander down quiet side streets you'll uncover surprising hidden gems. From the charming William Street to the jewel in the area's crown, the extremely Instagrammable Dean Village, the neighbourhood is filled with various pockets of pretty.

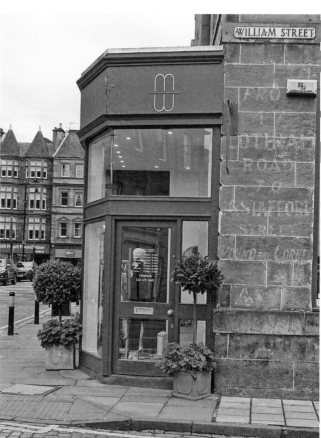

Pockets of Pretty in the West End

CALEDONIAN STATION

The previous Caledonian train station is definitely one of the landmarks of the west end of Princes Street. The magnificent red sandstone building is now home to the Waldorf Astoria. If you're a fan of afternoon tea, I would highly recommend visiting their Peacock Alley which pays homage to the hotel's Caledonian Railway, formerly located beneath the hotel. As you sit sipping your tea and nibbling on a scone, you'll be surrounded by the original red sandstone station walls, complete with the historic Caledonian station clock.

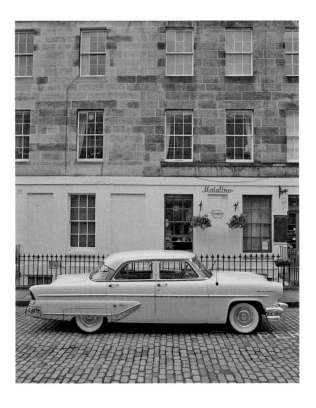

RUTLAND SQUARE AND ATHOLL CRESCENT LANE

Next to the Caledonian hotel is a little lane that leads to Rutland Square. Despite having walked through this beautiful Georgian square on many occasions, I am still taken aback by just how tranquil it is, especially given its setting in the midst of Edinburgh's busiest streets. A walk around the corner of Rutland Square brings you to Atholl Crescent Lane. This striking lane, along with Circus Lane, has become one of my favourite in Edinburgh to photograph. There's something about how the lane curves in contrast to the uniform regularity of its buildings which creates a shot almost frozen in time.

WILLIAM STREET

Tucked away among the grand townhouses of the West End lies William Street, a quaint street consisting of Georgian shopfronts; so charming in fact, it has been the backdrop for various TV shows and films. One interesting feature to keep an eye out for is the cast iron balconies under the shop windows, a rare surviving feature designed to allow customers to get a closer look at the goods. Joining the likes of Broughton Street and St Stephen Street, William Street is another haven for independent shops. Pop into Strumpets for a cuppa, Rogue Flowers for a beautiful bouquet, or browse Liam Ross's stunning jewellery collection. My favourite time of the year to visit is during the festive period when William Street becomes postcard perfect as it's decked out to the nines with garlands and mini Christmas trees.

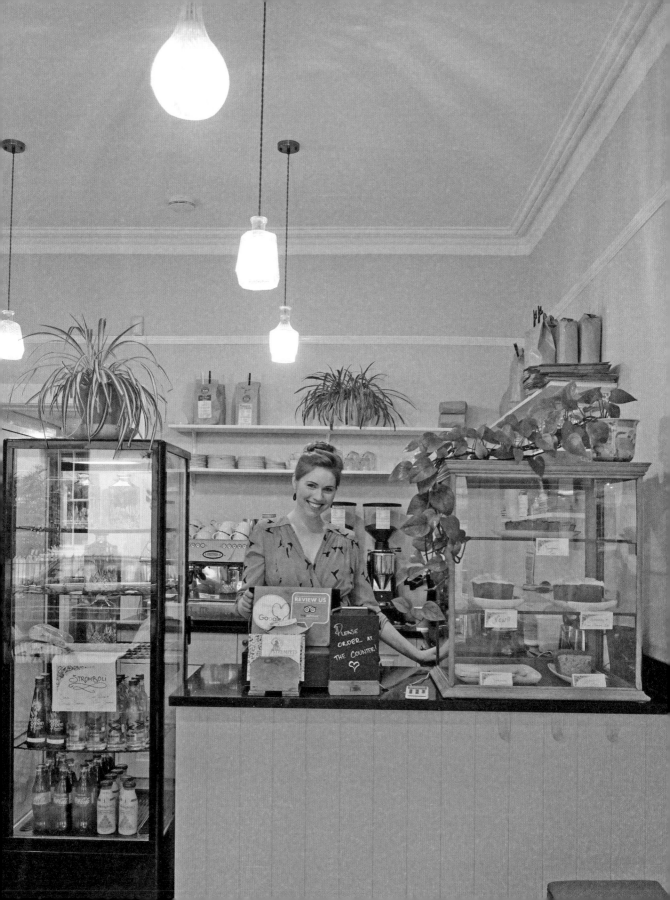

Strumpets of the West End

Tea and cake is arguably my favourite meal of the day, so, naturally, I've visited my fair share of Edinburgh cafés over the years and have developed firm favourites in each area. When I'm in the West End, and sometimes even if I'm not, I'll make my way to Strumpets. Nestled away on William Street, Strumpets is a beautiful café which manages to feel cosy in the winter while light and breezy in the summer. To give you a feel for the place, you can expect a great cup of tea or coffee, a selection of home baked goods, oodles of witty banter and the occasional visit from their neighbourhood cat. It's a delightful spot to enjoy a cuppa with friends or sit peacefully by yourself with a book.

I joined its lovely and charismatic owner Ingrida for a pot of Tchai-Ovna tea and a plate of lavender shortbread biscuits for a chat.

Strumpets is an unusual name for a café. Is there a story behind it?
The name 'Strumpets' has two different meanings. In Shakespearean terms, a 'strumpet' is a lady of the night! In modern parlance, it's a desirable woman. The café's choice of name was influenced by a well-known Edinburgh female personality, a madam named Dora Noyce, who operated brothels (most notably on Danube Street in Stockbridge) in the mid-1900s. Despite the stigma, she was a respectable and intelligent woman with razor-sharp wit and vivacious panache, who had a rocky relationship with the law and won the hearts of the city folk. She was mourned across Edinburgh when she died in 1977, and to this day her notoriety is a topic of conversation.

Do you have a favourite corner of the café?
Personally, I love the navy blue thrones in the back of the café, where you can forget the hustle and bustle of the city for a moment and feel at home.

I know you're a huge advocate for the West End, what do you think makes it so special and unique?
For me, the West End is where you truly become familiar with the pulse of contemporary Edinburgh. From born-and-bred Edinburghers to the widely diverse ethnic communities, the West End sees everyone coming together in working and familial life. Health and well-being is an important aspect of the West End; the mind, body and soul are catered for by a variety of holistic entities. The West End is environmentally proactive and pushes a green agenda of recycling, well-maintained greenery and excellent public

transportation lines. The emphasis here is on the modern, but rooted firmly in Edinburgh history, as seen in the beautiful local architecture and cobbled streets. Its strong sense of community and forward-thinking that will see the West End continue to develop and improve in the years to come.

When you have a day off, how do you like to spend it?

I love working with my hands, so on my days off, I enjoy tinkering with and learning about building materials. Or cuddling with my cat, who is the biggest Strumpet of us all!

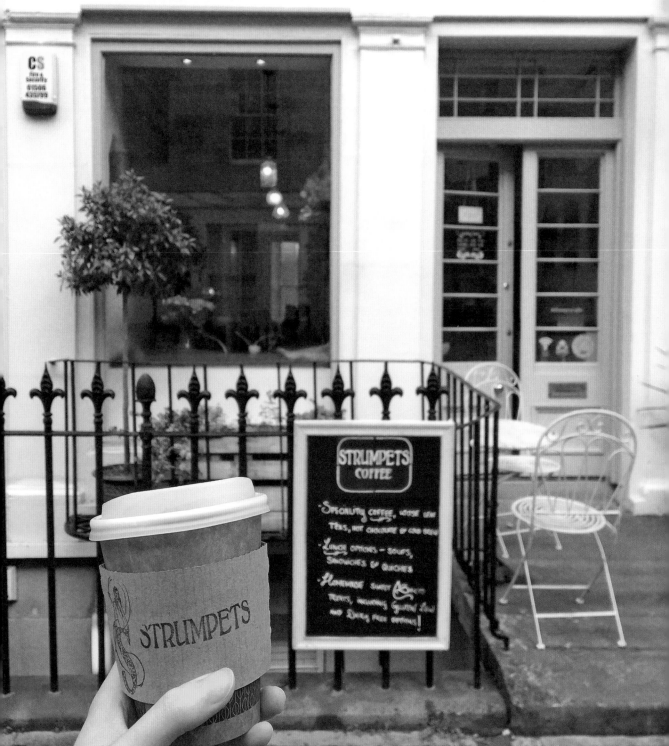

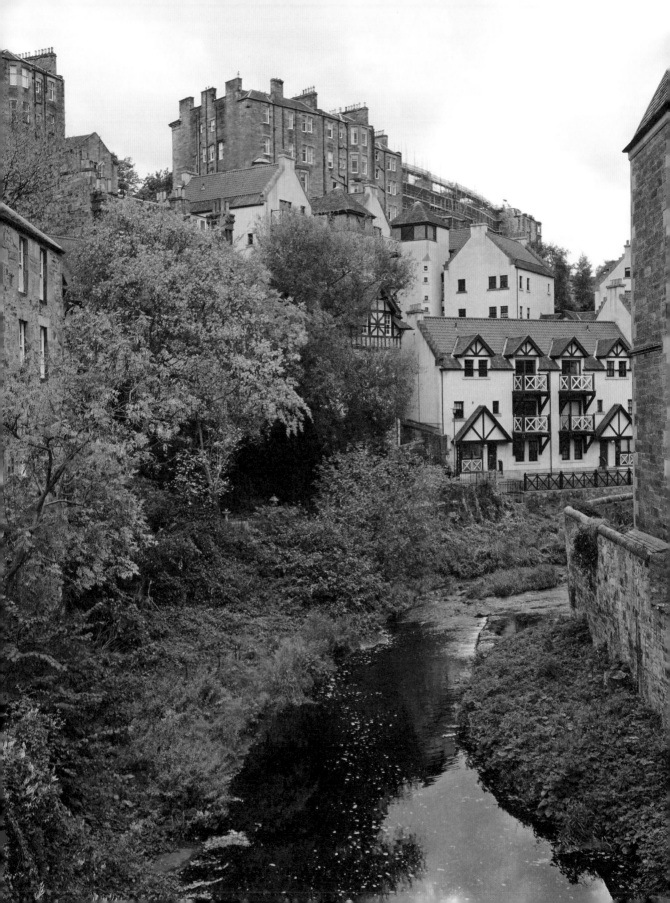

DEAN VILLAGE

As you walk along Queensferry Road, you'll cross the Dean Bridge, a magnificent structure built by Thomas Telford, and you'll spot the equally fascinating, photogenic Kirkbrae House. There's various great photo opportunities to be taken from here. Just before the bridge, there's a small lane called Bell's Brae which snakes downwards and brings you to Dean Village.

As you wander down the lane you leave behind the familiar sounds of the city and the busyness of Queensferry Road and enter a tranquil, green oasis in the city. To me, Dean Village is the definition of a pocket of pretty and a photographer's dream. Unlike the various tones of grey you expect in Edinburgh, Dean Village embraces colour. As you wander around, you'll spot the main feature of the area, the red sandstone Well Court rising into the sky and the yellow Tudor-style buildings opposite it. One of my favourite spots is the small footbridge beside Well Court, which has an amazing view of the area plus the pleasant background noise of the Water of Leith as it meanders downstream through the village on its way to Leith.

SCOTTISH NATIONAL GALLERY OF MODERN ART

If you're expecting the Gallery of Modern Art to be housed in an ultra-modern building, you may be in for a surprise as the gallery is split between two buildings, one neoclassical and the other neo-baroque. Personally, I find the

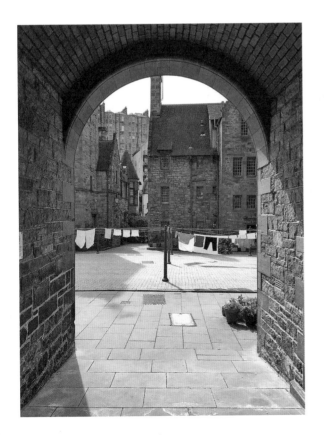

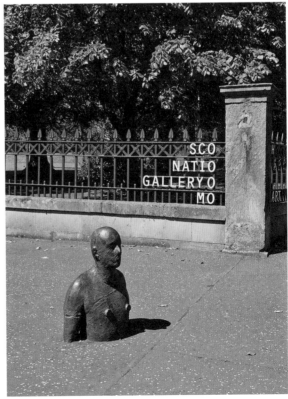

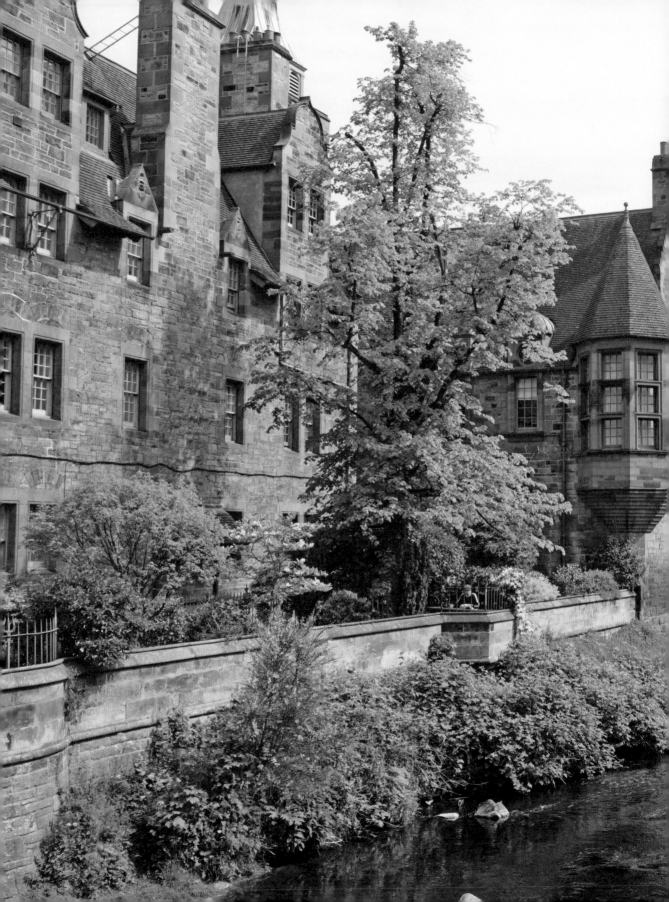

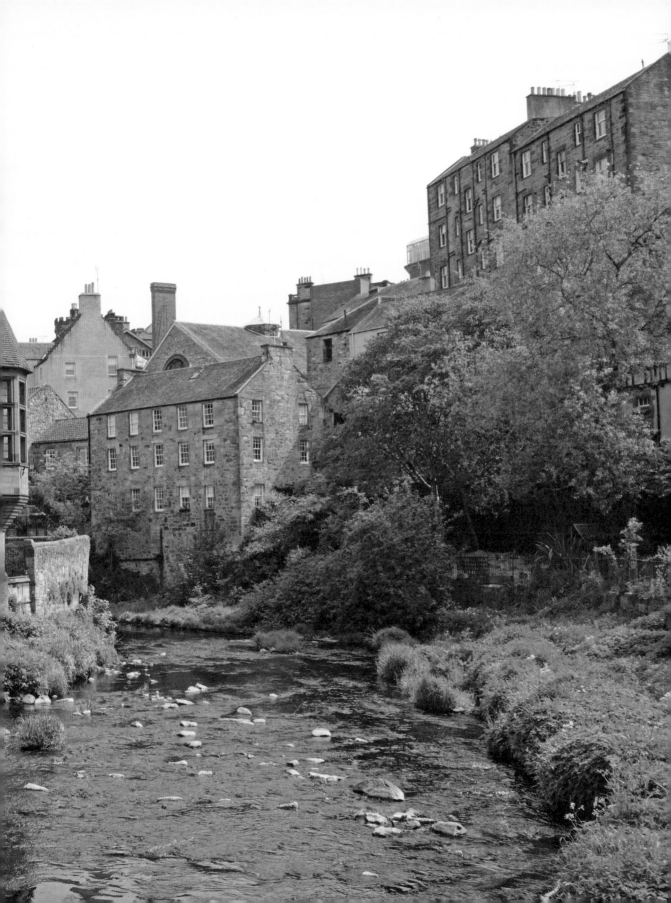

two buildings fascinating as upon first glance they exude grandeur and opulence but at closer inspection you'll notice these old buildings are very much the cool grandparents on the block. This is hinted at by a blue neon sign – 'Everything is Going to Be Alright' – blazoned across the Gallery Modern One's frieze and the Charles Jencks sculpture park on its lawn. Cross over to Modern Two and you'll spot a six-metres-high illuminated text reading 'There Will Be No Miracles Here'. There's so much to see and do in these two galleries that you could easily spend a whole day here – perhaps something to keep in mind for the next rainy day.

DONALDSON'S

Last, but not least, and although technically in Wester Coates, the majestic Donaldson's is worth mentioning. One of the most distinctive buildings in Edinburgh, it was designed by the much-celebrated architect William Playfair and has gone through various identities over the years; including a hospital and a school for the deaf, and is now a luxury housing development. Depending on the direction you travel into Edinburgh on the train from, you may spot the green-tinged domes of the Victorian palace rising up in the distance.

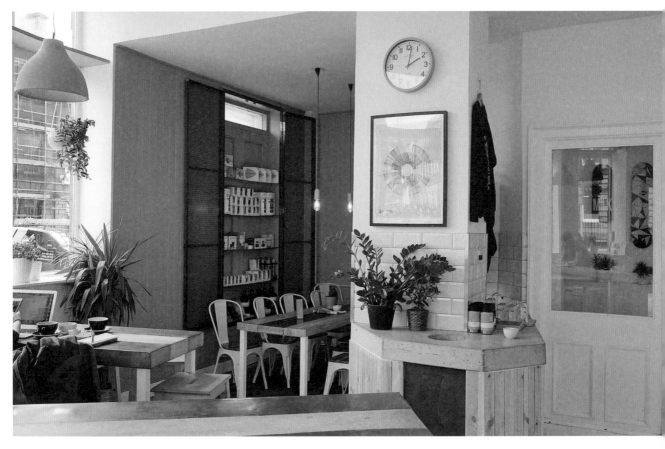

Coffee Shop Corner

You're guaranteed to find a lovely café in any of Edinburgh's neighbourhoods and the West End most definitely does not let the side down. Here are a few of my favourites to keep in mind on your visit.

CAIRNGORM COFFEE (1 Melville Place) is a local go-to and I can see why. Their large windows and ultra-modern interior create a lovely bright and airy atmosphere; pair that with a great cup of coffee, and you really can't go wrong.

One of my highlights of William Street is the ever-so-lovely STRUMPETS (35 William Street). From its hot drinks, freshly baked goods and charming interior, every inch of this café has been lovingly thought out and it's an absolute pleasure to be in.

The last two cafés I recommend visiting in this area are housed within the Scottish National Galleries of Modern Art. Both cafés offer excellent brunch and lunch options, as well as delicious baked goods, the trickiest part will be choosing which to dine in. Do you choose MODERN ONE for its outdoor garden or MODERN TWO where you'll dine in the shadow of Sir Eduardo Paolozzi's *Vulcan* statue?

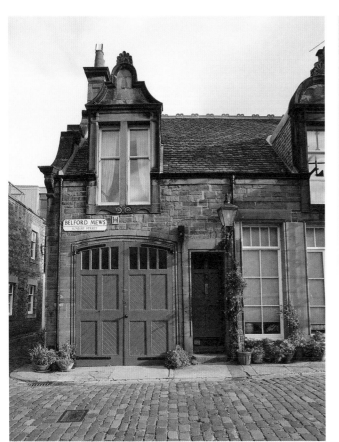

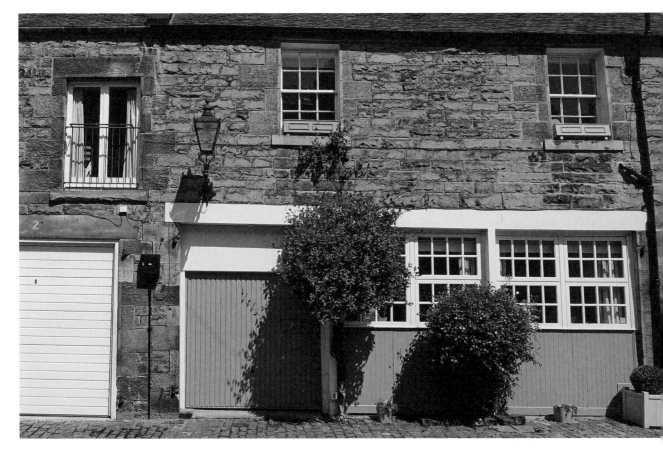

MEWSING AROUND THE WEST END

Personally, I think the West End has some of the most characterful and charming mews in Edinburgh. From the striking red sandstone homes of Belford Mews' to the secluded Lennox Street Lane, there's plenty to explore.

BELFORD MEWS

A stone's throw away from Dean Village lies Circus Lane's 'rival', Belford Mews. I say 'rival' because despite Circus Lane being the most well-known mews lane in Edinburgh, once you've visited the beautiful red sandstone mews houses which makes up Belford Mews, you might be torn as to which you prefer.

DOUGLAS GARDENS MEWS

Across the road from Belford Mews is a smaller set of red sandstone mews houses. If you're close by, it's always worth popping your head into the secluded lane for a nosy around.

ROTHESAY MEWS

Around the corner from Douglas Gardens Mews, hidden below Douglas Gardens, lies Rothesay Mews. The pleasing aspect of this lane is that it's visible from Douglas Gardens, so you can frame your photo with the mews houses below and the square tower of a church in the distance.

LENNOX STREET LANE

This mews cul-de-sac is a relatively recent discovery of mine. Hidden away behind the grand Georgian façades on Clarendon Crescent lies a group of quaint mews houses. My favourite detail when I visit is that the locals seem to have colour coordinated their garage doors to various shades of blue.

BELGRAVE MEWS

You'll find Belgrave Mews just next to Dean Cemetery. It's the mews lane I'm least familiar with as I tend to forget to visit as it really is off the well-beaten path. But, if you're in the area, remember it's there and take little wander through.

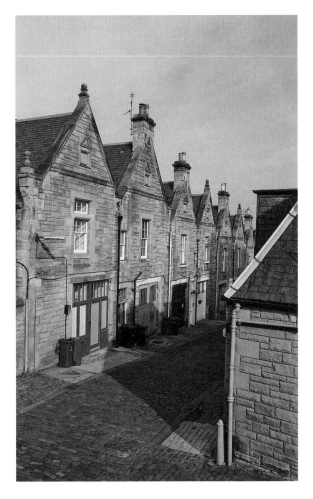

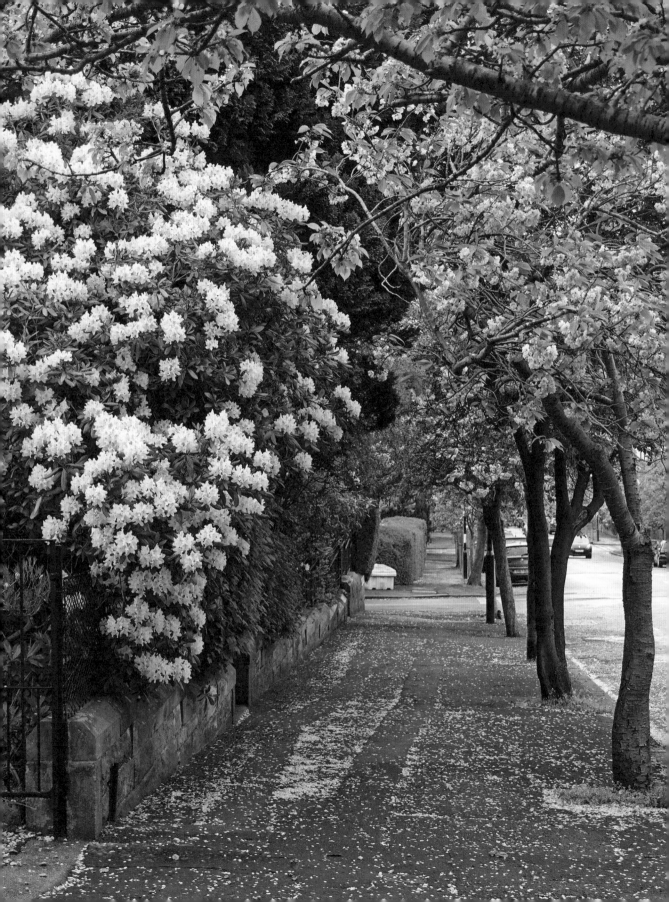

BRUNTSFIELD & MORNINGSIDE

'Half a capital and half a country town,
the whole city leads a double existence; it has long
trances of the one and flashes of the other.'
– ROBERT LOUIS STEVENSON

Bruntsfield and Morningside are two charming residential neighbourhoods linked by a much-loved high street. For this reason, the adjacent neighbourhoods are often synonymous with each other. Both are considered extremely desirable areas to stay in, yet locals will be familiar with the fact that the neighbourhoods have distinct and differing personalities. In my mind, Bruntsfield – with its trendy bars and places to eat – is the cool, younger cousin to Morningside, which has retained a more traditional village atmosphere heightened by local bakeries, IJ Mellis Cheesemongers and Morningside Library. Personally, I think the best way to experience these neighbourhoods is to start in Bruntsfield and wander along the high street to Morningside, stopping as often as you like to admire the various pockets of pretty.

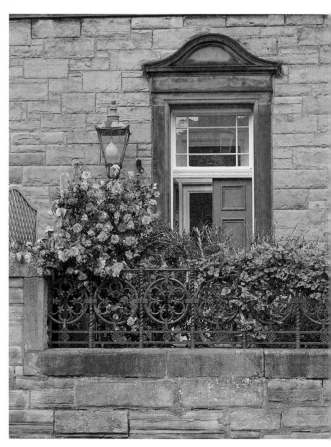

A WALK THROUGH BRUNTSFIELD

As you enter Bruntsfield, you'll spot a lush open green space to your left called Bruntsfield Links. The area is the last remnant of Burgh Muir, an ancient forest which once covered almost everywhere south of Edinburgh's city centre. Bruntsfield Links is also said to be one of the earliest known locations where golf was played in Scotland and, to this day, you're welcome to bring your golf clubs to play a free 'putting style' game. The sense of space and greenery along with some majestic tenements, plus its close proximity to the University of Edinburgh, has made this area a desirable home for young families, students and young professionals.

As you continue up Bruntsfield Place, you'll come across its high street. The street feels like it's been carefully curated to only include the finest stores, creating a wonderful browsing experience. Honestly, it's one of the best places to go if you're looking for a gift. A few of my personal favourites, which you might enjoy too, are Rosevear Tea, who stock an array of 135 different teas; the prize-winning Edinburgh Bookshop, with its famous library ladder signed by visiting authors and illustrators; and Curiouser for an eclectic mix of everything from beautifully illustrated cards to quirky homewares – to name but a few.

To top it off, Bruntsfield is also a foodie's paradise, whether you're in the mood for one of Meltmongers indulgent grilled cheese sandwiches, a decadent French pastry from La Barantine, succulent steak from Chop House, or your choice of vegan treats from Seeds For The Soul, there really is something for everyone's taste buds and shopping baskets. And if you're craving all things cocoa, drop into Coco Chocolatier for their beautifully packaged artisan chocolates.

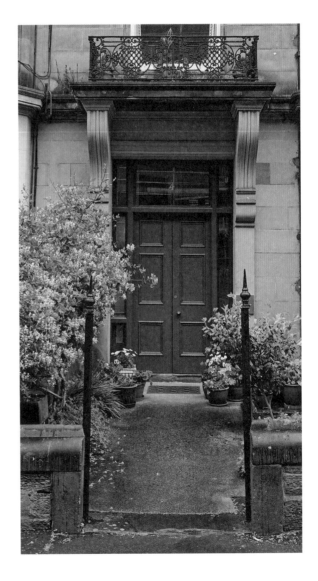

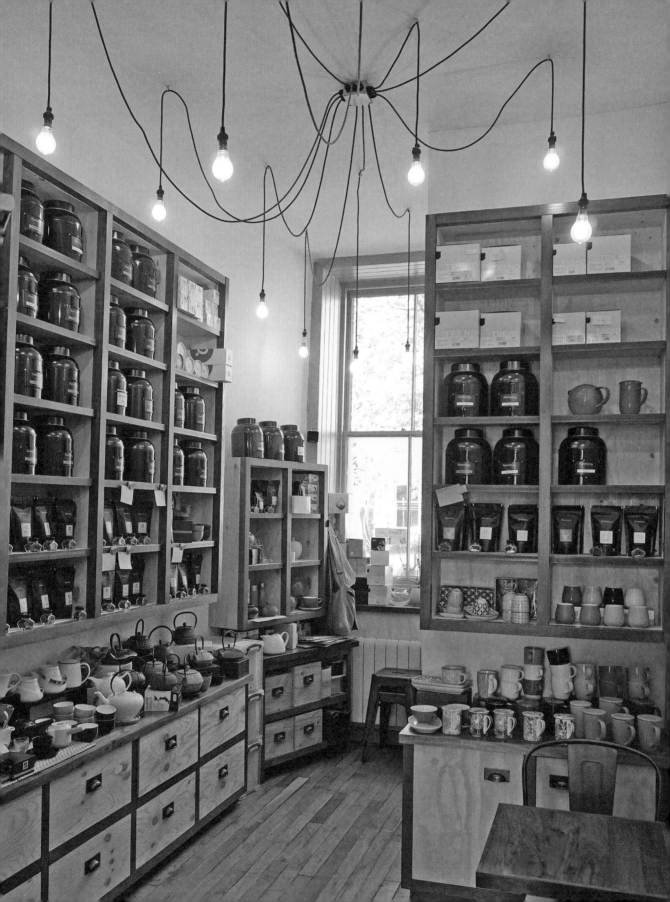

Time for Tea with Rosevear Tea

Rosevear Tea was founded by husband and wife duo Adam and Isabelle. In 2015, after living away for a number of years, the pair returned to Edinburgh – the city where they had first met and studied – to fulfil a shared dream of opening their own tea shop. Four years later they have three stores in Edinburgh and stock a whopping 135 different types of tea.

I first encountered the Rosevears on a cold wintry day. I popped into their Broughton Street shop to escape the Edinburgh weather and was greeted by a friendly face who I later learned was Mr Rosevear himself. He offered me a sample of their vanilla green tea, and I ended up spending the afternoon browsing the floor-to-ceiling shelves of tea. We had the loveliest of chats, and I've been a loyal fan ever since.

When did your passion for tea start?

We've always loved tea, but in the early days we mostly drank black tea with milk. It wasn't until the nineties, through travelling for work to places that grew tea or that simply drank tea differently, that we discovered that the world is host to an expansive myriad of tea.

How do you maintain good quality tea?

As well as paying visits to tea gardens, we conduct regular blind tastings to choose teas for our shops. We invite colleagues and friends to take part; it's completely unbiased – we don't bias our decisions by price, reputation or our relationship with the supplier. For instance, first flush teas from Darjeeling taste different each year. So, it's necessary to conduct annual taste tests to choose the best of the season's harvest. We also regularly sample our own teas and sometimes, sadly, must remove one from our collection to ensure consistent quality. One example was a popular Assam tea that had declined in quality and, after a little investigating, we learned that the estate manager of the plantation had changed.

Do you have a favourite tea?

Yes, our current favourite tea is Balasun, a second flush Darjeeling, and there's a story behind it. We first drank it in what is now our Clerk Street store, and it was originally one of Anteaques' teas. We'd been invited to the shop for a meeting with our friend, and then owner of Anteaques, Cedric. We spent the whole morning talking about tea and drinking

Balasun. We learned that Cedric was leaving the tea business and that his wonderful location could lose its association with tea. Although we weren't seeking a third shop at that time, we couldn't let that happen. The rest, as they say, is history. We're now so glad that we did take on the shop, and Balasun has become one of our favourite teas. As well as its wonderful flavours, favourite teas can be something associated with our warm and special moments. We particularly love to drink Balasun Darjeeling with toast and marmalade.

When you have a day off, how do you like to spend it?
We are so lucky to live in such a wonderful city. We often take a flask of tea to a communal garden in the beautiful Dean Village or walk along the Water of Leith. In town, we love visiting all the quirky bookshops around town. In the warmer months, we like to take day trips to East Lothian or Cramond for a walk with friends.

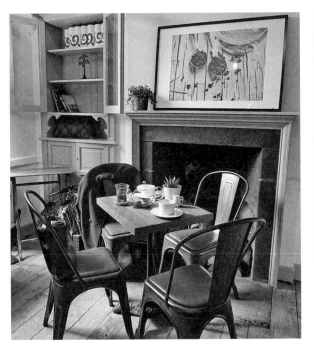

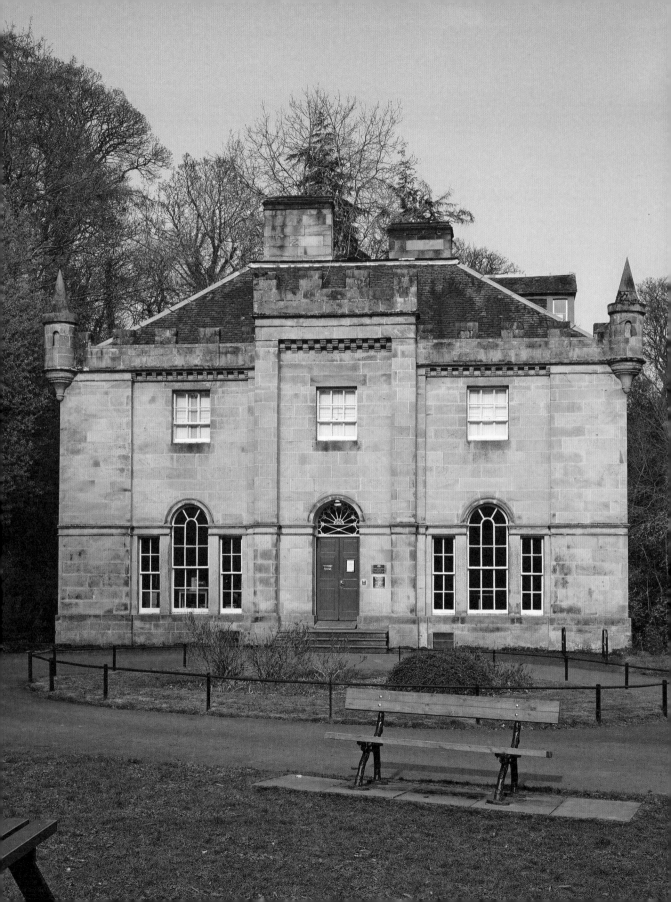

Pockets of Pretty in Morningside

What started off as a quiet country village consisting merely of a row of thatched cottages, grew to become a summer resort referred to as the 'Montpellier' of the east of Scotland, thanks to its fresh air and pleasant surroundings, and today Morningside has become one of the most desirable neighbourhoods to stay in. The neighbourhood is largely residential with most of its shops and eateries congregated on Morningside Road. Much like Bruntsfield, Morningside's high street is brimming with independent stores, various places to eat and an abundance of charity shops where you may stumble across the luxury bargain of the century – well, one can hope!

DOMINION CINEMA

As you enter Morningside, keep an eye out for Newbattle Terrace and you'll spot one of the neighbourhood's best-loved and most treasured institutions, the Dominion. In an era of impersonal chain cinemas, it's a wonderful treat to come across a family-run establishment. The Dominion's art deco exterior and stained-glass panels entice you in and its glamorous red interior with black leather sofas in the screening rooms will have you wishing that you never have to leave.

THE WILD WEST

Further up the Morningside Road is one of the most unexpected sights in Morningside, a little piece of the Wild West tucked behind Morningside Library. As you step off Springvalley Gardens and venture through an alley, you'll be greeted with the bizarre sight of a saloon, a jail, stables and even a Native American mural on one of the walls. What started off as an advertising feature for 'The Great American Indoors', a furniture store specialising in Santa Fe style furniture has turned into a local institution. Sadly, the area has seen better days and currently looks like an abandoned Wild West town, but it's still worth a visit.

BEAUTIFUL DOORS OF MORNINGSIDE

One of the best ways to get to know Morningside is to simply wander around the neighbourhood: you never know what you'll find tucked away down one of its streets. The affluent, eclectic neighbourhood is home to Georgian and Victorian villas, cobbled streets and hidden gateways, which can only mean that there is an abundance of beautiful doors and gardens to admire.

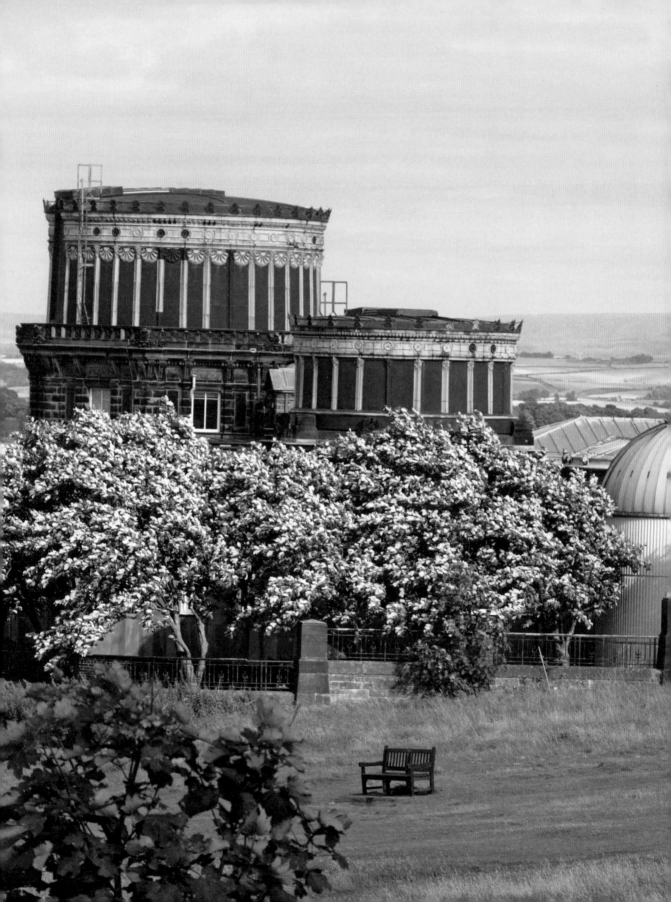

BLACKFORD HILL & THE HERMITAGE OF BRAID

Where Bruntsfield has Bruntsfield Links and the Meadows has green spaces, Morningside has Blackford Hill and the Hermitage of Braid.

The Hermitage of Braid is a picturesque nature reserve which lies within a steep-sided wooded valley. At the entrance to the Hermitage is a quaint cottage which is home to the Lodge Coffee House, a lovely spot to enjoy a bite to eat and a cuppa. As you walk through the forest, you'll spot the Braid Burn which flows through the forest, snaking along with the footpath, providing walkers with gentle gurgling background sounds and a welcome source of water for four-legged visitors. It's no wonder that the Hermitage has become very popular among local dog walkers. Along the way you'll also spot the picture-perfect Old Hermitage House, with its lovely Doocot surrounded by a walled garden, where those with keen eyes might also spot the old ice house.

Adjacent to the Hermitage is Blackford Hill, one of Edinburgh's seven hills. Unlike Arthur's Seat or Calton Hill, Blackford Hill plays a rather inconspicuous role in Edinburgh's skyline. However, the unassuming hill is often regarded as a locals' secret as it boasts magnificent views over the city – some even argue that they're better views than Arthur's Seat – while also being a relatively easier hike with its gentle grassy slopes.

As you ascend to the top of the hill, not only will you have panoramic views of Edinburgh, but you'll also spot the stunning Victorian Royal Observatory building. If you'd like to have a peek inside, the observatory opens to the public on Doors Open Days, as well as certain days for public events.

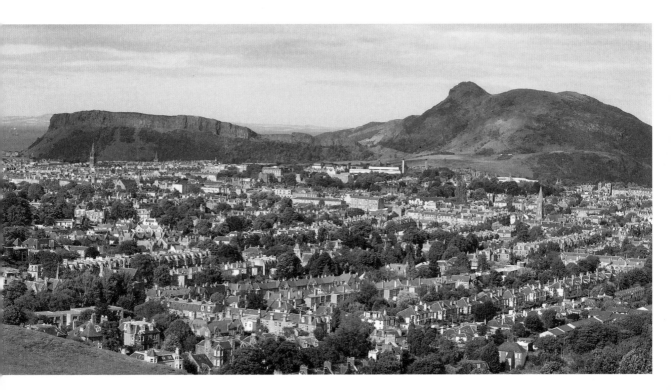

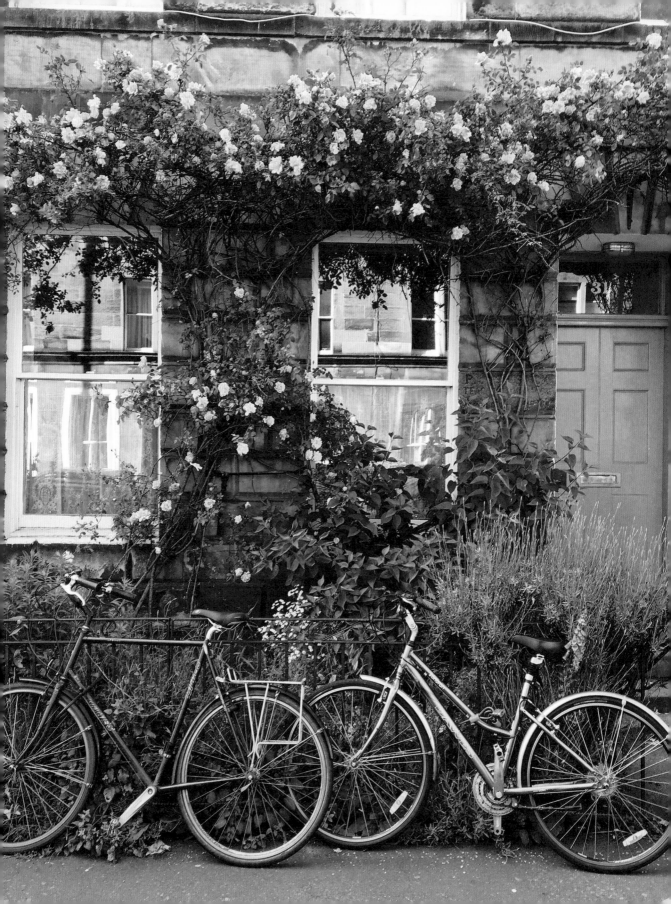

SOUTHSIDE

'By experience we find out a short way by
a long wandering.' – **ROGER ASCHAM**

If you head south-east of Edinburgh's historic Old Town,
you'll stumble across Southside. It's a bustling, vibrant
area of the city and home to the University of Edinburgh
since 1582. Despite its close proximity to the Old Town,
Southside has a completely different feel. You'll rarely
find a tourist aimlessly sightseeing here; rather, the area
is dominated by students and local residents. That's not
to say that it lacks charm, far from it! Southside – with
its ever-growing collection of street art and plethora of
coffee shops – exudes a more urban vibe yet has retained
an intriguing selection of beautiful old buildings. There
are plenty of photo opportunities and pockets of pretty,
you just have to be on the lookout for them!

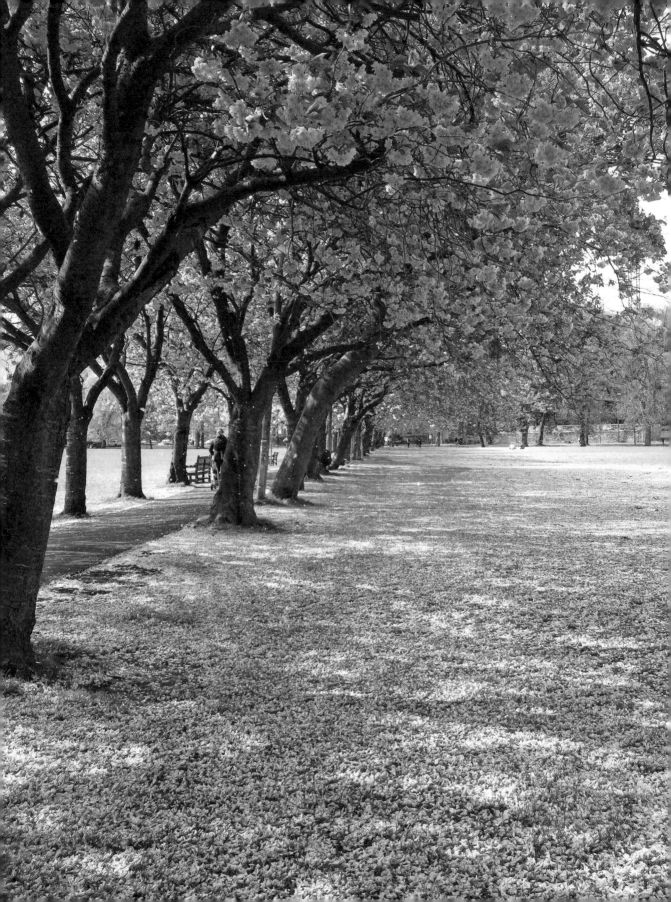

Pockets of Pretty in Southside

CHERRY BLOSSOM SEASON

Southside's glorious park, the Meadows, truly comes into its own during cherry blossom season, as it proudly heralds the arrival of spring and offers endless Instagram opportunities. The exact season can vary but it's usually in April and May. It's a breathtaking treat to witness the trees that line the network of crisscrossing pathways explode into visions of pink. Just when you thought it couldn't get any more enchanting, a week passes and the blossoms flutter down like confetti, providing the Meadows with a fleeting but exquisite pink carpet.

THE MEADOWS

This Edinburgh landmark is a lush open stretch of grass with tree-lined paths, which comes alive as a community hub on sunny days. This tranquil green space was once the site of Burgh Loch, a lake which served as one of the main sources of drinking water for the city. Nowadays the Meadows may appear to be much like any other park in Edinburgh, but it is in fact a diverse and colourful space where locals hardly bat an eyelid at the sight of an acrobat balancing precariously between two trees on a tightrope, or the clashing of swords as medieval combat

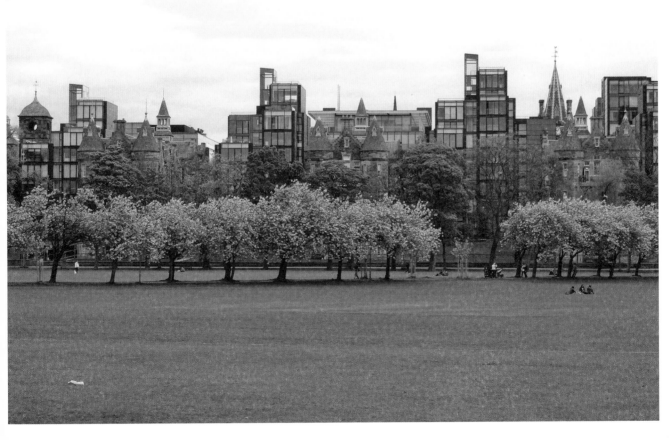

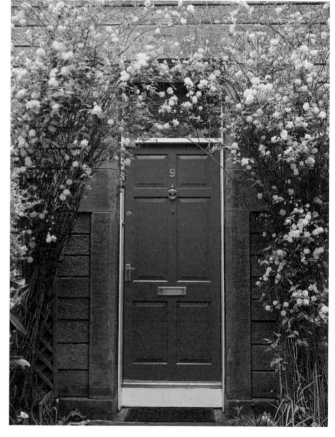

practice takes place. In the evenings, you may also spot pockets of fire illuminating patches of the Meadows as fire dancers and jugglers congregate for their weekly practice.

THE UNIVERSITY OF EDINBURGH BUILDINGS & OLD COLLEGE

Most likely the first beautiful building you'll come across when you enter Southside is one of the most well-loved buildings of Edinburgh, Old College. The building's iconic dome is a prominent part of the city's skyline and has become

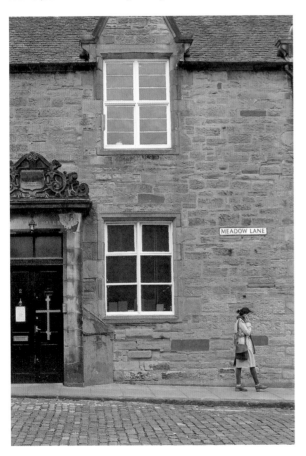

synonymous with the university. I've even heard first-hand that this building was a deciding factor in one international student's decision to move to Edinburgh to study. Old College's quad has also hosted various art exhibitions, outdoor cinema screenings, as well as its famous Christmas tree. The University of Edinburgh has several other beautiful buildings, including Teviot Row House (oldest purpose-built student union building in the world) and McEwan Hall. A walk through Old College is a great short-cut to explore these buildings.

From the Meadows, we'll continue our stroll along North Meadow Walk, which will bring you to Buccleuch Street. This street is home to various coffee shops, including two of my favourites, Cult Espresso and Press Coffee, and a delightful second-hand bookstore called Till's Bookshop. If you turn left at Buccleuch Street onto Gifford Park, you'll discover one of the brilliant murals I mention a little later. From here continue walking straight on until you meet St Leonard's Street.

HERMITS AND TERMITS

Hidden among the relatively newer builds and leafy trees just off St Leonard's Street, on Hermit's Croft, lies a beautiful country villa called Hermits and Termits. Despite its proximity to the main road, it's very easy to overlook. The home dates back to 1734 and one of my favourite features of the house is the ornate ironwork gate which was inspired by a floral archway that once led from the house to an orchard. The house is particularly beautiful in

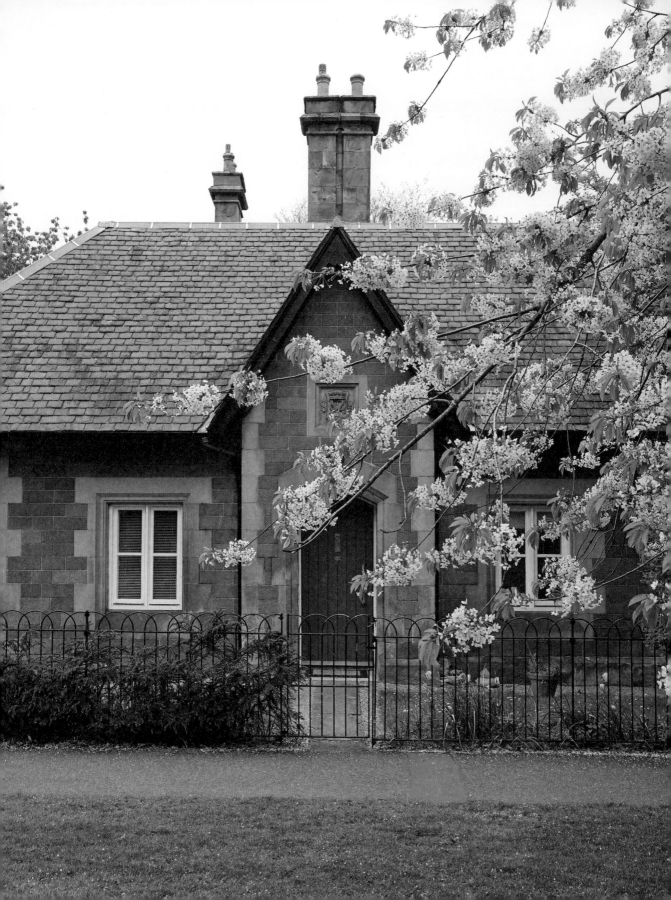

autumn when its surrounding trees turn to fiery shades of orange and yellow.

ST LEONARD'S BANK

Personally, I think this street is an amazing hidden gem and I stumbled across it quite by accident. The homes of this street are a mixture of Victorian villas and modest cottages. Whenever I walk past, I always make sure to have a look into their well-tended gardens to see what's in bloom. One of my favourite homes on this street is a beautiful Victorian villa which has been painted a wonderful vibrant pink, it's really eye-catching!

ARTHUR'S SEAT

There is an extinct volcano in the heart of Edinburgh, the peak of which is known as Arthur's Seat. With its spectacular views over the city and out to Fife, this craggy hill makes for a popular spot for a hike. Although not technically in Southside, my favourite route to hike up Arthur's Seat is along Holyrood Park Road and Queen's Drive. As you walk along Holyrood Park, you might spot a quaint chocolate box-style cottage at the entrance to Holyrood Park. It was built in the 19th century as part of Prince Albert's vision for the park.

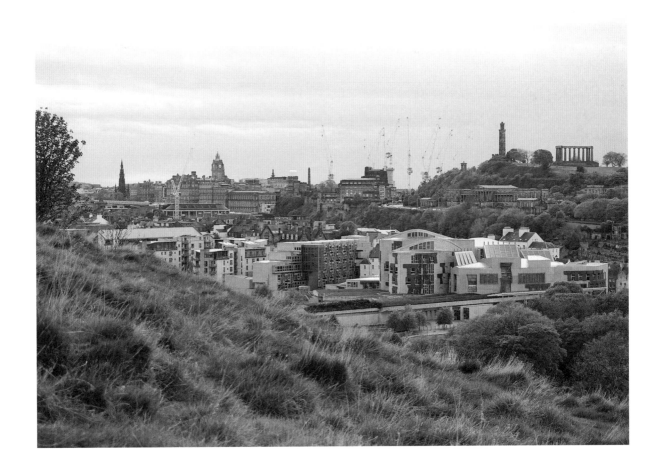

Coffee Shop Corner

Southside is home to a copious selection of coffee shops, which we have the large student community to thank for. Here are a few of my personal favourites below.

Whether you're in need of a caffeine fix or not, a visit to BLACK MEDICINE COFFEE CO (2 Nicolson Street) is well worth it, if only to see their interesting interior. Perhaps not to everyone's taste, but the café's use of wood and stone makes me feel like I'm sitting in a cosy, warm cave in the middle of a forest – the perfect place to hide away from a rain shower.

PRESS COFFEE (30 Buccleuch Street) was an old haunt of mine during my time at university and I'll always think fondly of it. It's the perfect place to head for a cuppa on a gloomy (or dreich) day as their walls are bright yellow and they have lovely big windows – perfect for people watching! Whether you're there for a cuppa, brunch or lunch, Press Coffee have it covered.

I have to mention my brilliant neighbourhood café, THREE.14 (38 Dalkeith Road). A few of you out there will have already guessed by the café's name (Pi . . . pie!) that it specialises in various sweet treats. The cosy café is relatively new to the neighbourhood but has already made a name for itself thanks to its freshly baked goods and great cuppas.

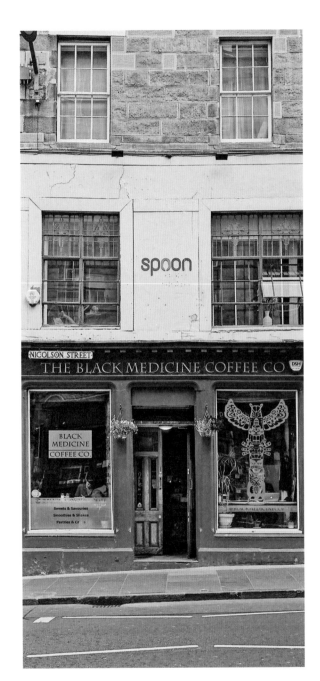

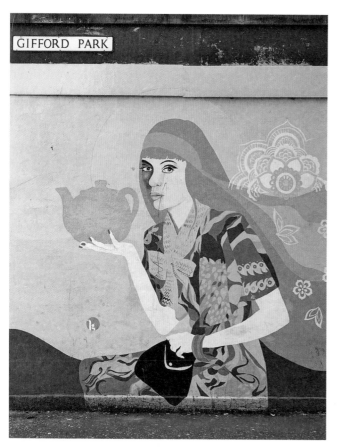

THE MURALS OF SOUTHSIDE

Unlike Glasgow or even Leith, Southside isn't an area that immediately comes to mind with mention of murals. However, over the past few years, several colourful murals have appeared on what were once drab and dingy alleyways – largely thanks to the Southside Association. As corny as it may sound, every time I pass one, it genuinely does bring a smile to my face.

GIBB'S ENTRY

A few years after the successful creation of the Gifford Park murals, this area was treated to a further two murals also designed by Kate George. The gorgeous, graphic murals that now adorn Gibb's Entry give a nod to the area's educational and academic roots.

GIFFORD PARK

In 2005, what was once an unsightly alley was transformed by two beautiful murals, designed by Kate George. The imagery incorporates various references to the area, as well as a local suggestion to include ducks in the painting, as apparently a well-known duck returns each year to nest in a nearby flower box.

HADDON'S COURT

A few shops down, and you'll come across another unassuming lane, which features an enchanting nature-themed mural. With an otter, heron, duck and swan picked out in white, the mural is inspired by the wildlife of the area and features a quote that speaks to all of us urban explorers: 'Look and see what you can find?'

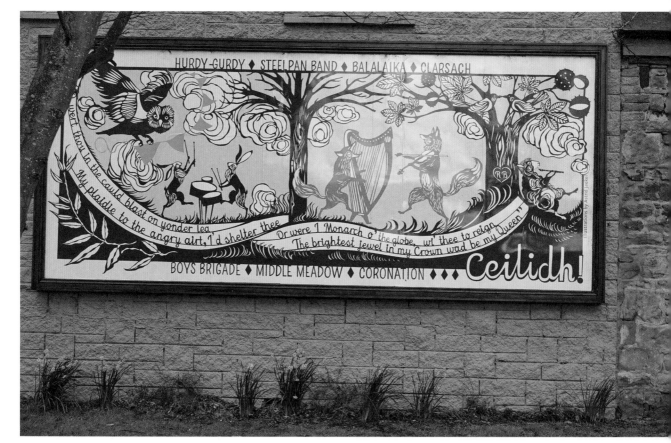

DUMBIEDYKES ROAD

Off the beaten path, an old commercial property in Dumbiedykes was treated to a fun and vibrant mural also designed by Kate George with help from local schools. It has the added bonus of the magnificent Salisbury Crags as a backdrop!

PLEASANCE POLICE BOX

Sitting at the foot of Drummond Street is one of Edinburgh's many old police boxes, but what sets this one apart are the ever-changing murals that clothe it. I always enjoy keeping an eye on it when I pass to see if it's been repainted.

THE MEADOWS

Slightly different in style from the rest on this list, but no less dramatic and eye-catching, The Mural on the Meadows by Edinburgh-based artist Astrid Jaekel and poet Rachel Woolf features local landmarks, quotes and an evocative poem about the area.

THE INNOCENT RAILWAY

Although not home to an official mural, I wanted to include the Innocent Railway as it's a distinctive feature of the area and home to everchanging graffiti. The Innocent Railway is one of Edinburgh's earliest railways and gained its unusual nickname from the fact that there were no casualties while building it! The tunnel is perhaps not for the faint hearted. Don't be alarmed if a cyclist or speedy group of runners come whizzing out of the darkness while you're checking out the local graffiti.

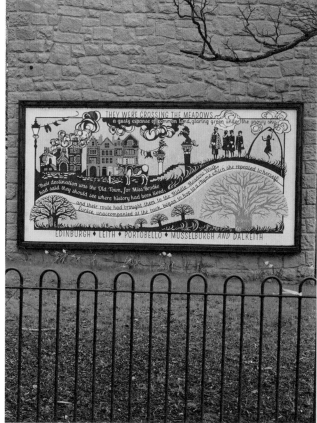

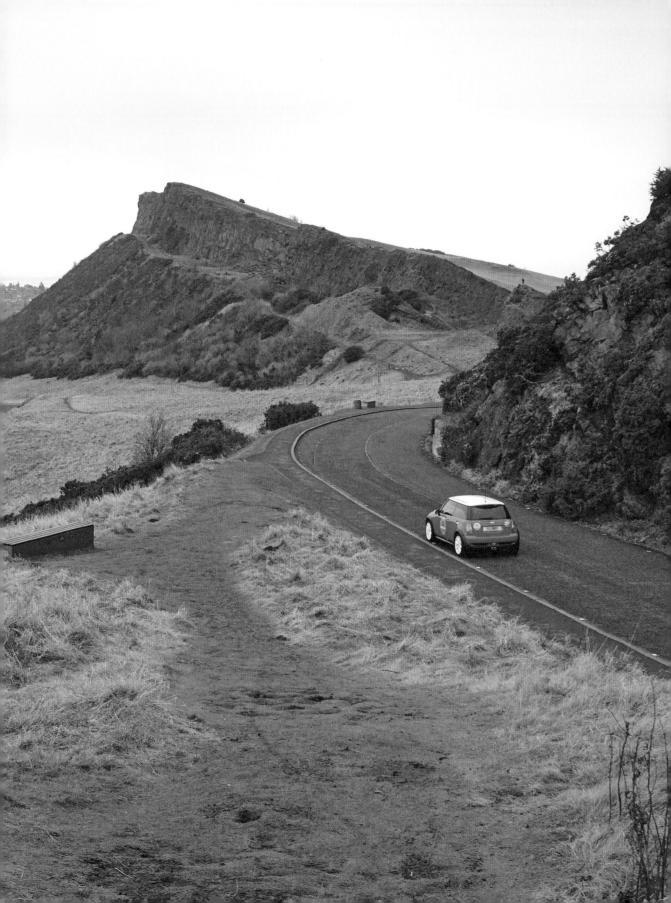

An Edinburgh Tour with the Mini Mack Brothers

Mini Mack Tours is a private tour business founded and led by two Edinburgh lads, Andy and Rowan. What makes their Edinburgh tours extra special is that the brothers have taken their knowledge of the city to design a wonderful tour, taking you to a select few of Edinburgh's hidden gems that even some locals have never visited. If you live in Edinburgh there's a good chance you've un-wittingly spotted one of their trademark blue or red Mini Coopers zipping about the city. To get to know the Mini Mack brothers a little better, I've joined Rowan for one of their Edinburgh private tours.

What inspired you to start Mini Mack Tours?

My brother, Andy, used to own and operate a fantastic cycling tour company in Florence, Italy. I actually helped the guys out for a couple of years as a tour guide, too. Once Andy and I were back in Edinburgh, my brother noted that tourism was really booming, and we should do something cool and a bit different to showcase our city to incoming visitors. We didn't want to do cycling tours as our weather and roads aren't the best, so we thought a Mini would be fun, great for getting down the back roads and it's a quintessential British vehicle!

I love the fun names you gave your Mini Coopers (Red Rocket and Blue Thunder). Is there a story behind that?

I was having a chat with the great graphic artist who designs the stickers for our cars and just for a laugh I mentioned 'Red Rocket' and 'Blue Thunder' and the next day he designed two motifs which are now placed on the rear of each car. I like them, it's a bit of fun!

What is your favourite part about your job?

Many things! The fact that we are our own boss, the freedom to go anywhere each day, the places we visit, but the most favourite aspect for me is the people we meet. We have taken people on tour from all continents and all walks of life. Titans of industry, professors, finance CEOs, firefighters, singers, professional ath-letes, you name it, we have had them on tour! It may sound corny, but it's like taking our friends on a small trip of the city as it's pretty intimate when you are together in the Mini and 99.9% of our clientele have been super cool. Some of our customers have brought us gifts and even offered to let us stay at their house if we are ever in their area. (We haven't done that yet, maybe we should, they might get a shock!)

If you had to choose your favourite spot in Edinburgh, where would it be and why?

It has to be Dr Neil's Garden in Duddingston Village. It's also known as the Secret Garden as it's tucked away behind Duddingston Kirk, right beside a beautiful loch which the locals used to ice skate on 200 years ago. Arthur's Seat overlooks the garden, and in the distance you can see the tops of the Pentland Hills. There is a spot in the garden where during the summer (if there is a bit of sun), it's stunning, always quiet and you could be anywhere in Scotland because you certainly wouldn't think you are in the centre of Edinburgh.

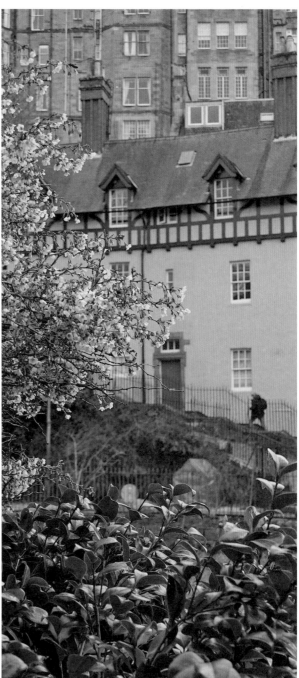

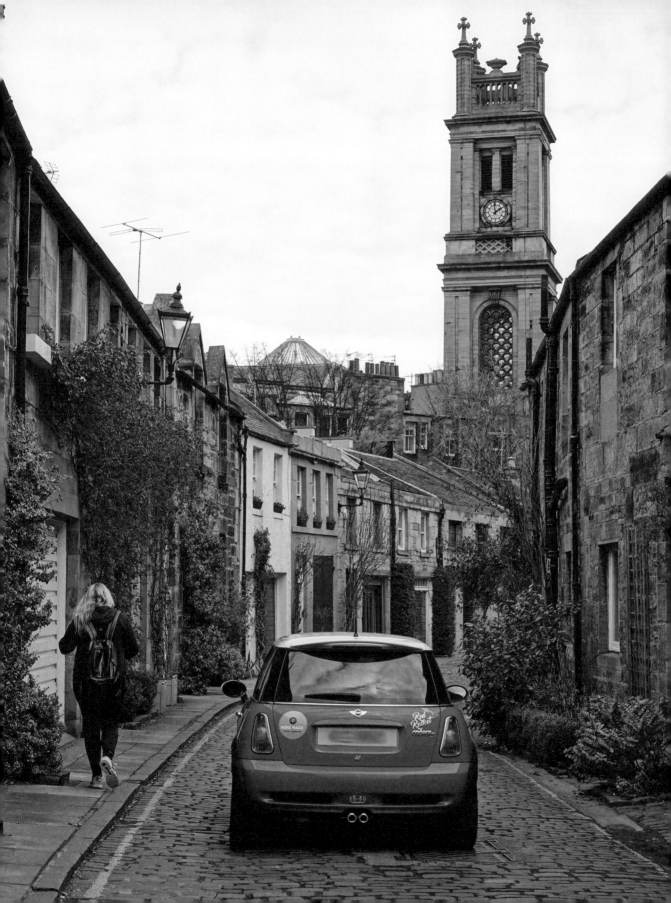

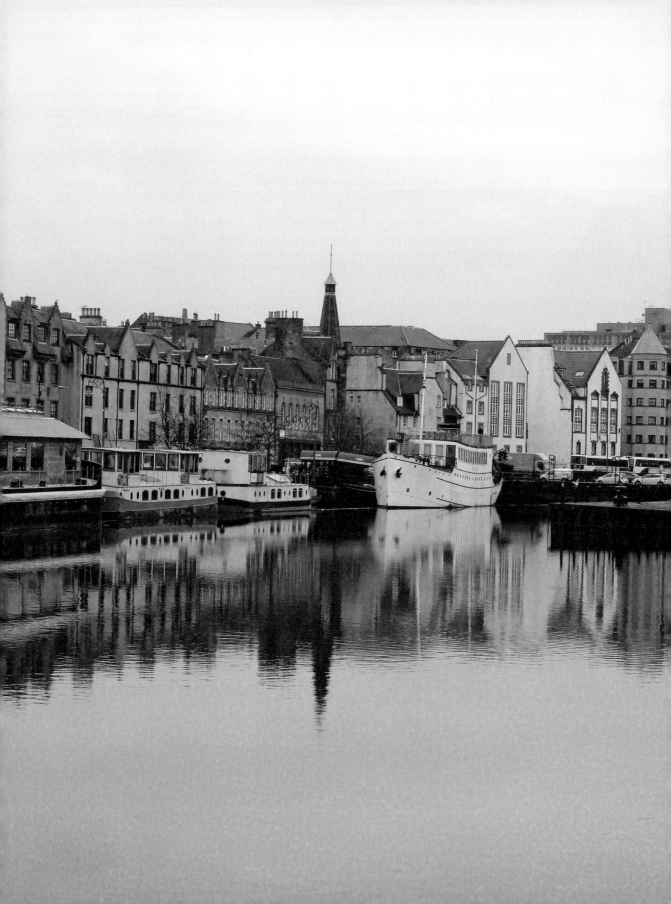

LEITH & THE SHORE

'And yet the place establishes an interest in people's hearts; go where they will, they find no city of the same distinction.'
– ROBERT LOUIS STEVENSON

Sitting on the shore of the Firth of Forth, Leith is a vibrant and eccentric neighbourhood north of Edinburgh's city centre. It's an area defined by its people, and the neighbourhood has a fierce sense of local identity, heightened by the fact that it operated as an independent burgh until 1920. Leith has its own rich history, including being the old maritime centre of Edinburgh, the final resting spot of the Royal Yacht Britannia and, more recently, the location of Irvine Welsh's *Trainspotting*. Over the years, the area has begun to shed its industrial skin and, although still a little rough around the edges, has taken on the title of Edinburgh's coolest district.

To me, Leith has always been something of an enigma – somewhere I'd visited several times but had never become properly acquainted with. So, for the purposes of this book, I set myself the task to walk the grid to not only discover what the area is famous for but also on the lookout for what I personally find interesting in different neighbourhoods.

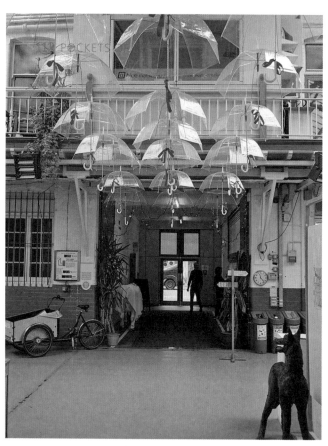

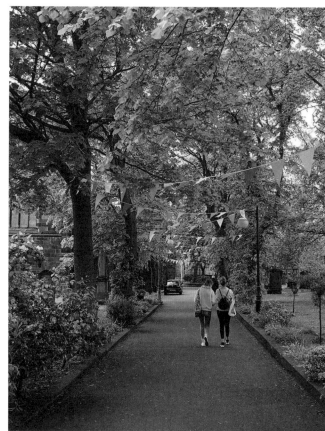

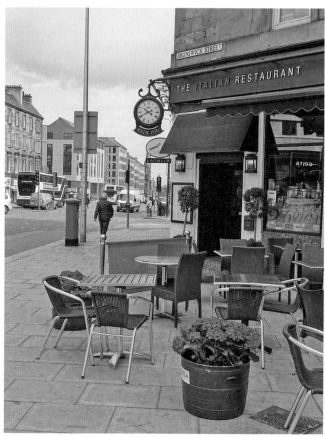

Pockets of Pretty in Leith

THE GATEWAY TO LEITH

For me, part of Leith's charm is that it doesn't feel innately Edinburgh. The most obvious way to enter Leith is down Leith Walk, one of the city's longest, most vibrant streets. As you walk down the hill, you leave the city centre behind and enter a neighbourhood with a distinct and wonderful sense of identity, in which many locals proudly call themselves Leithers. You might spot shops sporting 'I♡Leith' signs or even babygros celebrating a Leith heritage. The area has a strong creative community and you'll find plenty of clues to its artistic personality along Leith Walk, from murals peeking out from gable ends to a police box which acts as a pop-up space for a local tool library, a succulent shop, political debate and more.

Leith Walk offers a brilliant array of businesses, but if you're after a row of pristine shop fronts, it might not be your cup of tea. A few of my personal favourites in this part of town are Typewronger Books and Elvis Shakespeare for books, music and vintage typewriters. Out of the Blue Drill Hall offers an incredible range of workshops, classes and performances, and the newly established Projekt 42 is a not-for-profit wellness centre, a gym making a genuine difference. There's Twelve Triangles for delicious baked goods, and Weigh To Go, one of Edinburgh's only plastic-free, sustainable grocery stores.

CONSTITUTION STREET & LEITH LINKS

One of my favourite streets in Leith is quite possibly Constitution Street. As you reach the Foot of Leith Walk, it lies straight ahead, running north from the crossroads. I find it quieter than Leith Walk and so it's easier to notice the beautiful buildings that line the street. I'd also highly recommend popping down one of the side streets which leads to Leith Links, a tranquil green oasis surrounded by beautiful homes. One of the first eye-catching buildings you'll come across is South Leith Parish Church which has a stained-glass window, a hammer-beam ceiling and an ancient kirkyard. Tucked away behind the church is a beautiful Georgian townhouse, home to the Trinity House Maritime Museum, which is open on selected days and tours must be booked online. It's a hidden gem of sea-faring history and well worth a visit.

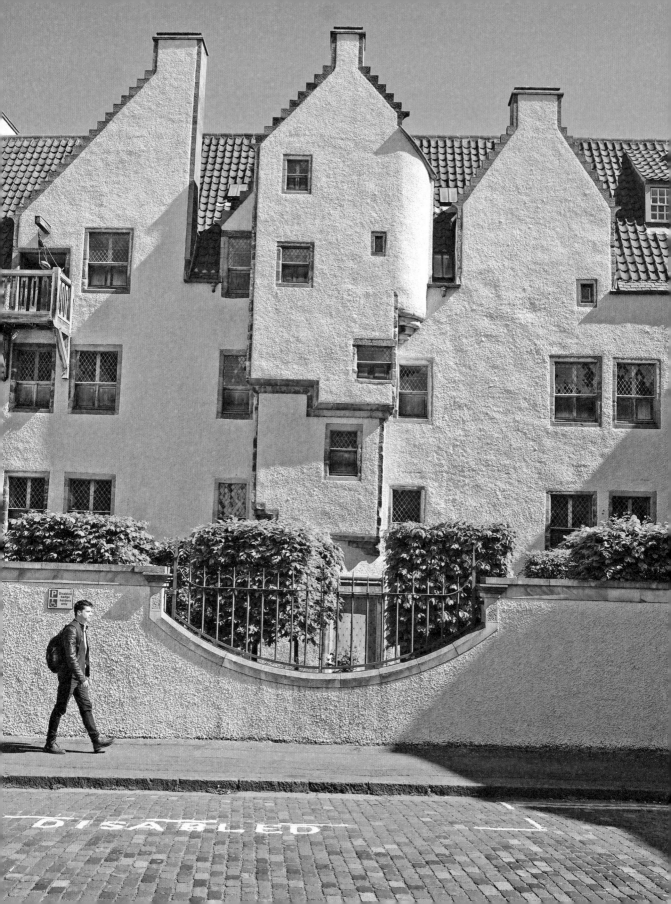

As you continue down Constitution Street, you'll enter a vibrant pocket of places to eat and drink. Head to cafés like the Hideout, Rocksalt, or Printworks Coffee for a bite to eat or a cuppa, or if you fancy something stronger pop into traditional neighbourhood pubs like the legendary Port O' Leith or head down to the King's Wark – a pub dating back to the 1400s and still offering warm welcome to 'kings and peasants'!

THE SHORE

As its name suggests, the Shore sits on the shores of the Water of Leith. If there was an award for the most photogenic area of Leith, it would have to go to this small pocket of pretty, which has even garnered comparisons to Amsterdam. The banks of the Shore are lined with a range of excellent places to eat, from Martin Wishart, the Michelin Star restaurant, to local favourites such as the quirky Roseleaf Bar and cake extravaganza that is Mimi's Bakehouse.

HIDDEN GEMS OF THE SHORE
LAMB'S HOUSE

One of the Shores many hidden gems can be found nestled away on Burgess Street. Lamb's House is a brilliant example of early-17th-century architecture often seen in harbour towns around the North Sea and is one of the finest surviving examples of a Hanseatic merchant's house in Scotland. Unfortunately, the house is not normally open to the public but keep an eye out during Doors Open Days Scotland for an unmissable chance to peek inside.

CUSTOM LANE

Another relatively hidden gem and one of my favourite discoveries can be found on the northern bank of the Shore. Look out for an unassuming archway decorated with twinkly lights, and you'll have found your way to Custom Lane. Tucked away within the little lane is the lovely coffee shop, William and Johnson, which shares the space with the Custom Lane pop-up venue. The venue has seen collaborations with independent Edinburgh stores like Lifestory as well as online fashion brands such as Hush Clothing.

LEITH FARMERS MARKET

Just behind Custom Lane is a cobbled space which plays host to Leith's weekly farmers market. If you find yourself in Leith on Saturday, pop by for a browse through the various stalls and a bite to eat. A regular attender is Teenie Tings Terrariums, an independent home and garden stall specialising in air plants; once you've seen their amazing display, you won't be able to resist taking an adorable air plant home, too!

WATER OF LEITH WALKWAY

The Shore marks the end of the Water of Leith Walkway which starts at the foot of the Pentlands in Balerno. If you have yet to explore a section of the walkway, I'd highly recommend it as you never know what you'll come across. The meandering route is shown by a map embedded into the paving stones across the road from Mimi's Bakehouse, it's easy to miss so keep your eyes peeled.

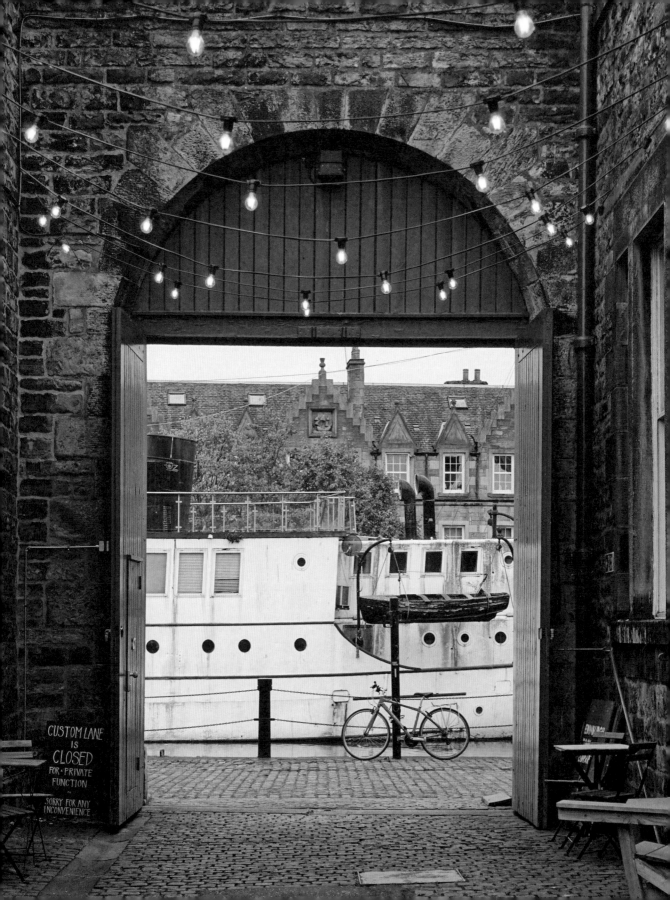

CUSTOM LANE
IS
CLOSED
FOR · PRIVATE
FUNCTION

SORRY FOR ANY
INCONVENIENCE

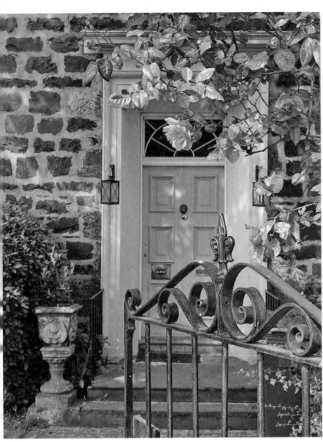

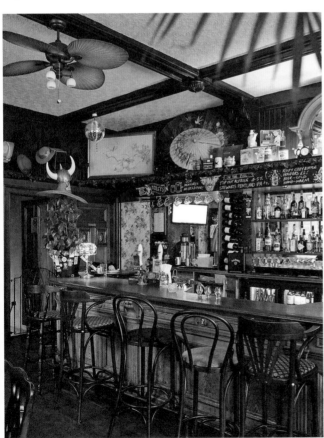

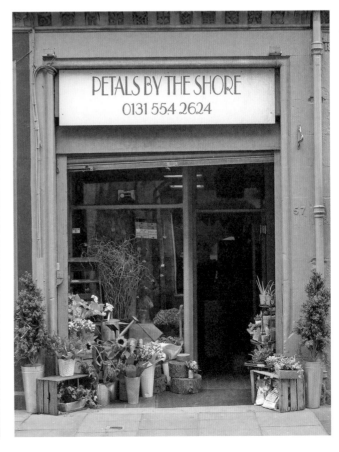

Artistic Licence in Leith

It's only right that one of Edinburgh's main artistic hubs is home to the largest collection of street art and murals in Edinburgh. It's by no means as extensive as Glasgow's or Aberdeen's street art scene, but still Leith has murals dating back to the 1980s with an influx of newly painted walls from 2013, thanks to LeithLate's mural project. As well as LeithLate's mural map, I've come across a few unofficial murals dotted around the neighbourhood.

MURALS TO KEEP AN EYE OUT FOR

Wronger Rites by Kirsty Whiten (2015)
⚲ Dalmeny Street

Untitled Mural by Elph (2016)
⚲ 115 Leith Walk

**The Leith Aquatic
by Blameless Collective (2013)**
⚲ Halmyre Street

Leith Dockers Club by Tom Ewing (2013)
⚲ 17 Academy Street

Untitled Mural by Artists' Collective (1984)
⚲ Tolbooth Wynd

**Eduardo Paolozzi
by Russell Dempster (2014)**
⚲ 77 Henderson Street

**Leith History
by Tim Chalk & Paul Grime (1985)**
⚲ Next to Leith Library on Ferry Road

København by Chris Rutterford (2018)
⚲ Custom Lane

**A survivor of the Gretna rail disaster
by Guido Van Helten (2013)**
⚲ Out of the Blue

A Visit to Studio Emma's Workshop

Edinburgh has a wealth of very talented and creative individuals, and one particular artist I've been a long-time admirer of is Emma McDowall of Studio Emma. Using a relatively overlooked material, concrete, Emma has changed people's perceptions and made a name for herself with her colourful concrete vessels and homewares. As a relatively recent graduate of the Gray's School of Art, Emma's career has already seen her create bespoke pieces for prestigious stockists such as Liberty London, the Design Museum, the TATE and the V&A, alongside becoming a V&A Dundee Design Champion and designing the prizes for the Scottish Awards for New Music 2019.

Emma kindly invited me over to her studio for a nosy around and a chat.

How did your love affair with concrete begin?
After I graduated, I'd moved back home to Alloa as I needed time to find my feet. It was a bit of a low point as I had gone from being an art student, where I had the freedom to create all day, to being thrust into the real world where I had the pressure of finding a job. I remember during that period constantly creating in my free time and experimenting. I first came into contact with concrete when I was hunting around in my mum's shed for something to make a few pots out of for her tiny window ledges. Having never worked with concrete, coupled with the fact that the concrete was very old, the first few attempts were pretty unsuccessful! But, after a trip to my local outdoor centre, I've never looked back.

What was your inspiration for adding colour to your concrete creations?
Being a textiles student, I've always had a strong connection with colour. After I discovered white concrete, I spent months experimenting with painting it then mixing it with colour until I found a recipe that worked for me. When it comes to selecting colours, it's probably not the best method, but I often find myself choosing colours that I'm in the mood for.

How did you end up in Edinburgh?
I had a lot of friends in Edinburgh so I started applying for art studios and flats in the hope that someone would get back to me. I started off in Leith, which has turned into my favourite place in Edinburgh. Despite being from Alloa, I definitely want to be considered as an honorary Leither!

What is one of the biggest challenges you've faced?

When I first started, all my moulds were recycled, and so I found myself eating things I didn't even like, just so I could use the container it came in as a mould. When the Liberty order came in, it was quite a large order, so despite it being a dream come true, it was a stressful process trying to find a large volume of recycled moulds. The original square vessels were made from juice cartons, so I found myself going around local cafés asking for empty juice or milk cartons. I also bought lots of orange juice and donated it to local food banks then collected the empty cartons after. That's how I made my original vessels and, after some time and development, I learned to create silicone moulds, which opened up so many possibilities for future designs and collaborative projects.

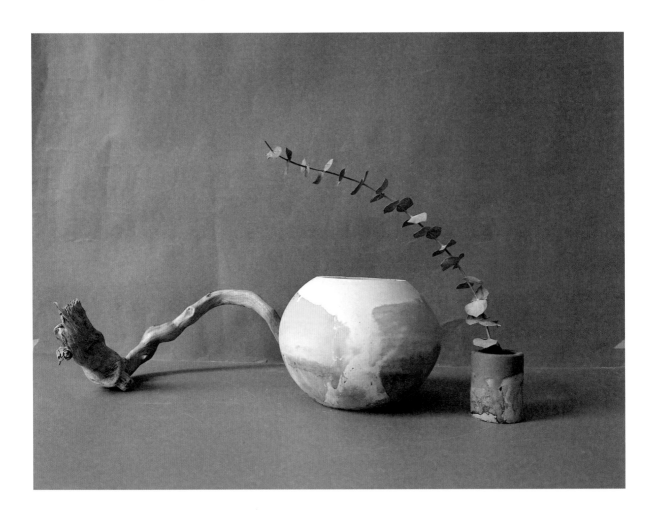

Coffee Shop Corner

There's so much of Leith to explore, that you'll definitely be in need of a coffee break. Here are a few Leith cafés I've come across on my wanders.

THE HIDEOUT CAFE (40–42 Queen Charlotte Street) is just one of the various lovely cafés on Constitution Street. The café's blue frontage with decorative arched windows, is a picture-perfect moment in itself. Inside, the café has cultivated a cosy atmosphere with its eclectic and homely style, and one look at their menu will bring a smile to your face, with their 'action' smoothies named after movie stars like Sylvester Stallone and Chuck Norris.

As I mentioned above, WILLIAMS AND JOHNSON COFFEE CO is a brilliant coffee shop which resides in Custom Lane and shares an open-plan space with the Custom Lane pop-up venue. What makes the space even more special is that Williams and Johnson Coffee roasts their beans on site, every Monday and Tuesday.

OSTARA (52 Coburg Street) is a charming and popular neighbourhood café, just off the Water of Leith walkway. What I think is particularly great about this café is that their menu is ever changing thanks to a strong focus on local and seasonal produce. It also has an enticing and imaginative vegan selection.

COLONIES OF LEITH

Move over mews houses . . . where the New Town is dominated by mews houses, Leith's version of pretty, compact homes are the Edinburgh Colonies. Colony houses are dotted around Edinburgh, but, unlike other Edinburgh neighbourhoods, Leith has a range of different Colonies, four to be precise. The layout of the Leith Colonies creates pockets of an almost village-like atmosphere.

PILRIG MODEL BUILDINGS, SHAW'S PLACE

Surrounded by tenement buildings, the Pilrig Colony is easy to overlook. But, this Colony is of particular historic and architectural importance as it's a great example of the earliest forms of colony architecture in Edinburgh.

LEITH LINKS

Sitting a stone's throw away from the picturesque Leith Links, these houses follow a similar style to the Pilrig Colony, with internal staircases rather than the external staircases which are more common with later colony developments.

LOCHEND (RESTALRIG PARK)

A few streets away from the Leith Links Colonies, lies the Lochend Colonies. The seven rows of colony houses vary in design because of the gap of five years in development but are all equally picturesque.

NORTH FORT STREET (HAWTHORNBANK)

The most northerly in Edinburgh, Hawthornbank Colony houses are a secluded haven of greenery where washing hangs on lines and gardens bloom. Hawthornbank has the external staircases which are synonymous with the style of Edinburgh's other colonies. A significant new development on the same street echoes its older neighbours with houses modelled on colony-style homes to create a thriving local community.

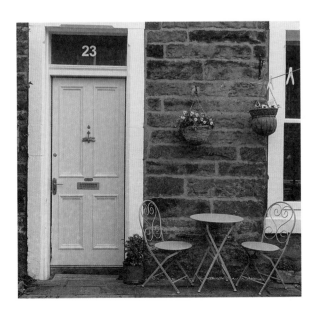

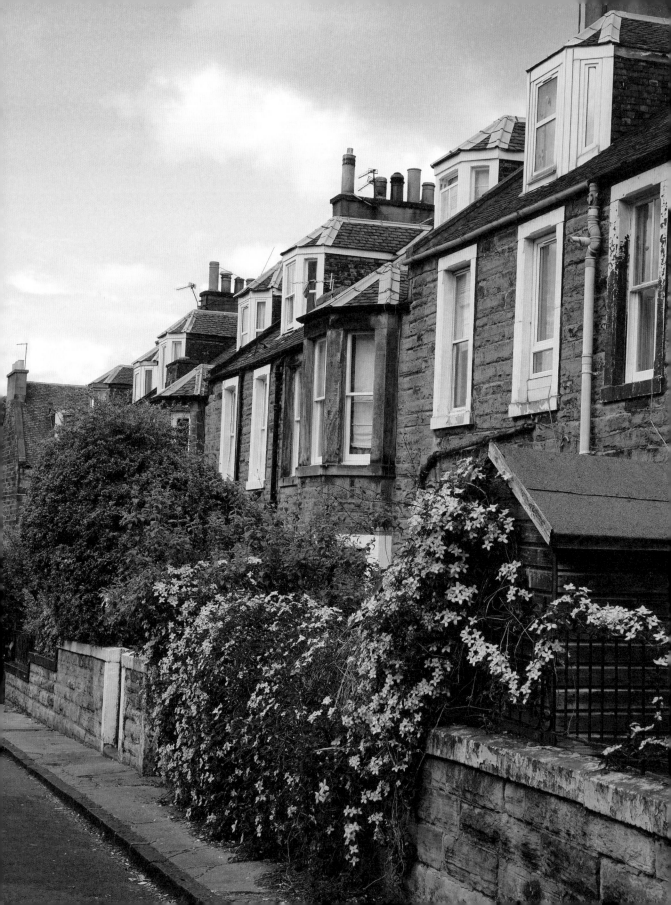

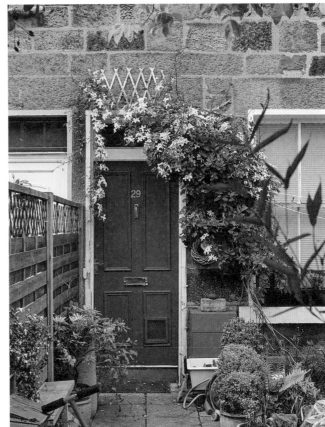

A CUPPA AND A BOOK

Bookshops are alive and well in Edinburgh – thank goodness! If you're looking for something to do on a dreich day (*dreich* being a term for generally miserable weather in Scotland), I can't think of anything lovelier than moseying around a bookshop until you find a title that takes your fancy, then delving into a whole new world over a cup of tea or coffee at a local café. No matter where you are in Edinburgh, there's bound to be a bookshop and café nearby. Here I share a few of my favourites.

Till's Bookshop
⦿ 1 Hope Park Crescent

Till's Bookshop is an unassuming second-hand bookshop located next to the picturesque expanse of the Meadows. Covered in vintage posters, Till's Bookshop consists of two rooms of floor-to-ceiling shelving laden with everything from poetry to vintage crime novels. It's a lovely place for a browse on a sunny day when the sun spills through their large front windows, and it's an equally lovely place to lose track of time on a cold winter's day as they have a cosy coal-burning fire in their back room.

LOCAL COFFEE SHOP Cult Espresso, a quirky eclectic coffee shop, is practically across the road from Till's Bookshop; there are plenty of cosy nooks to sit back and enjoy your read.

Armchair Books & Edinburgh Books
⦿ 72–74 West Port & 145–147, West Port

Just past the heart of the Grassmarket is West Port which has become a bit of a haven for book lovers. There are at least four bookshops just a short walk apart and therefore it's the perfect place for a 'bookshop crawl'. If you're short of time, I'd personally recommend Armchair Books and Edinburgh Books.

Armchair Books enjoys something of a cult following. Thanks to its maze-like layout, floor-to-ceiling bookshelves and twinkly fairy lights, it's not only become a booklover's paradise but also an Instagrammer's dream. A short walk from Armchair Books, and you'll stumble across Edinburgh Books. The bookshop is bursting at the seams with a wide range of second-hand and antiquarian books. As you delve into the shop, you'll be taken on a journey as you discover their room dedicated to all things Scottish, their section on history and military, as well as a large collection of classics – plus much more!

LOCAL COFFEE SHOP Lovecrumbs is just a few doors down from Edinburgh Books and, as their name suggests, they specialise in cakes, but you're also guaranteed a brilliant cup of coffee or tea too! If you're fortunate you might even nab their coveted window seat.

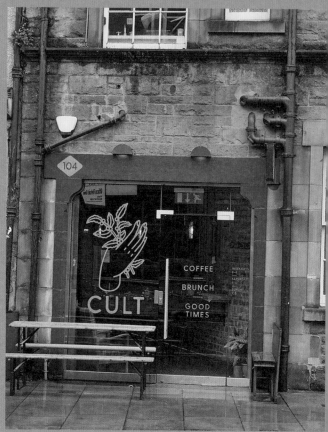

Lighthouse Books
⦿ 43–45 West Nicolson Street

Lighthouse is one of the lovely colourful shop-fronts that sits on West Nicholson Street. As you step through the door of the self-proclaimed 'radical bookshop', you'll be greeted by a beautifully presented, light and airy interior filled to the brim with a myriad of books on politics, fiction, travel writing, children's books, tattoo art and cookery. They also offer a vibrant year-round programme of events, with one or two events a week, as well as their Radical Book Fair in November.

Tip If you're a fan of comic books, don't forget to nip into Dead Head Comics next door.

LOCAL COFFEE SHOP Machina Espresso is only a few minutes' walk from Lighthouse Books and is a stylish little coffee shop, which also stocks brilliant kits for coffee-making at home.

Golden Hare Books
⦿ 68 St Stephen Street

Golden Hare Books is a beautifully presented bookshop with 'a love and appreciation for book design at its heart'. To me, their interior is almost comparable to an art gallery, with each book showcased as a little piece of art, which makes the browsing experience truly delightful. You can expect a range of design magazines, coffee table books, novels and more, ensuring there's something for everyone. Nestled away at the back of the shop, you'll discover

a cosy room dedicated to children, and if you head along with your little ones on a Sunday morning, you'll be treated to 'Sunday Stories' – their free storytelling session.

LOCAL COFFEE SHOP One of my favourite reading spots, Leo's Beanery, is a short walk from St Stephen Street. The café is tucked away below street level, making it feel extremely cosy. I personally recommend trying their delicious and cleverly named croque-mon-scone.

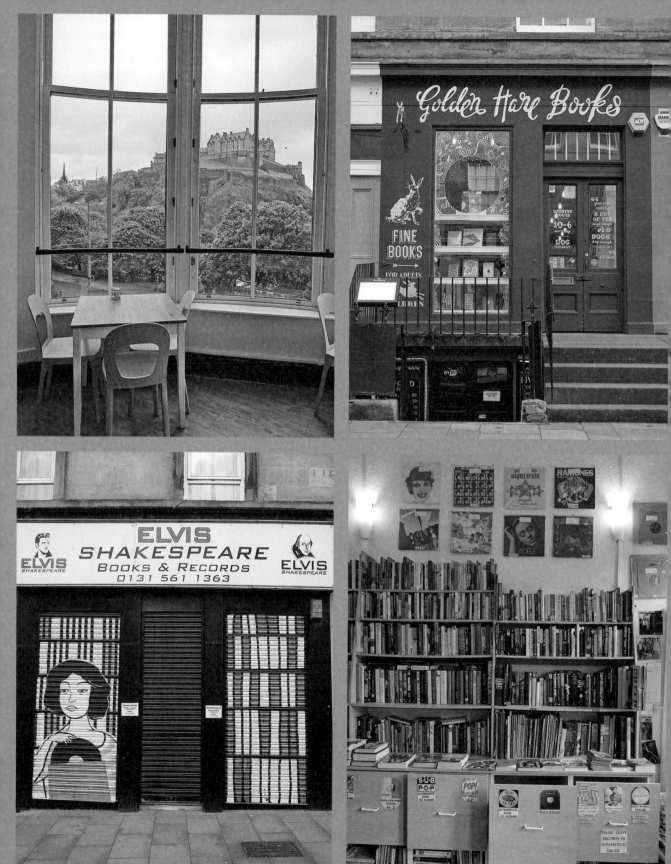

Elvis Shakespeare
⊘ 347 Leith Walk

Elvis Shakespeare is a Leith Walk institution, and almost as famous as the pair it's named after. As its name suggests, the shop is a wonderful fusion of rare vinyl and quality literature. Their impressive vinyl collection specialises in punk, alternative, indie and dance music from the late 1980s onwards. Co-existing happily alongside the vinyl collection is a diverse and interesting array of second-hand books – keep a lookout for a box filled with local authors' works.

LOCAL COFFEE SHOP A short walk along Leith Walk and onto Dalmeny Street will bring you to the Out of the Blue Drill Hall, a creative hub which has a lovely café within its walls. As you sip on your drink and flick through your new read, you'll be surrounded by brilliant up-and-coming artists' work.

The Portobello Bookshop
⊘ 46 Portobello High Street

Launched in summer 2019, Portobello Books is a new kid on the block. Passionate, community-focused and friendly, this elegant, inclusive space is the first independent bookshop to open in Portobello in living memory. It's perfect for browsing after – or before! – a walk on the beach and an ice-cream. I particularly love the magical mural by local illustrator Eilidh Muldoon that adorns the wall of the children's section. PS: Porty Books even has a piano and welcomes your well-behaved canine companions too.

The Edinburgh Bookshop
⊘ 219 Bruntsfield Place

Sitting on Bruntsfield's vibrant high street, the Edinburgh Bookshop has won the hearts of locals with its comfy sofa, gorgeous window displays, as well as extremely friendly and knowledgeable staff. If you're planning to visit, be sure have a read of their famous library ladder signed by visiting authors and illustrators; it's an unmissable Bruntsfield highlight.

LOCAL COFFEE SHOP Bruntsfield is blessed with an abundance of wonderful cafés, but if like me you have a weakness for French patisserie, I'd recommend visiting La Barantine. The French café offers a mouth-watering selection of delectable treats: it'll be hard to pick a favourite.

McNaughtan's Bookshop and Typewronger Books
◎ 3a–4a Haddington Place

Established in 1957, McNaughtan's is not only a beautiful bookshop but also the oldest second-hand and antiquarian bookshop in Scotland. Browse their shelves to discover a range of rare, collectable and second-hand books. Currently residing in McNaughtan's gallery space is Typewronger Books, a relatively new addition to Edinburgh's bookshop scene and perhaps the quirkiest bookshop on the list. For instance, you may receive an origami animal and the shop's stamp when you buy a book. You can expect to find a range of new books from classics to books by lesser-known, local authors. As well as being a bookshop, Typewronger also sells and repairs second-hand typewriters. Keep an eye out for their typewriter which types any Tweets they receive!

LOCAL COFFEE SHOP A short walk will bring you to Twelve Triangles, a delightful café specialising in sourdough breads, pastries and some of the best doughnuts in the city. It's a must-visit!

Waterstones
◎ 128 Princes Street

Sitting proudly at the west end of Princes Street, Waterstones is a four-storey book lover's paradise, complete with comfy seats at every turn. It's one of my favourite places to nip into on a rainy day, where I proceed to forget about the weather and lose myself among the never-ending bookshelves and neatly stacked tables labelled 'Books from the Bucket List' or 'A Dystopian Reading List'.

LOCAL COFFEE SHOP You won't need to walk far to find a cuppa as Waterstones has its own café on the top floor which overlooks none other than Edinburgh Castle.

Topping & Company Booksellers
◎ 2 Blenheim Square

At the start of 2019, there were excited whisperings that independent bookseller Topping & Company were opening an Edinburgh branch in the early autumn. Not only that, it'll be 'the largest independent bookshop to open in the country for decades', and they'll make their home within the Grade A-listed William Playfair building. Having visited Topping & Company's beautiful St Andrews' branch, I'm extremely excited to see what they have in store for Edinburgh.

LOCAL COFFEE SHOP You might not need to pop out the bookshop for a cuppa, as they promise complimentary pots of fresh tea and coffee along with plenty of friendly, bookish advice, as you browse the store. How delightful!

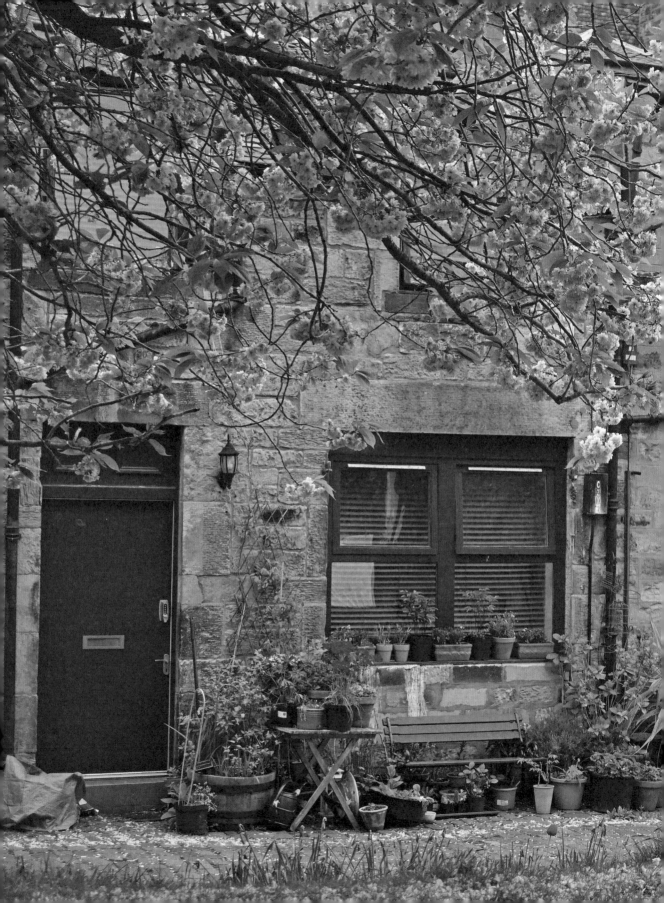

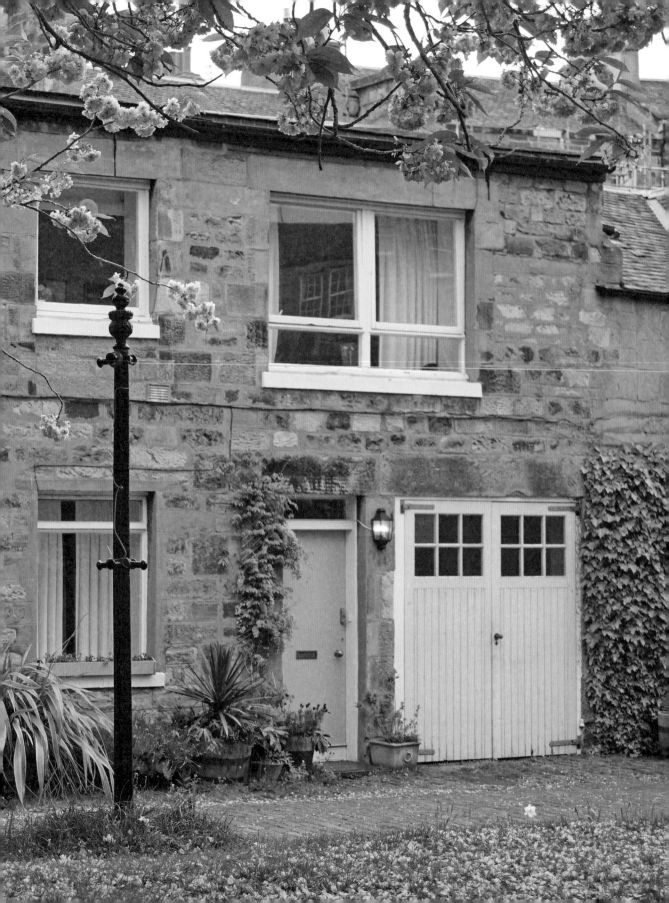

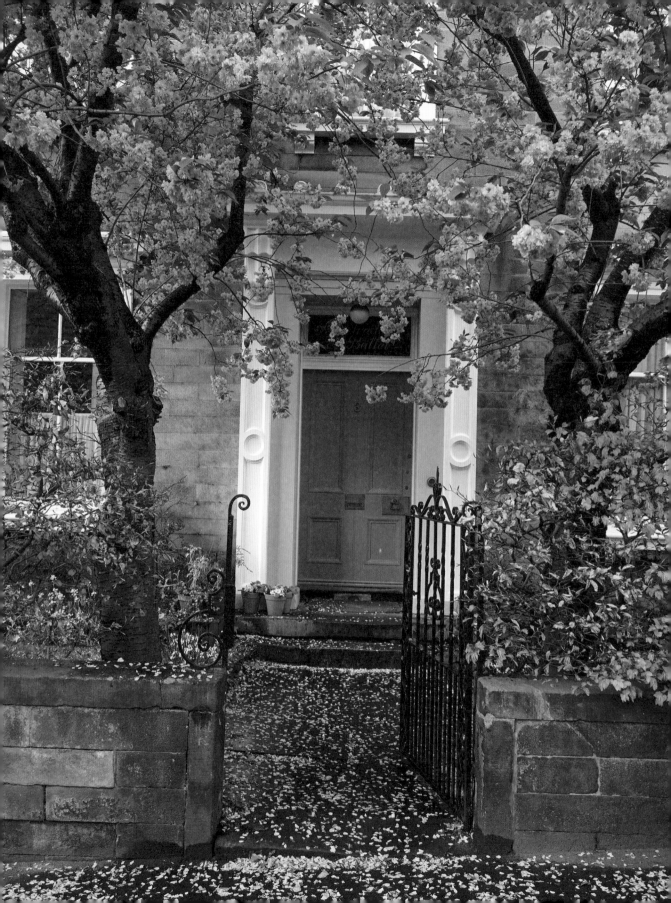

HIDDEN POCKETS

Edinburgh's
Little Gems

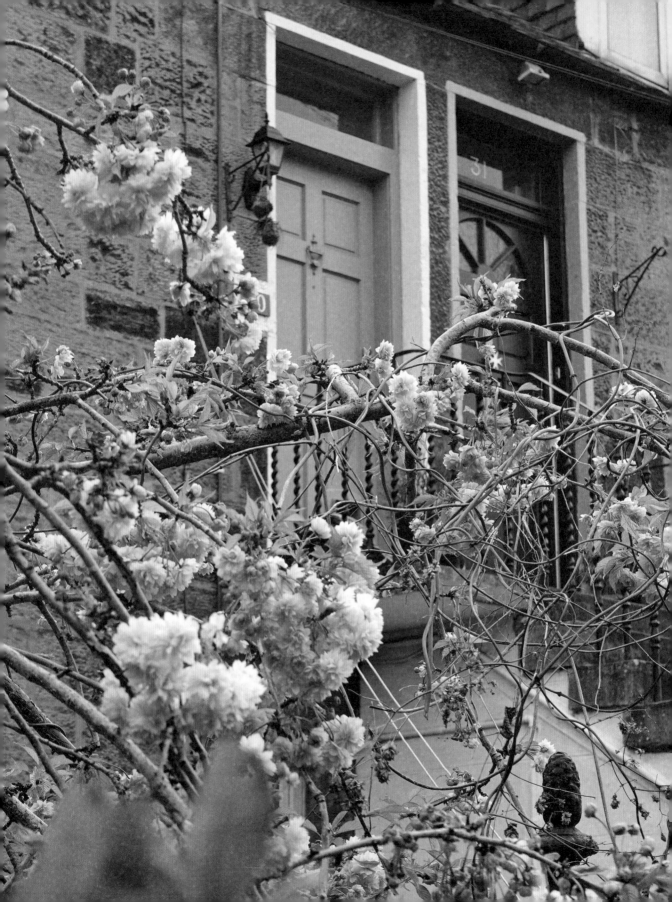

ABBEYHILL

Surrounded by Edinburgh's historic Old Town, regal Holyrood Park and the iconic Calton Hill, the neighbourhood of Abbeyhill is often overlooked. This relatively small area is mostly residential, but if you know where to look it can be a delightful place to spend an afternoon.

SUGGESTED WALK

As you leave behind the Royal Mile and venture into Holyrood Park, there's a good chance you'll miss a quiet cobbled lane, sitting on the north edge of Holyrood Park behind Holyrood Palace, called Croft-an-Righ. Croft-an-Righ means 'The King's Field' in Gaelic and next to the lane is a beautiful 16th-century mansion. The house is said to have been originally built for Regent Moray, and once served as flats for Holyrood Park's gardeners. It currently houses Historic Scotland's regional office. Despite a few modern additions, the quaint lane still closely resembles what I imagine it would have looked like a few hundred years ago and walking along it always transports me to another time. It's also a great place to snap a few Instagram photos.

As you leave Croft-an-Righ and venture up Abbey Mount, you'll come to Montrose Terrace. Both of Abbeyhill's main roads, London Road and Montrose Terrace (part of the A1), are quite busy and if you're passing through by bus or car, blink and you'll miss it, but hidden in plain sight is a creative hub of independent business-es, such as Mud Station Pottery, an open studio

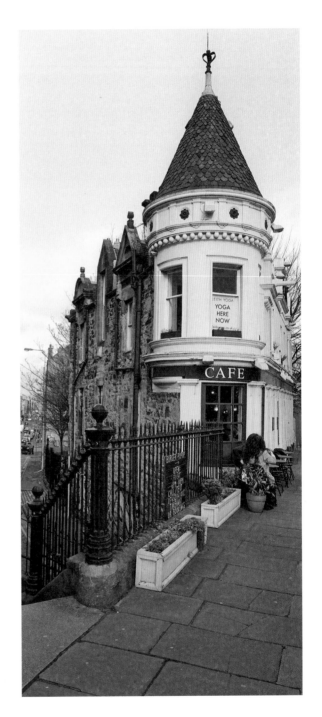

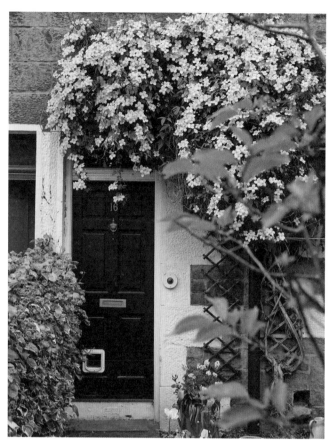

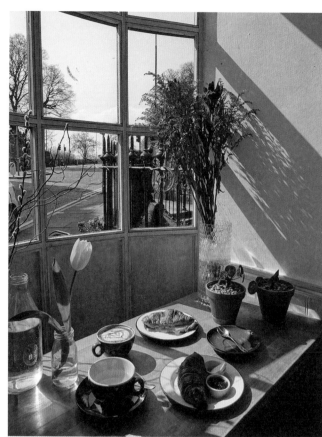

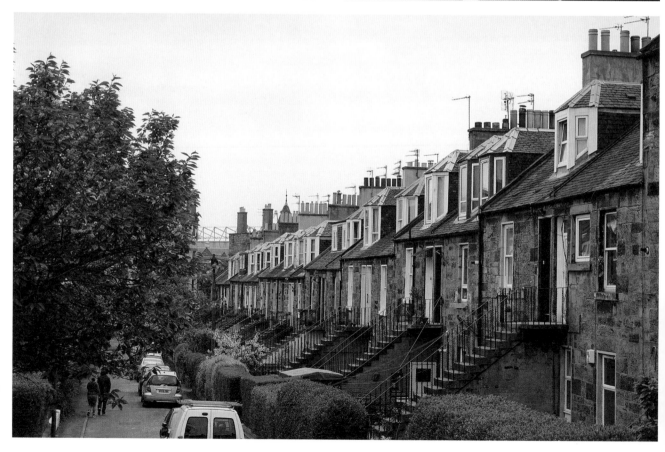

pottery workshop; Narcissus Flower Workshop, famed for their various floral-related workshops; and We Make, a studio space which also hosts a varied range of creative workshops.

If you're like me, you'll be on the lookout for a coffee shop to pop into and, despite its humble size, Abbeyhill has various options. As you approach Montrose Terrace, across the road lies Montrose House which, in my opinion, is one of Edinburgh's loveliest buildings. The off-white building was built in the grand Scots Baronial style as a pub and is now home to a brilliant café and shop, Century General Store. Continue along Montrose Terrace and you'll come across Art & Vintage, a beautiful art gallery and café, as well as another local favourite, Red Kite Café. For those of you looking for something a little stronger than coffee, the 'old-school pub turned funky real-ale bar', the Safari Lounge might be right up your street, and don't forget to check out their food menu which has proved very popular with locals.

An afternoon wander in Abbeyhill wouldn't be complete without a visit to the charming Abbeyhill Colonies. As well as being extremely picturesque, the Abbeyhill Colonies is an artistic hub and hosts a popular annual festival, The Colony of Artists. The Colony of Artists began in 2005 and includes exhibitions, talks and live music from creatives who live or are involved in the Abbeyhill Colonies. What I personally love about the festival is that it takes place in the artists' colony homes, so there's the chance to have a peek into over twenty individual studio spaces, each with their own style.

DALRY

Dalry is another area of the city centre that is often slightly neglected. I'm as guilty as anyone as, despite living and exploring Edinburgh for several years, Dalry is somewhere I wasn't very familiar with. Thankfully, a good friend and fellow wanderer lives in the area and kindly offered to show me her favourite spots. I find Dalry quite similar to Southside in character. Its main road is bustling yet has a great collection of places to eat dotted along it. My friend even jokingly referred to it as the Little Italy of Edinburgh thanks to its abundance of Italian restaurants – most notably the Edinburgh institution, Locanda de Gusti.

SUGGESTED WALK

Starting near Haymarket Station and heading up Dalry Road, the first turning on your left will bring you to one of Edinburgh's loveliest colony developments. Consisting of eight streets, Dalry Colonies date back to 1868, and were primarily built to house Caledonian Railway workers. If you're familiar with Edinburgh's various other colony houses, you'll see that Dalry Colonies closely resemble them, yet they have become my particular favourites. Unlike many of the rest, the central street which leads off to the eight lanes is mostly pedestrianised, with benches and a Little Free Library. There are also quirky features, such as a beautiful curved stone staircase leading up to one of the homes.

Continuing up Dalry Road, look out for a turning on the left for Orwell Place, where you'll find the oldest building in Dalry. Unlike many other neighbourhoods in Edinburgh, such as the Grange, I'm pleased to report that Dalry's 17th-century mansion house still exists. It was built by wealthy merchant and baillie Walter Chieslie, and the large mansion sat proudly in a sprawling country estate that stretched to Gorgie and Fountainbridge. Nowadays, despite a few cherry blossom trees which stand guard outside of the house, gone are the acres of lush green land and instead the house is surrounded by Victorian tenements. However, I think its unsuspecting location makes it all the more of a hidden gem, and it's a must-see during spring when the trees explode into a vision of pink. At the end of Orwell Road, you'll find another of Edinburgh's watery havens, the Victorian swimming baths, now known as Dalry Swim Centre.

Last but not least, at the end of Dalry Road lies one of Edinburgh's smaller cemeteries, Dalry Cemetery. Just before you reach the cemetery, you'll pass by a tiny lane with high walls, known as 'Coffin Lane', which has been the site of many fictional murders including one in Ian Rankin's Inspector Rebus novel *Let It Bleed*. What was once a grand cemetery has sadly become somewhat neglected. However, if like me, you find it interesting to read the inscriptions on old gravestones, it's still an intriguing cemetery to explore. The highlight for me is the beautifully intricate gothic lodge house at its entrance.

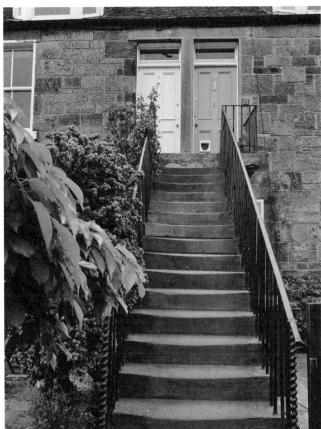
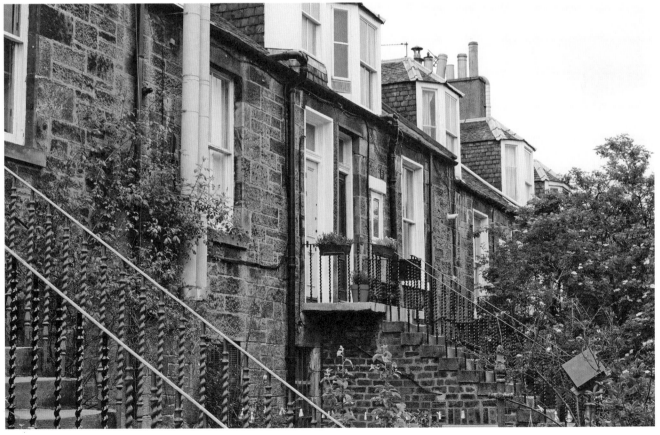

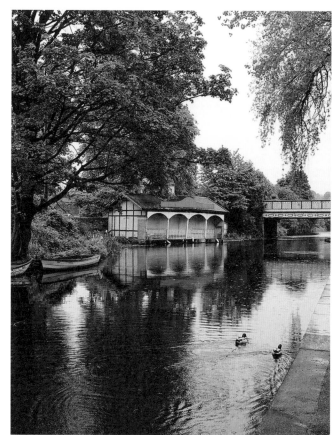
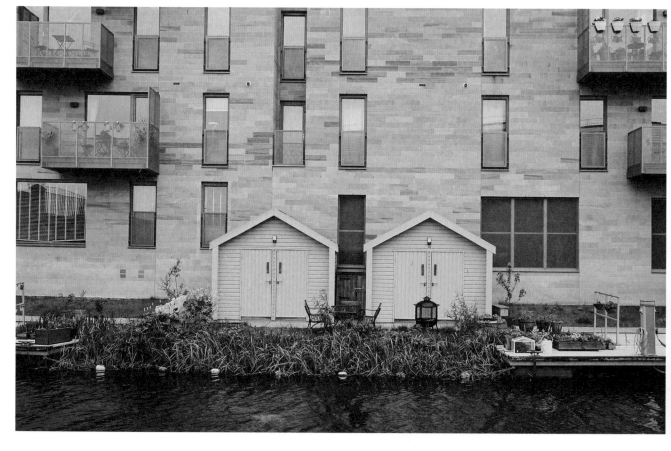

FOUNTAINBRIDGE

Once a thriving industrial neighbourhood and home to one of Edinburgh's most famous sons, Sir Sean Connery, it's easy to pass through Fountainbridge and only spot the Edinburgh International Conference Centre, student accommodation, plus various office blocks, and assume that's all there is to the area. Far from it. Hidden behind tall modern façades are unexpected, charming pockets of pretty and lovely places to eat.

SUGGESTED WALK

I want to introduce you to Fountainbridge by sharing something I found a few years ago that took me by surprise. Hidden away among Fountainbridge's modern developments and tenement buildings is a little pocket of pretty consisting of the Rosebank Cottage Colonies, Gardner's Crescent and the Rosemount Building.

As you enter the area, you'll notice a small public garden surrounded by a crescent of symmetrical Georgian homes, a cluster of charming, quirky cottages, and a red and yellow brick quadrangle building. The peculiar collection of houses pricked my curiosity and I found out that Gardner's Crescent was in fact designed to be a circus which surround-ed the communal garden, in a similar style to the New Town circuses. Instead, Rosebank Cottages were built directly opposite and a wall constructed in between to prevent mixing of the classes! Today, as you wander around Rosebank Cottages, it's easy to imagine you're in a small rural hamlet and forget you're ac-tually in the city centre. Beside Rosebank Cottages is Rosemount Building, which I'd passed by several times but only ventured for a peek inside the other day. I was amazed to find, at the centre of the quadrangle, a patch of greenery with a couple of large leafy trees and clothes lines zigzagging back and forth. What makes the space extra charming are the bright colours of the doors which face the courtyard.

As you leave Gardner's Crescent behind and cross over Fountainbridge Road, you'll see a footpath directly ahead which will lead you to the jewel of Fountainbridge, Union Canal. The canal runs from Edinburgh to Falkirk and once acted as the main transport system to deliver coal and minerals to the capital. Once you step into Lochrin Basin, you leave the noises of the city behind and are greeted by a picture-perfect scene of colourful canal boats surrounded by ducks and swans. If you're in need of something to eat, Akva is a locals' favourite or keep your eyes peeled for a floating coffee shop in the form of a baby blue canal boat with the words 'The Counter on the Canal' inscribed on the side.

It's completely up to you how far you feel like walking. On a sunny day, preferably avoiding the mad dash of bicycles during rush hour, it's a very relaxing walk and I've surprised myself at how far I've ventured. A few photo opportunities to watch out for are: the picturesque scene at Polwarth Parish Church, Harrison Park and the extremely charming Ashley Terrace boathouse. You can also leave behind the canal to visit the Edinburgh Printmakers, one of the newest and most exciting developments in Fountainbridge. The Edinburgh Printmakers saved the former North British Rubber Company building from demolition and has restored it to a vibrant new creative hub with gallery space and excellent café.

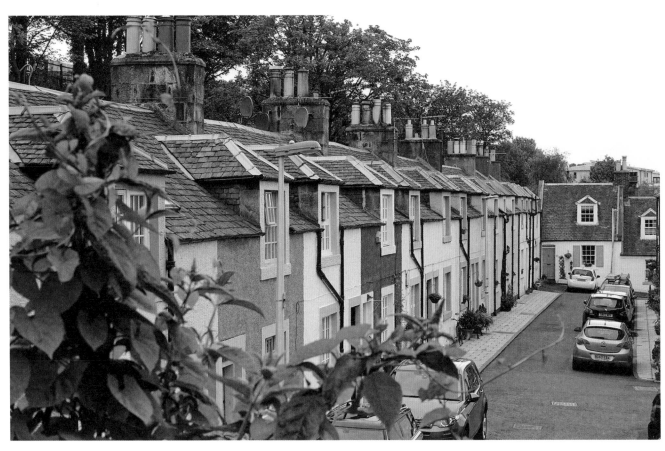

AN AFTERNOON STROLL: 'The Villages Beyond Leith'

GRANTON HARBOUR & VILLAGE

Historically an industrial neighbourhood, Granton sits on the shores of the Firth of Forth. Today, the area is largely residential and far from the well-trodden path. However, there is one pocket of pretty that is particularly worth noting.

As you leave the city centre behind, and venture through Granton's various modern developments, you'll eventually reach Granton Harbour and the colourful, picturesque homes which line the waterfront, known as Wardie Bay. In comparison to the quaint scene at Newhaven or the picturesque Shore in Leith, Granton harbour has remained relatively neglected over the years; however, there are plans in place to build 'The Edinburgh Marina' – a new waterside development featuring residential properties, a luxury marina, a hotel and spa.

The road which runs parallel to the harbour has long been a route connecting Newhaven to Cramond, and now comprises the busy A901. These colourful homes are referred to as East Cottages and were built by the Duke of Buccleuch to house workers who were building Granton Harbour in the 1830s. I love how, they do a great job of adding a splash of colour and energy to Lower Granton Road.

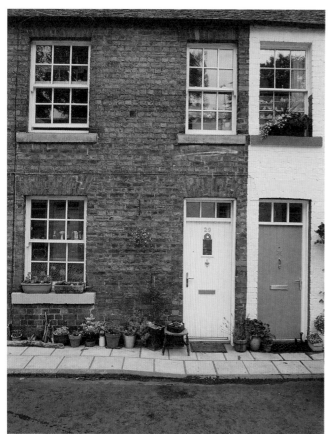

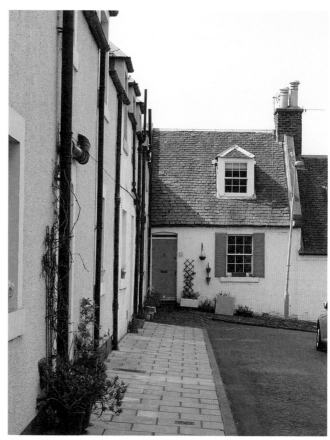

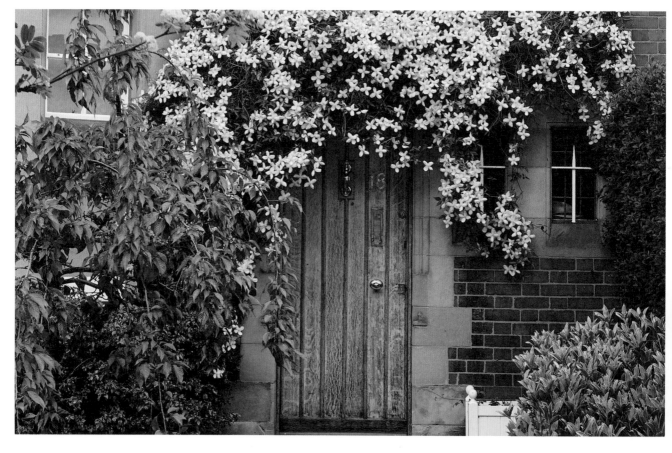

Wardie Square

Tucked away, just off Lower Granton Road, is the peaceful Wardie Square. As you step off the main road into the square, you leave behind the usual hustle and bustle that accompanies a busy road and you'll be greeted by a charming collection of seaside homes dating back to around 1840. From colourful shutters adorning a few windows to collections of potted plants, each little house has its own distinct character.

As you wander around the square, you'll spot a set of steps which lead upward to Trinity and boasts a lovely view of Wardie Square and the harbour.

TRINITY

As you reach the top of Wardie Steps, take a left and head along Boswall Road. Welcome to Trinity. Of a similar style to the Grange, Trinity is a leafy residential area with an eclectic mix of grand mansion houses, Victorian terraces and a scattering of modern homes. The neighbourhood is named after the Trinity House and farmland estate which originally resided on the land. In the 19th century, the neighbourhood became very popular among wealthy New Town residents, with many properties being built as second homes, turning it into a district of impressive, eclectic houses.

The neighbourhood is beautiful all year round but a walk through Trinity is especially enchanting during spring or summer, when the blossoms decorate the pristine front gardens. A few streets to keep an eye out for are Trinity Road, which is lined with cherry blossoms, Primrose Bank Lane and Lennox Row.

Starbank Park

Arguably one of the most delightful parks in Edinburgh, Starbank Park is a glorious garden on the edge of Trinity, which is lovingly cared for by Friends of Starbank Park. The garden is a wonderful fixture in the community, hosting weekly community gardening events, plus regular activities such as the Cherry Blossom Tea Party and Picnic, and the incredibly popular Easter Sunday egg rolling bonanza. If you're not familiar with this tradition, egg rolling entails bringing your hard boiled and decorated eggs

to the park and rolling them down its steep grassy slopes until they fall to pieces. The sight of local seagulls on the pickings afterwards is quite something to behold!

The best way to enter Starbank Park from Trinity is through the Laverockbank Road entrance, which brings you into the upper section of the garden consisting of Starbank House and a tranquil formal garden with geometrical flower and herb beds as well as beautiful old trees, which come to life during cherry blossom season. One of my favourite aspects of the garden are their two Little Free Libraries, one dedicated to children's books and the other, Tardis-shaped, stocks a range of fiction and non-fiction.

Once you've explored the upper garden, head to the north-end of the garden, where you'll be greeted by a magnificent view over the Firth of Forth. The garden slopes downwards and leads to Starbank Road; before you leave be sure to look up and admire the iconic star-shaped flower border which takes centre stage.

NEWHAVEN

A short walk along Starbank Road, brings you to Newhaven. Once a thriving fishing village, Newhaven has sadly lost elements of its distinct character. However, there are a few endearing traits that remain to hint at its history, including typical Scottish fishing village houses, a small harbour and a very attractive lighthouse.

As you enter Newhaven from Pier Place, the first thing to catch your eye will be Newhaven's landmark, the pint-sized white Newhaven Lighthouse which lights up in the evenings. The

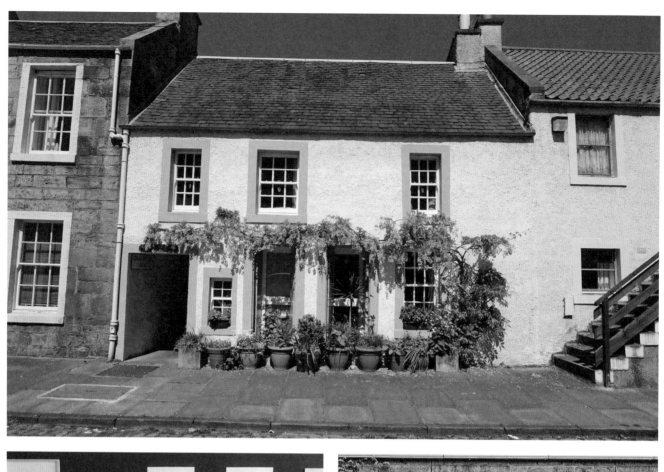

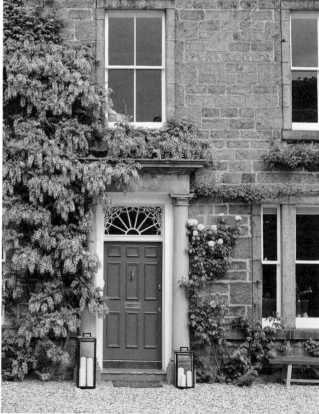

lighthouse is surrounded by a small harbour with an old Victorian fish market sitting on the east corner which has now been turned into a fish and chip restaurant under the name the Fishmarket Newhaven; they do amazing and extremely popular takeaways, too. If you enjoy fish, Welch Fishmongers is worth a visit for their traditional, extensive selection. They have been serving the people of Edinburgh since 1959. The harbour itself is picturesque any time of the day but is particularly stunning when the sun sets.

Leaving the harbour behind, cross over Pier Place and down a narrow lane called Westmost Close, this will bring you to Newhaven Main Street, where you'll be greeted by a mix of typical Scottish fishing houses. Most of the homes are decorated with various plant pots but be sure to keep an eye out for a small fishing house beautifully adorned with wisteria during spring.

If you're anything like me, I enjoy nothing more than finishing a walk with a hot drink and a slice of cake, and thankfully as far as coffee shops goes, Newhaven is blessed with a hidden gem. As you come to the end of Newhaven Street, walk up Newhaven Road until you come to Hawthornvale which is home to the Edinburgh Sculpture Workshop. Tucked away out of sight is a lovely café called MILK, which is often bathed in a beautiful light and has views over the Edinburgh Sculpture Workshop's outdoor studio space. If you're feeling creative, the workshop offers courses in stone-carving, ceramics, and bronze casting.

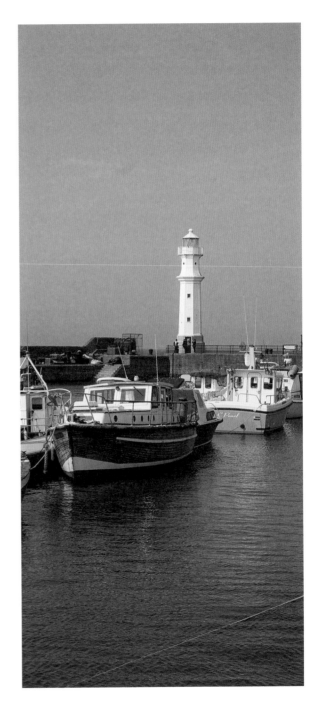

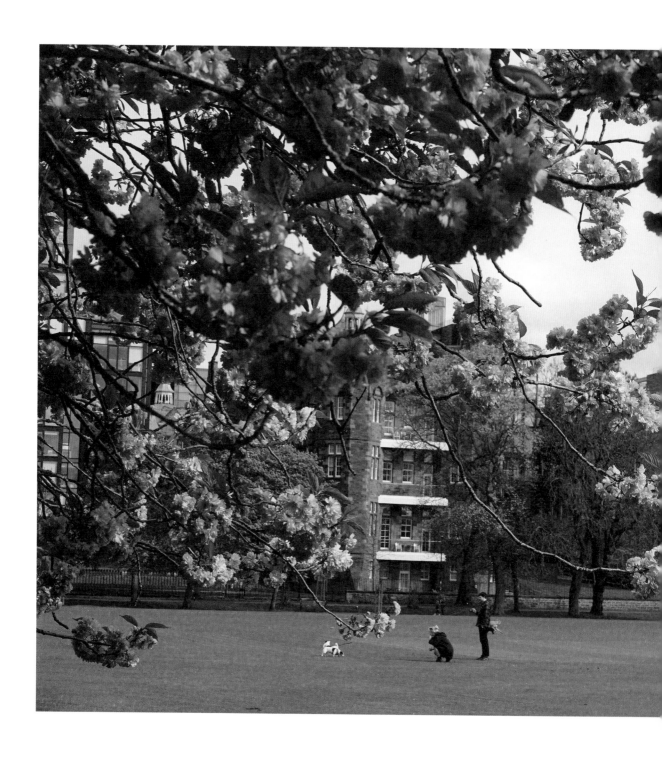

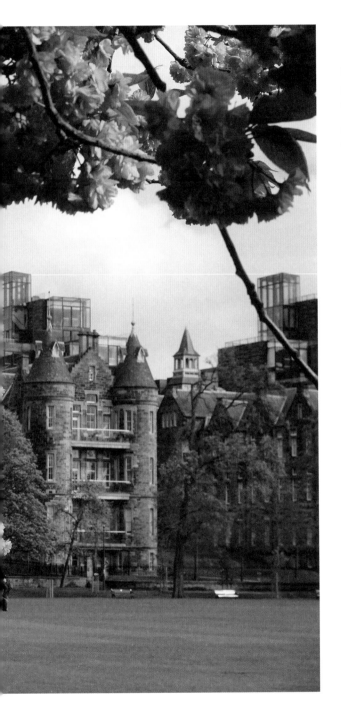

LAURISTON

Despite being one of Edinburgh's smaller neighbourhoods, Lauriston has a special place in my heart as I spent several years living in the area. It doesn't take long to explore, but along the way I think you'll be surprised at what it manages to cram in: an impressive collection of beautiful buildings and my favourite corner of the Meadows.

SUGGESTED WALK

The best way I can think of introducing you to this neighbourhood is a walk through Simpson Loan. Once the home of Simpson Hospital, the area is now host to the luxury development, Quartermile. Tall glass structures rise up into the sky with an almost youthful exuberance while the original hospital buildings stand proudly beside them showing off their charm and character. As you walk through Simpson Loan, look out for a red sandstone building, it's one of my favourite places to snap a 'stride-by'. Tucked away within the development are also various places to eat, including the independent Scandinavian chain, Söderberg, and the Malaysian restaurant, Nanyang.

As you reach the end of Simpson Loan, turn left to enter the Meadows. This will bring you to one of my favourite corners of the Meadows, Coronation Walk. During cherry blossom season, the narrow tree-lined path becomes a little secret among local photographers and Instagrammers. Coronation Walk is narrower

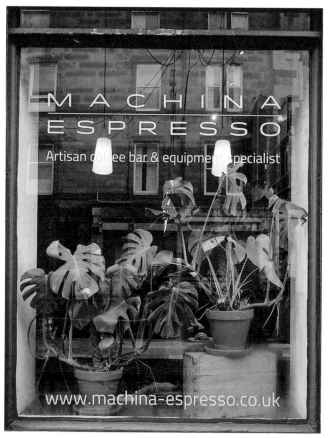

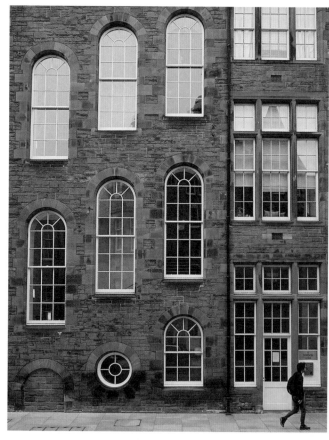

and less busy than Middle Meadow Walk so it's one the best places to take a photo of the blossoms. At the end of Coronation Walk is a quaint wooden building, known as the Pavilion Café, which opens in spring and summer as a laid-back café with outdoor seating.

From there, I'd walk down Jawbone Walk (named after Jawbone Arch, a much-loved local landmark, currently removed for restoration), which will connect you back to Meadow Walk. As you walk along Meadow Walk, you'll get another chance to have a peek at the Quartermile development from a different perspective. Further down the path, you'll spot a row of beautiful Victorian terrace houses which face the Meadows, one of which even belonged to Arthur Conan Doyle. I admit I'm a bit a 'nosy parker' when it comes to people's gardens, and I'm pleased to report most of these are very well taken care of.

If you'd like to pause for a drink or a bite to eat, Machina Espresso is just around the corner on Brougham Place, or you could leave the Meadows behind and head up Lauriston Gardens. I'd like to end my tour of this area with one of my favourite views of Edinburgh Castle. Once you're at the top of Lauriston Gardens, turn right and walk along Lauriston Place until you spot a sign for Heriot Place on your left, just before George Heriot's School. This will lead you to the Vennel, and its iconic view of Edinburgh Castle.

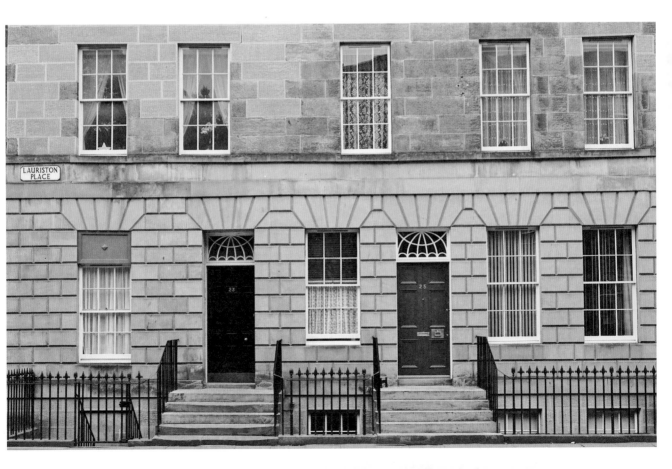

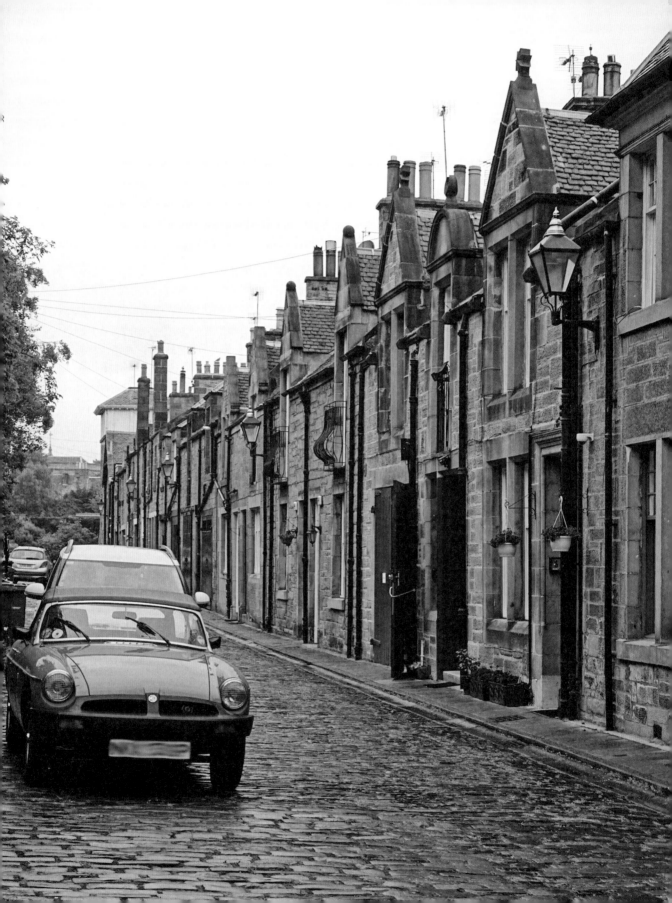

MARCHMONT

Just south of the Meadows, Marchmont is largely residential and, despite its short distance from the city centre, remains relatively quiet and suburban, making it a desirable area to live in. Over the years, the area has also become synonymous with students, in a way it's become a bit of a rite of passage to stay in Marchmont while studying at the University of Edinburgh. However, in the four years I was a student in Edinburgh, I have to admit I never stayed in the neighbourhood – but we'll just keep that between ourselves.

We have Sir George Warrender, the owner of the Bruntsfield House estate, to thank for Marchmont's instantly recognisable rows of tall Victorian terrace houses, as he undertook a project in the 19th century to convert the area into a tenement suburb for the middle classes. Since then, the area has also acquired strong literary connections, being the birthplace of Muriel Spark, and the home of Ian Rankin's ever-popular fictional Inspector Rebus.

Despite having never been a Marchmont resident myself, I've often enjoyed a wander there and a browse through its shops, so I've put together a suggested walk to introduce you to the area.

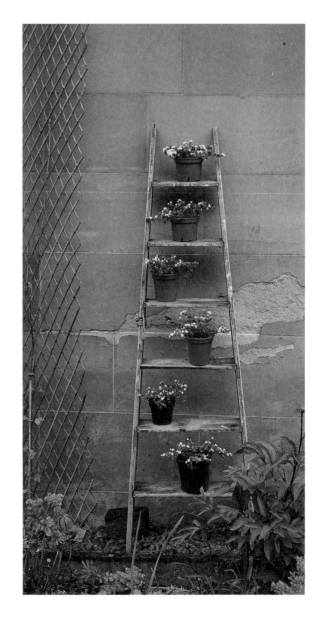

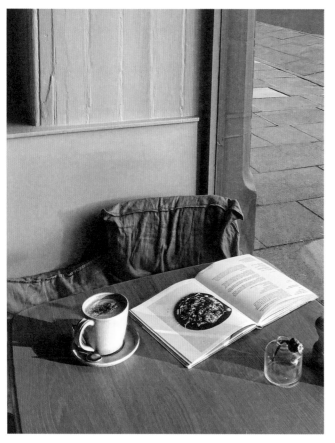
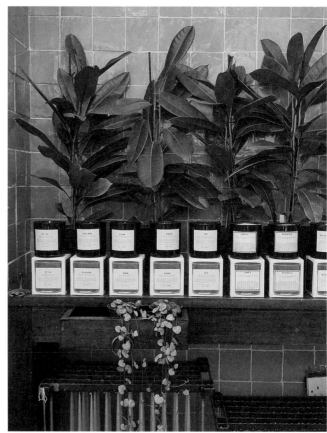
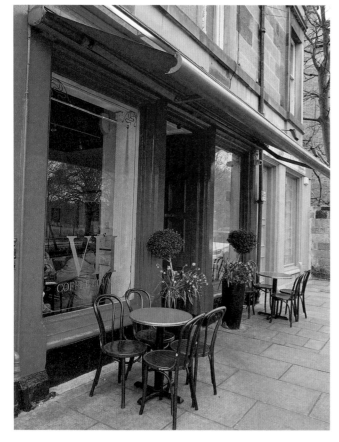

SUGGESTED WALK

Starting off in the west of Marchmont, what better introduction than a walk through Warrender Park Crescent. As the name suggests, the street has a gentle curve, allowing you to take in the splendid Victorian terraces with their turrets rising into the sky. As stunning as the street is, I've found it notoriously hard to capture its full beauty on camera. As you continue along, you'll enter Warrender Park Terrace, where you'll be treated to views over the Meadows towards Edinburgh Castle. In fact, it's rumoured that the top floor flats on this street have the best views of Edinburgh Castle, which I'm particularly jealous of during the spectacular Edinburgh International Festival fireworks display held to mark the end of August's cultural celebrations.

You'll eventually reach Marchmont Road, but I prefer a walk up Marchmont Crescent as it's often quieter and more picturesque. Halfway up, you'll come to one of the main streets to enjoy a little shopping or relish a bite to eat. A few of my personal favourites to look out for are: Dahlia, a delightful lifestyle store, bursting at the seams with plants; Brochan, Marchmont's neighbourhood porridge café – need I say more?; 27 Elliott's and two Marchmont institutions: Doodles, a fun ceramics workshop; and Eddie's Seafood Market, which is arguably the best fishmongers in Edinburgh.

As you continue up Marchmont Crescent, you'll eventually meet back up with Marchmont Road, from here it's a short walk to Warrender Swim Centre – a beautiful Victorian swimming pool with B-listed mosaic tiles. As you might realise, I have a bit of a love affair with mews lanes, and tucked away off Marchmont Road is the ever-so-quaint Thirlestane Lane, complete with old-fashioned streetlamps. Thirlestane Lane is one of the last streets in Marchmont before you cross over into the Grange.

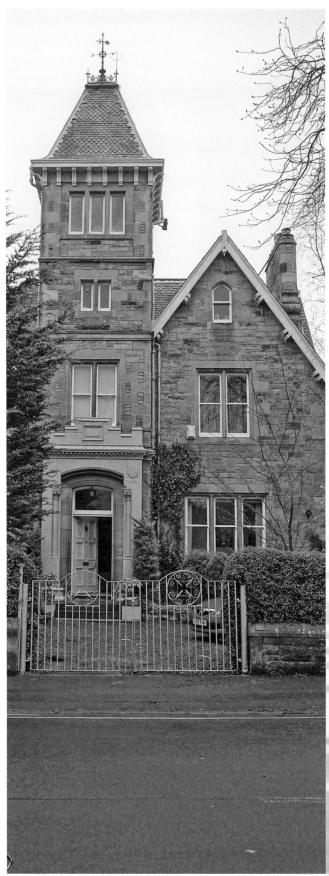

THE GRANGE

I admit, I was less than familiar with the Grange when I set out to write this book, which gave me a great excuse to do what I love most: wander aimlessly until I get a feel for an area. Walking through the quiet, leafy streets lined with Victorian villas and manicured lawns, you still get a real sense of the historical grandeur which was once synonymous with the Grange.

It didn't take long for this area to become one of my favourite neighbourhoods for a walk, as it's extremely pretty yet delightfully peaceful.

The area gets its name from the monks of St Giles' Cathedral who owned the land in the 14th century and referred to it as St Giles' Grange. It was home to one of Edinburgh's oldest and grandest mansions, Grange House, which was sadly demolished in 1936. However, if you're walking around the Grange, you may spot a few clues of the house's existence, such as the Lauder griffins pillars in Lovers' Loan, and the original garden walls which run along some sections of Grange Crescent. It wasn't until the 19th century that the area was developed into what we know and recognise as the Grange today.

During spring, magnolia trees sway gently in the breeze, daffodils pop their heads through the fences, and camellias spill over walls, turning the neighbourhood into an enchanting pocket of pretty. One glance at the photos I've taken, and there is proof that along with mews houses, I also have a thing for doors! The Grange is quite evidently the perfect place to capture a #DoorsofInstagram post.

LITTLE LIBRARIES

'Second hand books are wild books, homeless books: they have come together in vast flocks of variegated feather, and have a charm which the domesticated volumes of the library lack.' – VIRGINIA WOOLF

From literary legends such as Robert Burns to Dame Muriel Spark, Edinburgh enjoys an impressively rich connection with literature. So, it makes perfect sense that Edinburgh is one of the many locations around the globe that is part of the Little Free Library initiative. For those of you who haven't heard of the initiative, it's a non-profit organisation that strives to inspire a love of reading while fostering community spirit. All you need to do when you visit a Little Library is bring a book with you to exchange for a new one. If it was up to me, there would be a Little Library at the end of every street! Edinburgh has several Little Libraries dotted around the city, each with its own unique personality. Here are a few I've come across.

Scotland Street
⌖ 37 Scotland Street

Where better to begin than with the Little Library on Scotland Street – the location of Alexander McCall Smith's irresistible series 44 Scotland Street. The elegant light grey box is one of my favourites as it has a tiny garden on its roof – perfect for an Instagram snap!

Stockbridge Colonies
⌖ Teviotdale Place

I can't imagine a dreamier location for a Little Library than the Stockbridge Colonies. This Little Library, which sits at the foot of one of the Colonies' unique homes, is made from reclaimed timber that blends in beautifully with its extremely picturesque surroundings!

The Royal Botanic Gardens
⌖ Royal Botanic Gardens,
 next to the glasshouses

Hidden between the Royal Botanic Garden's glasshouses and main science buildings, this Little Library houses various genres of books, both fact and fiction, as well as the odd book with a more horticultural focus. This blue wooden box is easy to miss, so keep an eye out for it!

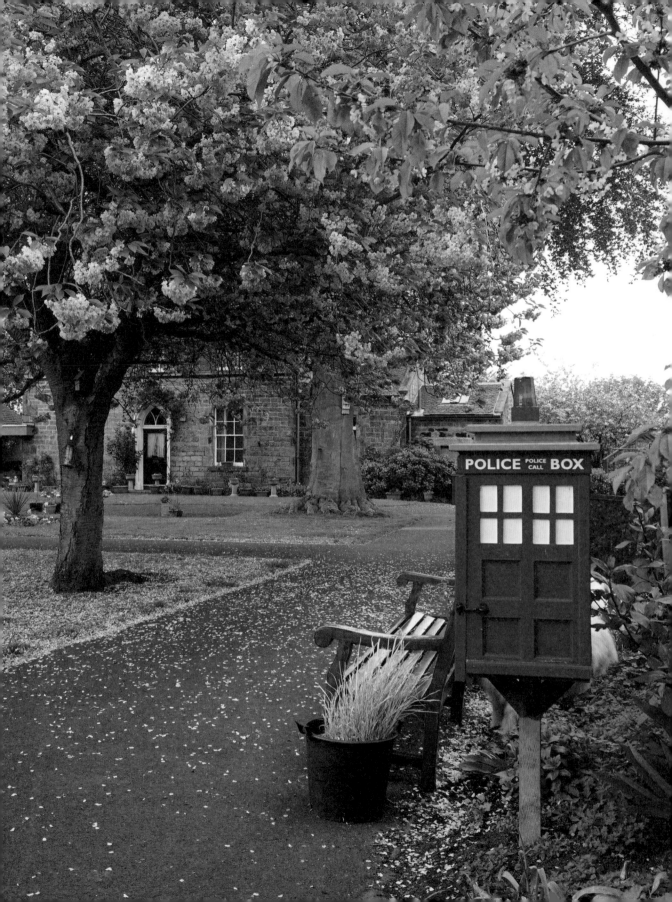

Dalry Colonies
◎ Dalry Colonies

Located near Haymarket, the Dalry Colonies comprise of eight charming streets and you'll find this Little Library partially hidden in one of the hedges. The pedestrianised street is lined with benches, making it the perfect place to pause and read a book.

Starbank Park, Newhaven
◎ Starbank Park

The award for Edinburgh's most creative Little Library has to go to Starbank Park's library, which is shaped like Doctor Who's Tardis! It's the perfect location for a jaunt on a warm summer's day. Stop off at Milk at the Edinburgh Sculpture Workshop for a to-go drink (and maybe one of their amazing snacks), then head to Starbank Park to enjoy a book in the sun.

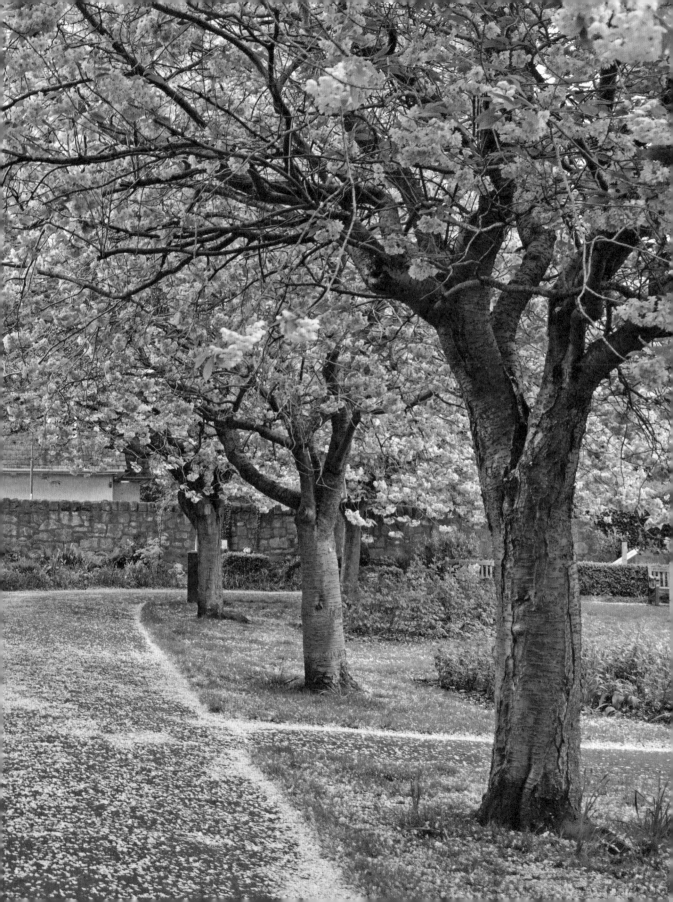

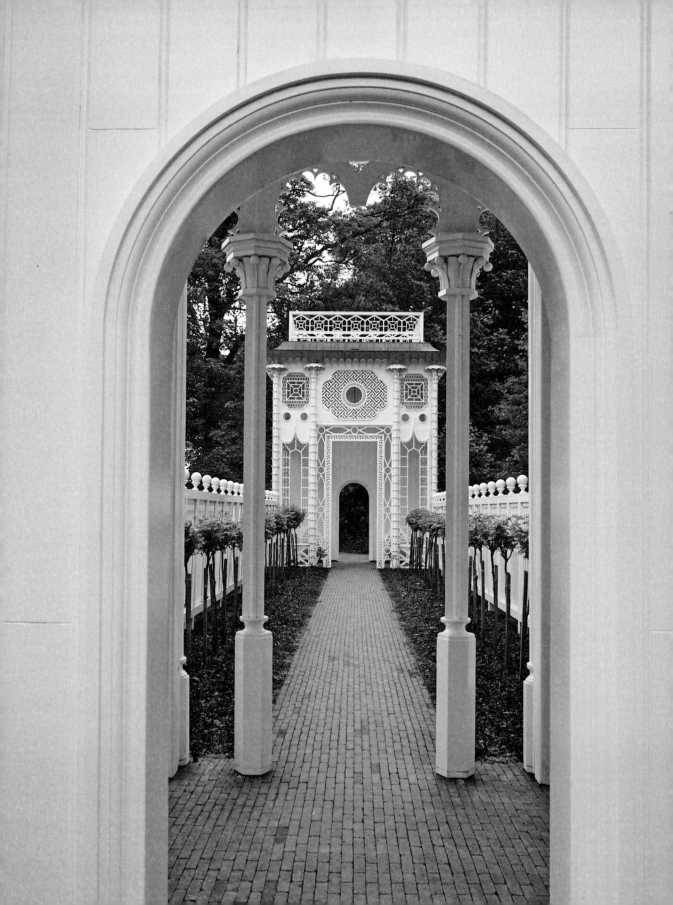

POCKETS OF TRANQUILLITY

Escape the City Centre

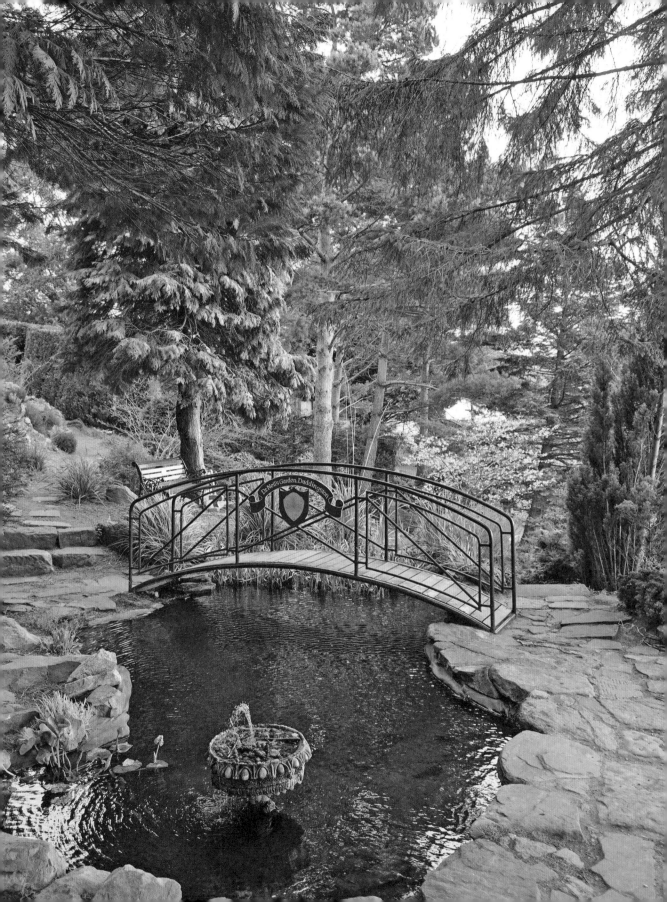

DAY TRIPS WITHIN EDINBURGH

'If the path be beautiful, let us not
ask where it leads.' – **ANATOLE FRANCE**

When compared to larger cities, Edinburgh is often
praised for successfully finding the perfect balance
between a city and the countryside, but sometimes
there's nothing lovelier than heading out of the city
centre for a little adventure. There are several wonderful
day trips from Edinburgh such as North Berwick, Culross,
Glasgow and St Andrews, but I wanted to show that you
don't even need to leave the city to enjoy a day out.

DUDDINGSTON VILLAGE
1.6 miles from city centre

How to get there?
If you have access to a car that's great, but if not, Duddingston is only a short walk from Arthur's Seat and Holyrood Park.

Tucked away behind Arthur's Seat is the picturesque village of Duddingston. Despite being within walking distance of the city centre, it often suffers from 'out of sight, out of mind', and can be overlooked by visitors and locals alike. However, this charming village is one of the oldest parts of the city, dating back to the 12th century, and is one of my favourite places to visit when I need a bit of peace and quiet.

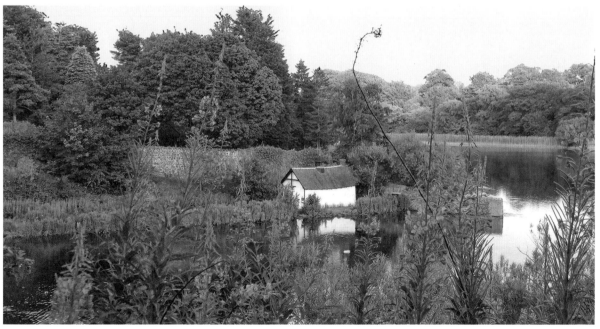

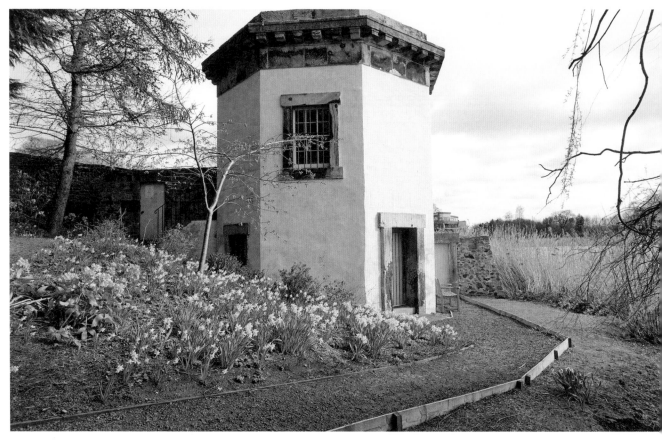

Suggested Walk

There are various lovely walks which lead to Duddingston, but a personal favourite of mine is to enter the village from Duddingston Low Road which skirts around Arthur's Seat. Along the way you'll pass Duddingston Loch, one of Edinburgh's few surviving lochs, which was also the site of Henry Raeburn's famous painting 'The Reverend Robert Walker Skating on Duddingston Loch'. As you continue along the road, it will eventually lead you past Duddingston Kirk and to a set of cast-iron gates, marking the entrance of Dr Neil's Garden – commonly referred to as Edinburgh's Secret Garden.

The garden sits on the banks of Duddingston Loch and once belonged to Doctors Andrew and Nancy Neil who were responsible for transforming the space from a wilderness into an enchanting oasis. Despite its relatively humble size, the garden is bursting with flowers and foliage of all colours and sizes. Nestled away in the eastern corner, lies the historic and beautiful Thomson's Tower, designed by renowned architect William Henry Playfair and built in 1825 for the Duddingston Curling Society.

Once you've enjoyed a wander around Dr Neil's Garden, you'll probably be ready for a bite to eat. A short walk will bring you to one of Scotland's oldest surviving pubs, the Sheep Heid Inn, where you can follow in the footsteps of royalty. The pub has long been known for its vintage skittles alley, where Mary Queen of Scots reportedly enjoyed a game or two, and more recently, Queen Elizabeth II made a short trip here from Holyrood Palace to dine!

Across the road from the pub, you'll spot a tiny lane leading to the village's community land where locals have lovingly planted an orchard and a vegetable garden, as well as rearing a flock of chickens. Before you leave, I also suggest a pleasingly aimless wander around the village to admire the quaint cottages.

SOUTH QUEENSFERRY
6.8 miles from city centre

How to get there?
South Queensferry is a few miles west of the city centre but a short train journey to Dalmeny Station brings you within walking distance of the high street.

From pretty pastel houses and cobbled lanes, to scenic coastal paths, this charming town has all the makings of a picture-perfect seaside town. However, what truly sets it apart are the spectacular views of Scotland's three iconic bridges, whose dates of construction span three centuries – the Forth Bridge the Forth Road Bridge, and the Queensferry Crossing.

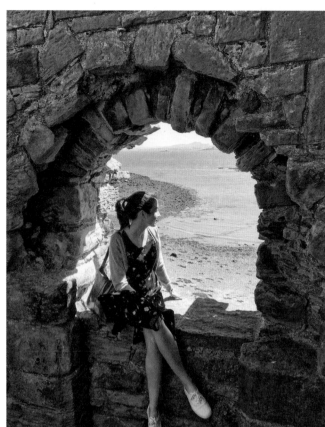

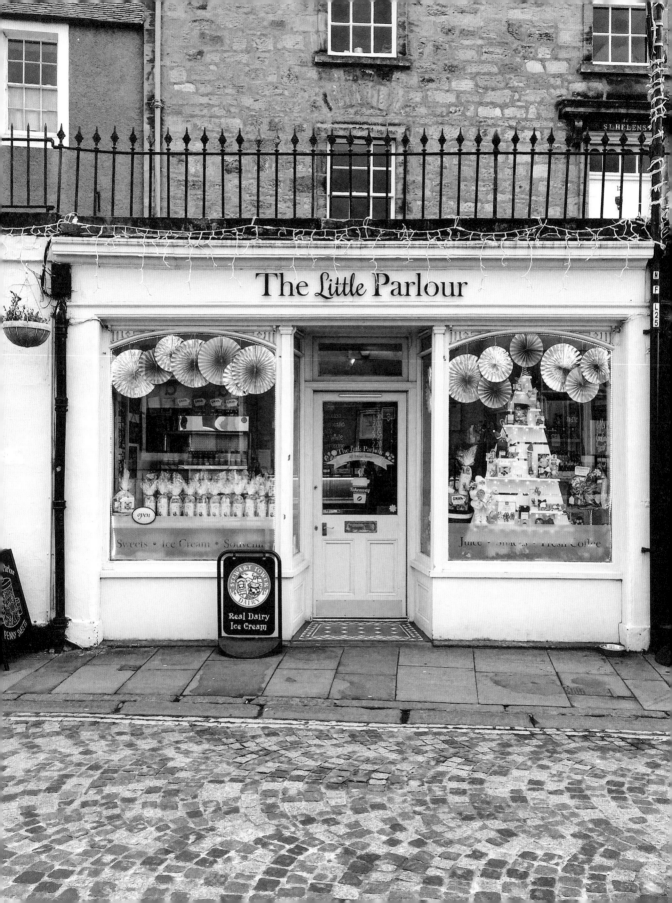

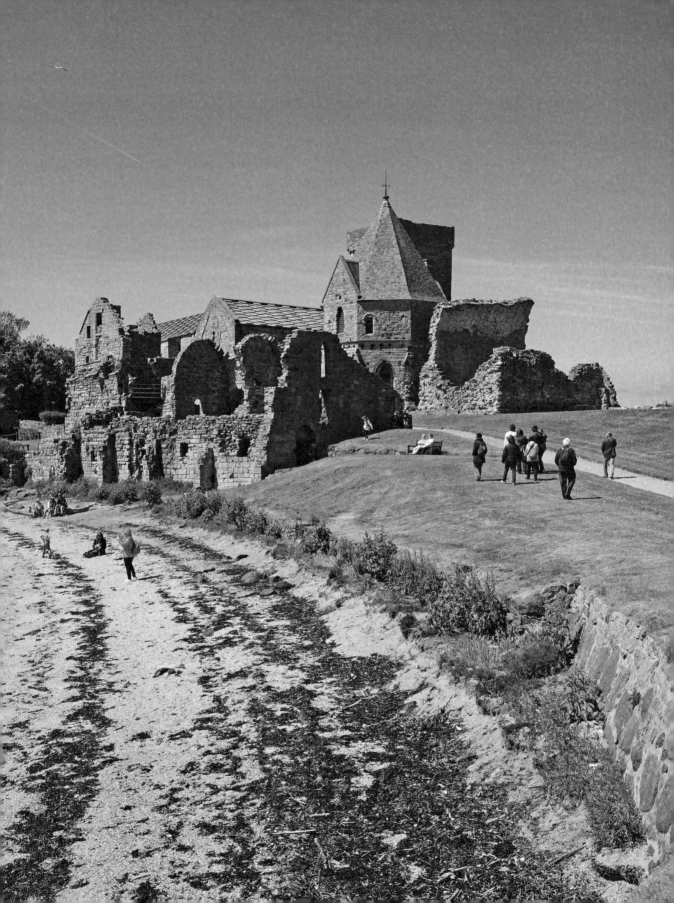

Things to do in South Queensferry

South Queensferry's quaint high street is by no means vast, but what it lacks in size it makes up for in history and delightful eateries. Check out the Little Parlour, the charming ice cream shop, as well as the other quirky shops. As you walk along the high street, you'll catch a glimpse of the bridges, and certain alleyways bring you down to the harbour or the beach where you can soak up the magnificent views.

If you're blessed with fine weather, I'd highly recommend a walk along South Queensferry's coastal path. The walk begins at the Hawes Pier opposite the Hawes Inn – which is famed for its connections with renowned Scottish author Robert Louis Stevenson and his book *Kidnapped*. If you enjoy a lounge in the sun, a short distance along the path, you'll come across beautiful, secluded sandy beaches overlooking the Forth Bridge and Fife. The path is four and a half miles long and will eventually bring you to Cramond. There are many wonderful sights along the way, including Dalmeny House – a Gothic revival mansion which is open for visitors during June and July – and the 13th-century Barnbougle Castle.

One of the best ways to appreciate the Three Bridges is to hop on a sightseeing boat tour for a cruise around the Firth of Forth. You'll cruise under the spectacular bridges, pass the beautiful scenery which lines the Firth of Forth, then end up at Inchcolm Island, the most beautiful island on the Firth of Forth, home to 12th-century Inchcolm Abbey, sandy beaches and an abundance of wildlife. Keep your eyes peeled for the odd puffin, seal and for the mysterious gnome island!

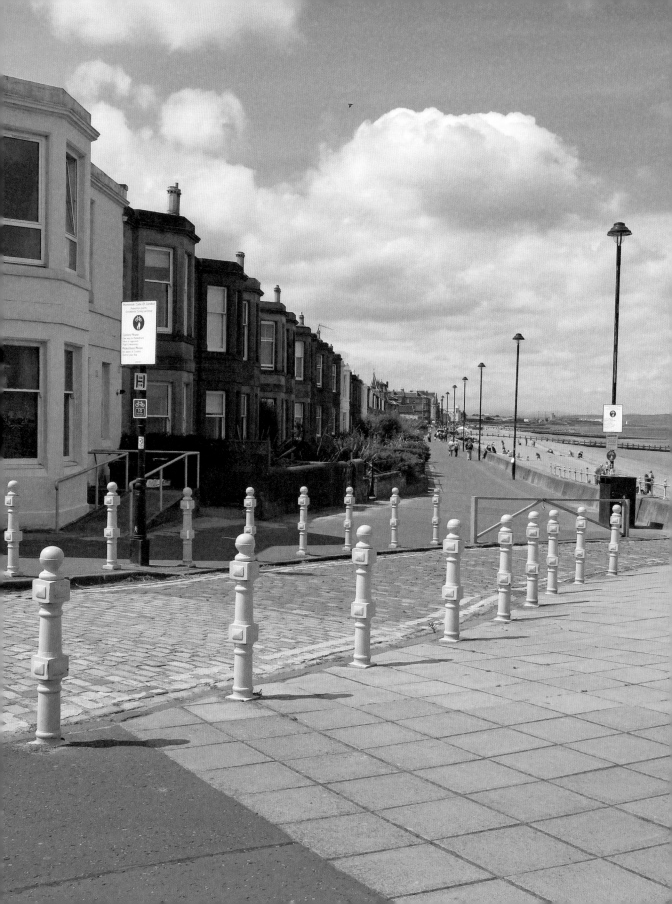

PORTOBELLO
2.8 miles from city centre

How to get there?
There is the option to drive, but I find taking the bus to be an even better option as it's roughly a 20-minute journey from Princes Street and you don't need to worry about parking.

Portobello, affectionately referred to as 'Porty' by many locals, is a coastal suburb of Edinburgh and a short bus journey from the city centre, making it the perfect place for a spontaneous seaside getaway! It's long sandy beaches still attract large crowds on sunny days, but in its heyday, Portobello was in fact Scotland's premier seaside resort, attracting holiday-makers from all over Scotland. The lively seaside town was once home to a pier with a pavilion large enough to host concerts, an open-air heated swimming pool (where none other than a young Sean Connery worked as lifeguard), and a permanent funfair.

As much as I would have loved to have visited Portobello in its prime, it has since evolved into a wonderful, quirky, community-led neighbourhood. Take, for instance, their annual Big Beach Busk which invites street performers from all walks of life to Portobello's promenade to perform all day! Portobello has also made the news recently due to the intriguing mystery of beautifully crafted wooden robots popping up about the neighbourhood, made by an anonymous toy maker.

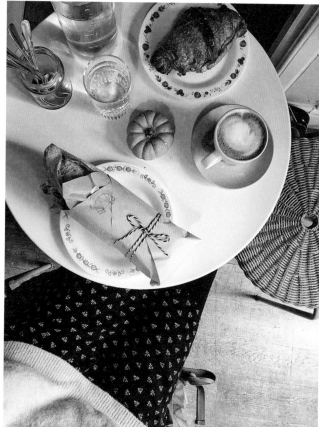

Things to do in Portobello

There's so much to see and do in Portobello, but let's be honest, if you're heading there on a sunny day, there's only one thing you'll be interested in and that's lounging on its sandy beach and soaking up the rare Scottish rays. If you get peckish, you needn't venture too far as there are a few places to get a snack or a drink dotted along the beachfront; including the Beach House, the Little Green Van and Crumbs.

If your visit to Portobello isn't blessed by sunshine, not to worry, there's plenty to see and do on Portobello's high street. There are plenty of fabulous lunch spots, from the ever-popular Bross Bagels to the artisan bakery Twelve Triangles. The high street is also home to a collection of charity shops, lovely gift shops and an exciting recent addition, the Portobello Bookshop.

One last thing I'd recommend, if you'd like to learn more about the area, is the Portobello Architecture Heritage trail. I first came across the trail thanks to a leaflet I found in a Portobello café – it can also be found online or at the Portobello library. The trail takes roughly an hour and leads you around the neighbourhood's architectural landmarks.

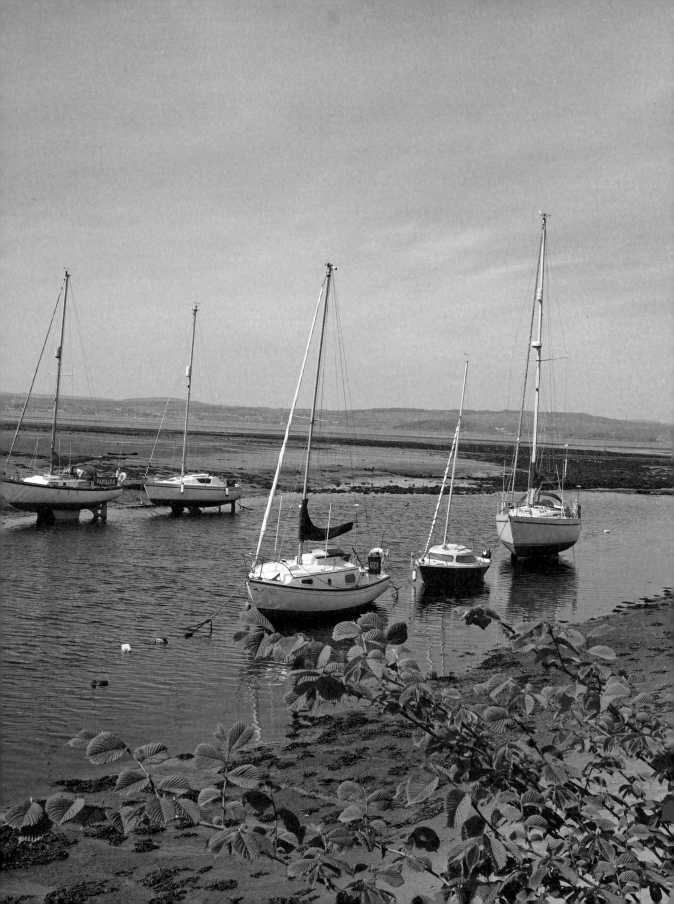

CRAMOND VILLAGE & BEACH
4.6 miles from city centre

How to get there?

Whether you have access to a car or not, Cramond is easy to get to. For those with a car there are various car parks, and for those travelling by bus it's just over a 30-minute journey.

Tucked away in the north-west of Edinburgh, Cramond is an idyllic seaside village. It has long been one of the most desirable places to stay in Edinburgh and with its sandy beaches, white-washed houses and quaint village atmosphere, it's not hard to see why! Cramond is also steeped in history. The area is thought to be home to the oldest known settlement site in Scotland, dating from 8500 BC, and was once inhabited by the Romans who built a fort there in the 2nd century AD.

Suggested Walk

For those of you who enjoy a walk in nature and a day at the beach, Cramond offers both in abundance. A quick note before you head out for your day trip, be sure to check the time of low tide so you don't miss a chance to walk out onto Cramond Island. I've included a suggested walk below but depending on tide times, it may need to be altered.

I'd recommend either starting or finishing your walk at the Falls of Cramond so you get a chance to visit both the River Almond and pay a visit to the beach, plus there's a car park and nearby bus stop. There's also the option to enjoy a leisurely two-hour walk along the Almond River if you'd rather visit the beach on another day.

If you'd like a drink before or after your walk, Cramond Falls Café sits on the banks of the River Almond and offers excellent food and drink options. Continuing past the café, brings you to a tranquil, leafy path which snakes along the River Almond. After a short walk, you'll soon approach the mouth of the river, where you'll be greeted by quaint, white-washed houses which line the small harbour with its sailing boats that gently bob at their moorings. Out towards the sea you'll spot Cramond Island with its famous path which was constructed in the Second World War as a submarine defence boom. A visit to a coastal village wouldn't be complete without a walk along the beach, and if you've timed it right, you'll be able to walk to Cramond Island when the tide is out. However, please take the notices seriously and set out during safe crossing times so you don't get caught out when the walkway is submerged and Cramond Island returns to its rightful status as an island.

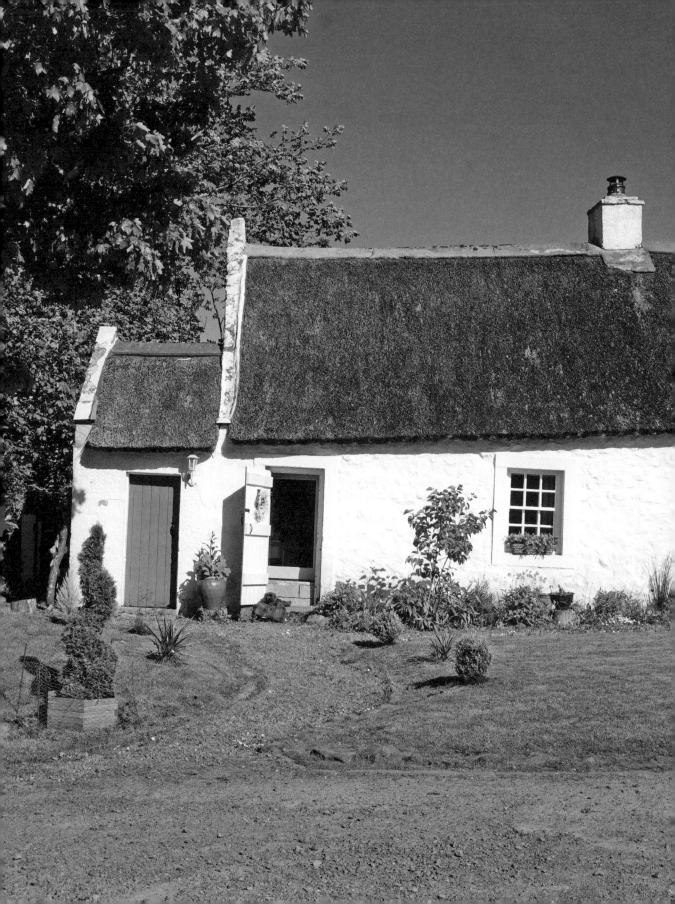

SWANSTON & THE PENTLANDS
15.4 miles from city centre

How to get there?
The easiest way to visit Swanston is by car but as I don't drive, I can vouch that a 30-minute bus ride from Princes Street to Swanston Road bus stop will bring you within easy walking distance.

Swanston is a picturesque hamlet nestled under the northern slopes of the Pentland Hills. As it's slightly out of the city centre, this rural gem is often forgotten about but having recently visited for the first time, I think it's well worth a visit, especially if you're looking to enjoy some time in the countryside.

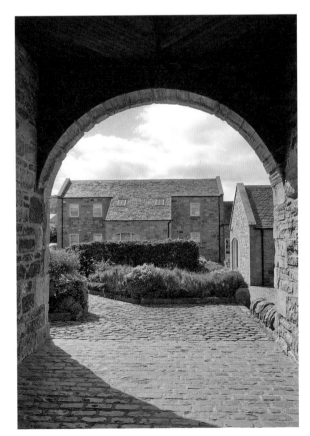

Suggested Walk

Don't be alarmed when you first get off the bus and are greeted by rows of suburban homes. A short walk will transport you from the suburbs to the sprawling countryside. Head south along Swanston Road, and you'll soon spot Swanston Golf Course and the surrounding farmland. Straight ahead is Swanston Brasserie which offers breakfast options, lunch and even dinner, and thanks to its location, also has fantastic views of the Pentlands and over towards Edinburgh.

To the left of Swanston Brasserie is a small lane leading to Swanston Village, a charming hamlet and one of the only places in Edinburgh where you'll spot thatched cottages.

Swanston is fairly humble in size, and by itself it may not count as a day out. However, fortunately, there are two paths which lead from the hamlet to the Pentland Hills Regional Park. The Pentlands are a striking range of hills with plenty of routes and trails of varying difficulty. One of the closest trails to Swanston is the 'Capital View' trail and, as the name suggests, the route boasts magnificent views over Edinburgh and beyond.

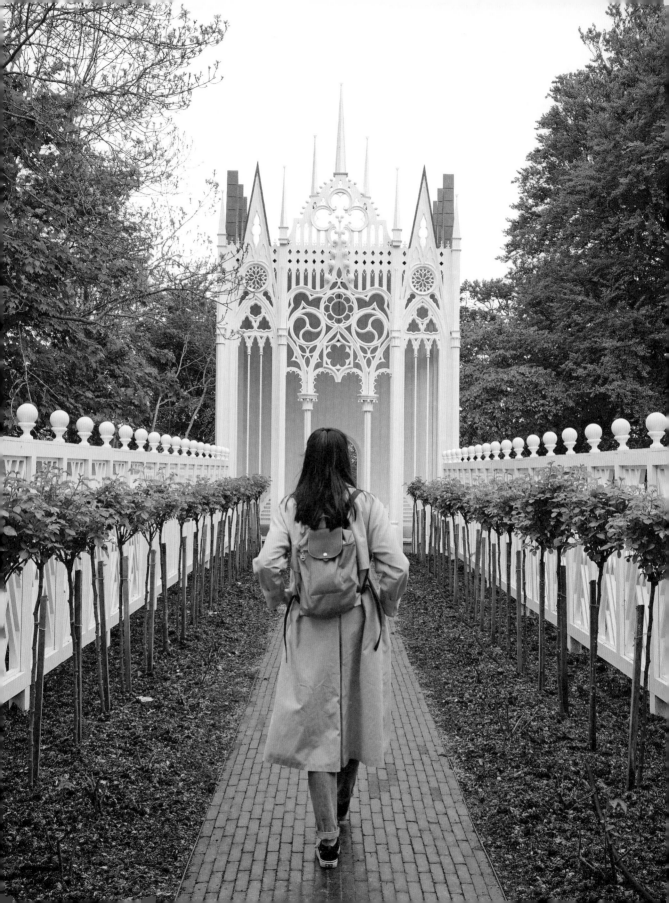

JUPITER ARTLAND
9.2 miles from city centre

How to get there?
The easiest way to get to Jupiter Artland is by car, and when I visited a kind friend drove us there, but the sculpture park is also served by two bus routes.

Sitting on the outskirts of Edinburgh, Jupiter Artland is a magnificent sculpture park set in 100 acres of meadow and woodland, surrounding Bonnington House. The tone is set as soon as you enter Jupiter Artland's gates and make your way through their grounds. You leave behind the everyday norms and emerge in a foreign land where Charles Jencks' *Cells of Life* art installation reimagines the landscape and a whimsical sign by Peter Liversidge points upwards stating 'Jupiter – 893 million to 964 million kilometres'. I've decided not to give too much away as it's a place best experienced first-hand. All I will say is whether you're an art enthusiast or not, the sculpture park makes for an unforgettable day out.

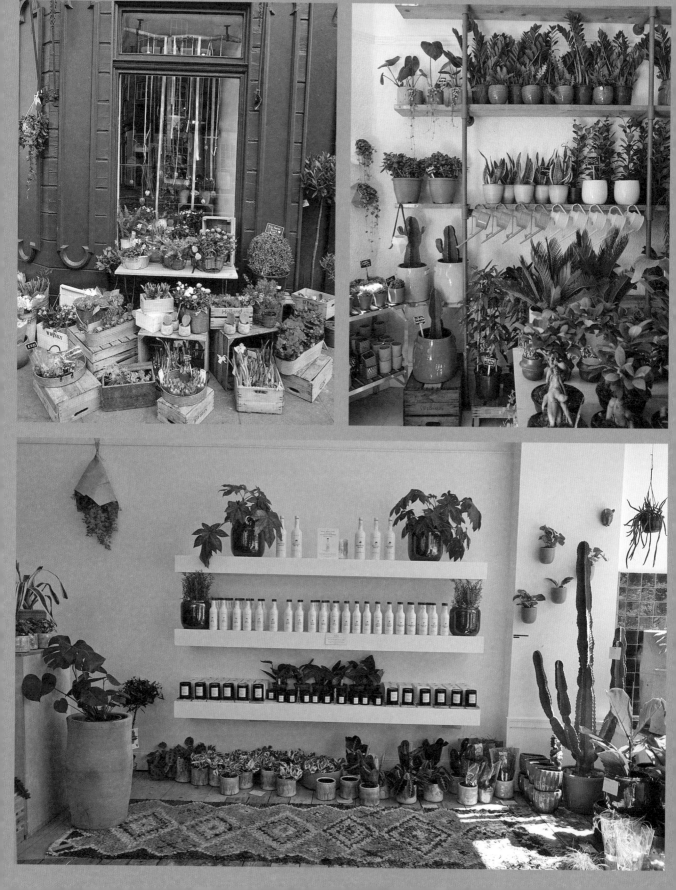

BOTANICALS IN BLOOM

One for the crazy plant ladies (and gents) out there!

Edinburgh was crowned the greenest city in the UK, and with its tree-lined streets and multiple lush green spaces, it's not hard to see why. As you walk about the city, you'll spot that locals have taken a cue from nature and are filling up their offices, window boxes and even the humblest of garden spaces – all of which are well tended with potted plants of all shapes and sizes. Being a self-proclaimed crazy plant lady, I'm happy to announce that plant stores and florists are flourishing in the capital with a couple of recent additions. Here are a few I enjoy visiting!

Rose & Ammi
⌖ 2 Gillespie Crescent

This delightful florist is tucked away on Gillespie Crescent and it's fairly easy to miss, so be sure to look out for its white and grey exterior adorned with plants and the occasional vintage bike. The store is bursting with fresh cut flowers and a variety of gorgeous house plants, all stylishly arranged, making it an incredibly Instagrammable spot!

Dahlia
⌖ 17 Roseneath Street

Dahlia is one of my favourite stores for a browse. It's incredibly aesthetically pleasing with a beautiful range of indoor plants – ranging from small succulents to stylish Calatheas. The plants are complemented by jewellery designed by local artists, shelves of candles, skincare, and much more!

Narcissus
⌖ 87 Broughton Street

Narcissus is one of Edinburgh's oldest flower shops. Since 1997, they've resided on Broughton Street and done a brilliant job of enticing passersby with their beautiful array of potted plants, floral wreaths and bouquets. As a result, the storefront has become a bit of an Instagrammer's hotspot. They also run a wonderful flower school in Abbeyhill with a variety of classes, such as seasonal hand-tied bouquet workshops.

grow urban.
⦿ 92 Grove Street

One of the newest additions to Edinburgh's plant scene is grow urban. You can imagine my excitement when I learned that the store had combined two of my favourite things, plants and coffee! With an aim to bring 'all things botanical to the lives of city dwellers', grow urban is filled to the brim with house plants of all sizes and there's always a friendly member of staff on hand to offer advice or brew you a cup of coffee.

Rogue Flowers
⦿ 5A William Street

With its cobbled streets and Victorian shop-fronts, William Street has to be one of the loveliest streets in Edinburgh, and I can't think of anywhere better to find a charming florist.

Rogue Flowers is a quaint little flower store which offers everything from exquisite floral bouquets to succulents and leafy house plants.

Snapdragon
⦿ 146 Bruntsfield Place

Bruntsfield is known for its wonderful collection of independent businesses and Snapdragon is just one of the various shops that makes this street so special. The botanical boutique specialises in flowers, but also stocks gardening items, books and lifestyle products. And to entice you further, they also run regular floral workshops aimed at beginners.

SEASONAL POCKETS

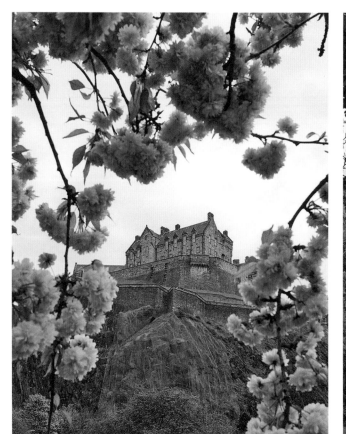

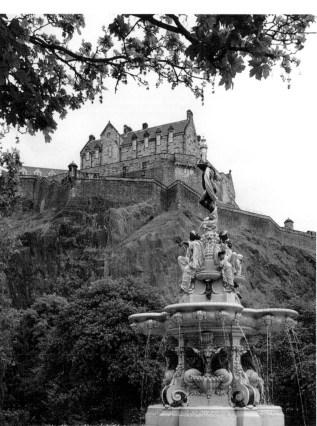

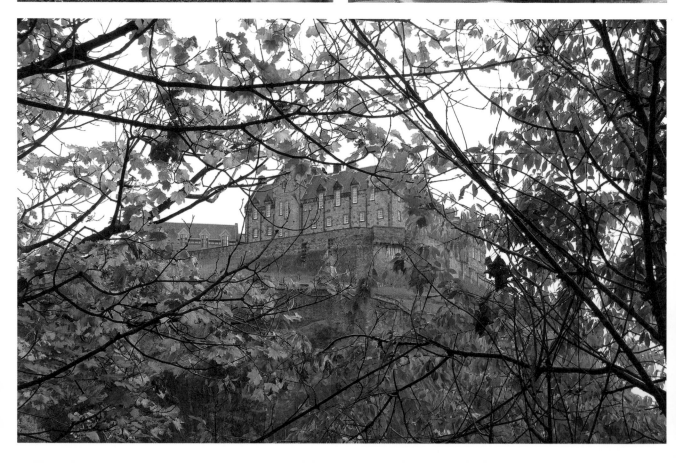

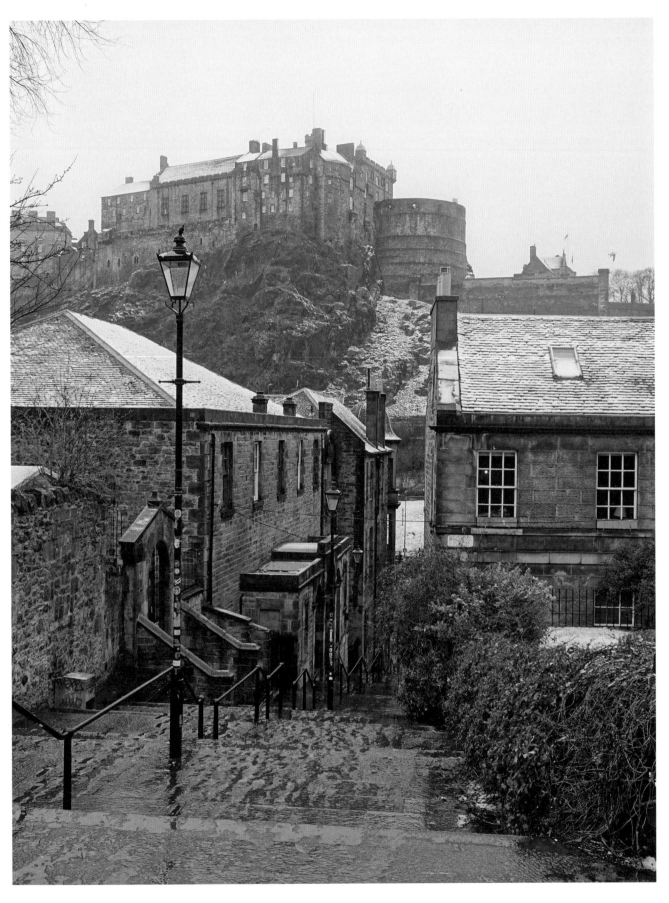

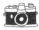

SPRING

'That is one good thing about
this world . . . there are always sure to be
more springs.' **– L.M. MONTGOMERY**

It always seems like the city and its residents breathe a sigh of relief when the days start to become noticeably longer, and the emergence of crocuses and daffodils bring a welcome reminder that winter will soon be behind us. After the seemingly never-ending Edinburgh winter tones of grey are pushed out by brilliant pops of pink, yellow and purple. In my opinion, it's one of the prettiest seasons to be in Edinburgh.

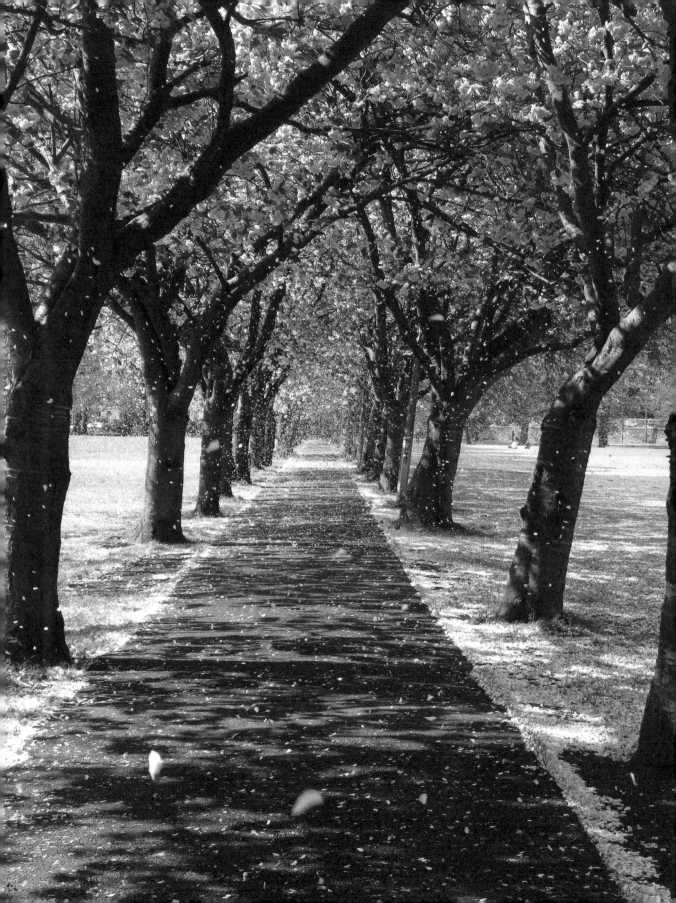

Spring Pockets of Pretty

Spring is one of the seasons I look forward to most, despite it turning me into a bit of a crazy plant lady. Don't get me wrong, I love how atmospheric Edinburgh is during the winter; nothing beats a day when the *haar* (cold sea fog) is in. However, just when I thought I'd exhausted every photo location, spring brings in a fresh burst of inspiration.

CHERRY BLOSSOMS

The Meadows is an absolute must-visit if you're in Edinburgh during cherry blossom season. The tricky part is, it's almost impossible to predict when the blossom will arrive; generally, it's sometime in April or May. Another lovely spot to visit is Princes Street Gardens where you can have fun framing the Castle or various other monuments with the pink blossoms. Last but not least, Starbank Park is a recent find of mine and if you want to avoid the crowds of the Meadows it has an equally impressive display.

SNOWDROP FESTIVAL AT THE ROYAL BOTANIC GARDENS

The Royal Botanic Gardens is one of the gardens that takes part in the annual Scottish Snowdrop Festival. They boast a fascinating collection of specialist snowdrops which carpets certain parts of the garden, allowing you a close-up look at delicately different species of snowdrops. There are often guided tours on certain days, too.

ANN STREET, STOCKBRIDGE

It's only to be expected that one of the most desirable streets in Edinburgh is also home to a row of beautifully tended front gardens which burst into bloom during spring. I often make a point of visiting at various times throughout the season to catch the delightful range of different floral offerings.

SPRING WREATH WATCH

Over the years, I've spotted the odd spring wreath adorn a select few doors around Edinburgh. However, this year it seems that several neighbourhoods have an unspoken pact to take part in spring wreath watch. I can only hope that this trend continues as I thoroughly enjoy keeping an eye out for them. A few neighbourhoods to visit if you're wreath hunting are the Grange, Morningside and Stockbridge.

WISTERIA HYSTERIA

Unfortunately, I cannot claim to have come up with this phrase, but I salute the person who did. During the small window in which wisteria blooms, I use any excuse to slip the phrase into conversations or captions. When comparing Edinburgh's wisteria blooms to London, sadly London wins hands down, but for those who think Edinburgh hasn't any #wisteriahysteria moments to offer they couldn't be more wrong. A few neighbourhoods to go wisteria hunting are the Grange, Trinity, and Stockbridge (you must visit Circus Lane for its particularly iconic wisteria).

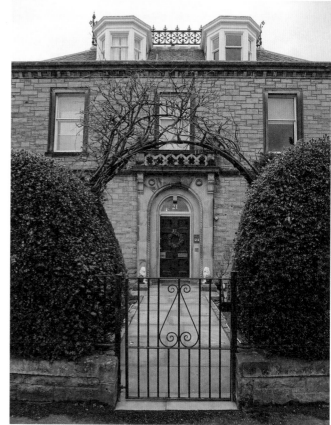
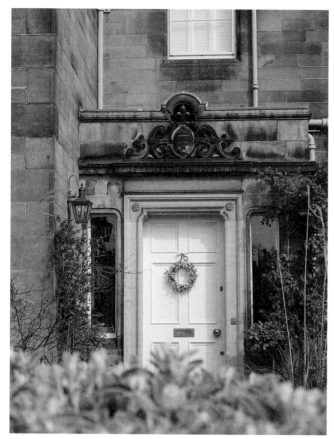

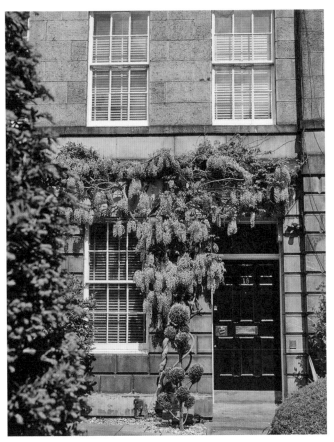
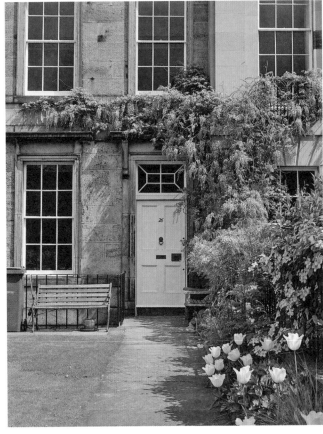
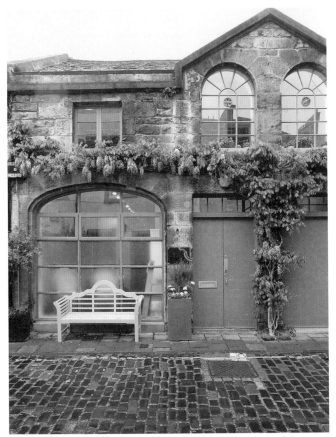
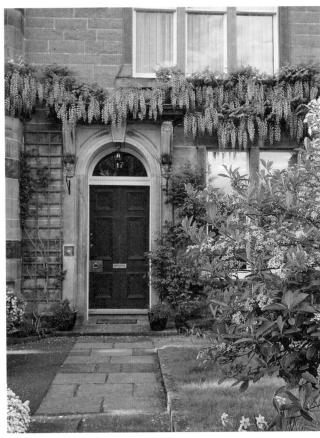

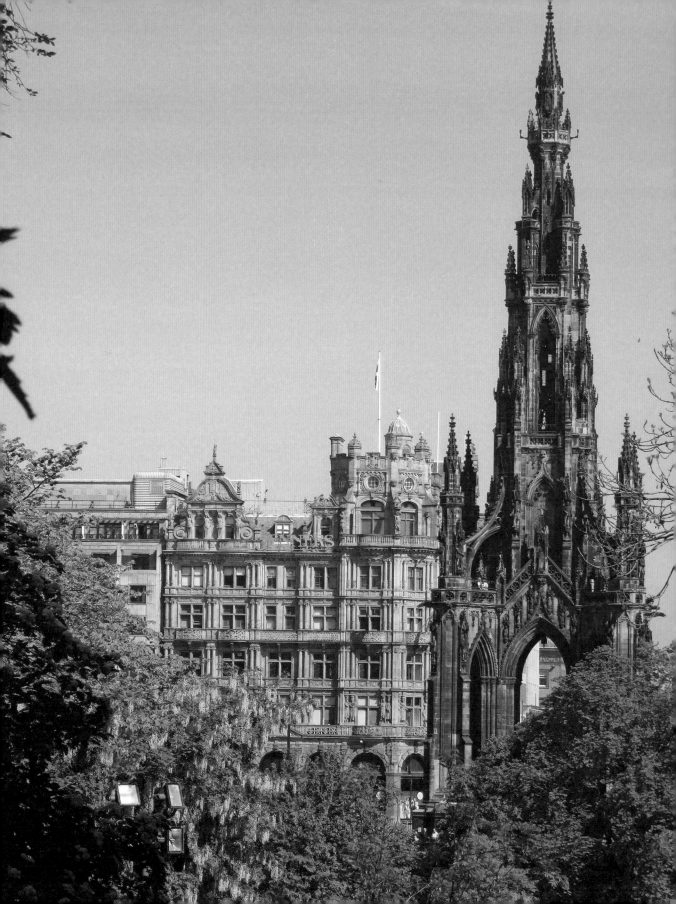

SUMMER

'And so with the sunshine and the great bursts of leaves growing on the trees, just as things grow in fast movies, I had that familiar conviction that life was beginning over again with the summer.' **– F. SCOTT FITZGERALD**

The arrival of June and July bring the hope of warmer days and I always find myself looking forward to community events such as the Film Fest in the City (a weekend of outdoor cinema screenings in St Andrew Square), yellow bath-duck or the Stockbridge Duck Race (an annual charity plastic duck race held on the Water of Leith). However, it isn't until August arrives that the city undergoes a fascinating change and its reputation as the City of Festivals comes into full swing. As you may know, the city plays host to the largest art festival in the world, the Edinburgh Festival Fringe as well as other popular events. Its iconic landmarks might stay the same, but otherwise the city in August is almost unrecognisable.

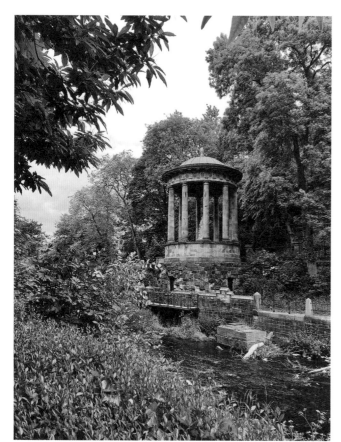

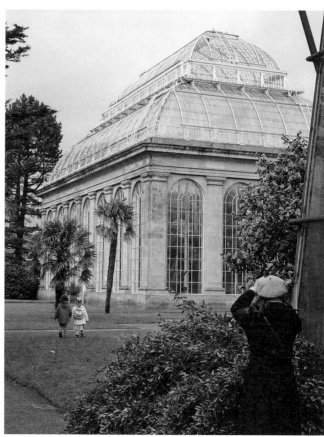

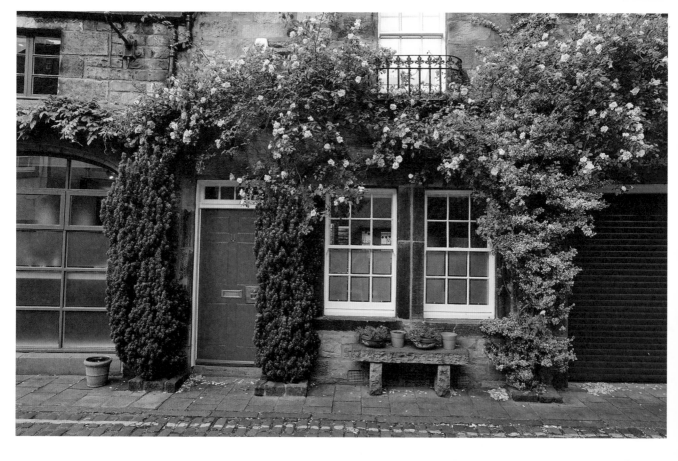

Summer Pockets of Pretty

There's so much to see and do during summer in Edinburgh; with sunset as late as 10.30 p.m., you can cram a lot more in than other times of the year. The only potential downside is that the city centre does become a lot busier, so that's when I like to head off the beaten track to quieter neighbourhoods for a wander.

A ROSY SEASON

Roses are one of my favourite flowers and they herald the arrival of summer in Edinburgh. They always have me reaching for my camera, whether they adorn the exteriors of various homes or burst into bloom and fill front gardens with their beauty. The season is hard to pinpoint, but June tends to be when roses are at their sweet-scented best.

A PEEK INTO EDINBURGH'S PRIVATE GARDENS

For most of the year, these exclusive gardens lie out of reach to non-key holders like myself, and for the longest time visiting one of these private gardens sat atop my Edinburgh bucket list. Other than a brief glimpse through a fence, I had to use my imagination to visualise what lay on the other side. Thankfully, I was introduced to Scotland's Garden Scheme whereby selected private gardens choose to fling their gates open to the public on certain days of the year. One of my all-time favourites is the magnificent Dean Gardens. It borders the Water of Leith and has a delightful Victorian layout of lawns, paths and pavilions.

EDINBURGH'S FLORAL CLOCK

One of the highlights of summer is the unveiling of Edinburgh's famous floral clock, a working clock laid out in flowers dedicated to commemorating a different anniversary each year. You'll find the clock in west Princes Street Gardens from July to October, and be sure to visit on the hour so you can catch a glimpse of its cuckoo popping out to say hello.

ROYAL BOTANIC GARDENS

The Royal Botanic Gardens have something to offer all year round, but summer is the perfect time to make the most of the extensive gardens by enjoying a leisurely walk to admire the latest blooms or lounging on the grass with a good book. If Scottish weather happens to surprise you with a brief summer shower, what better excuse to nip into their marvellous glasshouses.

THE WATER OF LEITH WALKWAY

The walkway follows the Water of Leith as it snakes through the city, from its starting point at Balerno to the Shore in Leith. The great thing is, you can join the path at many different points, where you'll leave the sounds of the city behind and be surrounded by lush greenery and nature. As well as spotting the odd pair of ducks or a graceful heron, you'll pass by gushing weirs and a few art installations such as life-size bronze men submerged in the river, part of the Scottish National Gallery of Modern Art's collaboration with Antony Gormley.

AUTUMN

'Autumn . . . the year's last, loveliest smile.'
– JOHN HOWARD BRYANT

We can all agree that Edinburgh is beautiful all year round, but the city does seem to wear autumn particularly well. For a brief but magical time, the city is clothed in brilliant shades of crimson and gold, accentuating its striking architecture and bringing it to life. Autumn the season to dig out woolly jumpers and wellies and head out with your camera to capture the wondrous golden tones.

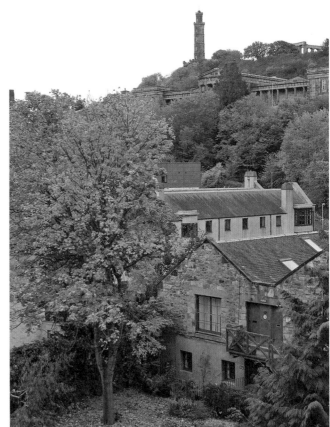

Autumnal Pockets of Pretty

Unlike the other seasons, where I can point you in the direction of the loveliest cherry blossoms or Christmas decorations, the best way to find autumnal pockets of pretty around Edinburgh is to simply walk through the city, visit the Royal Botanic Gardens or Holyrood Park to enjoy the pops of warm golden tones. However, here are a few more hidden gems you might miss.

THE GARDENER'S COTTAGE

Housed within a charming stone cottage, the Gardener's Cottage on London Road is known for its communal dining and locally sourced ingredients. The cottage is picturesque throughout the seasons, but I think it looks at its loveliest when the wind carries the burnt orange leaves off nearby trees and cloaks the ground surrounding the cottage.

ROTHESAY PLACE

Nestled away in Edinburgh's West End is an Instagrammer's autumnal secret. During October, where Rothesay Place joins Douglas Gardens, you'll find a stately tenement block impressively clothed in crimson red ivy. It's well worth making a detour for.

HERMITS AND TERMITS, ST LEONARD'S STREET

I only came across this hidden gem because I used to live in the neighbourhood. I'd admired it throughout the seasons; however, when autumn arrived, I was pleasantly surprised to find the gorgeous leafy trees had turned from shades of luscious green to brilliant yellow gold. A little while after and the ground is covered in a rich yellow carpet.

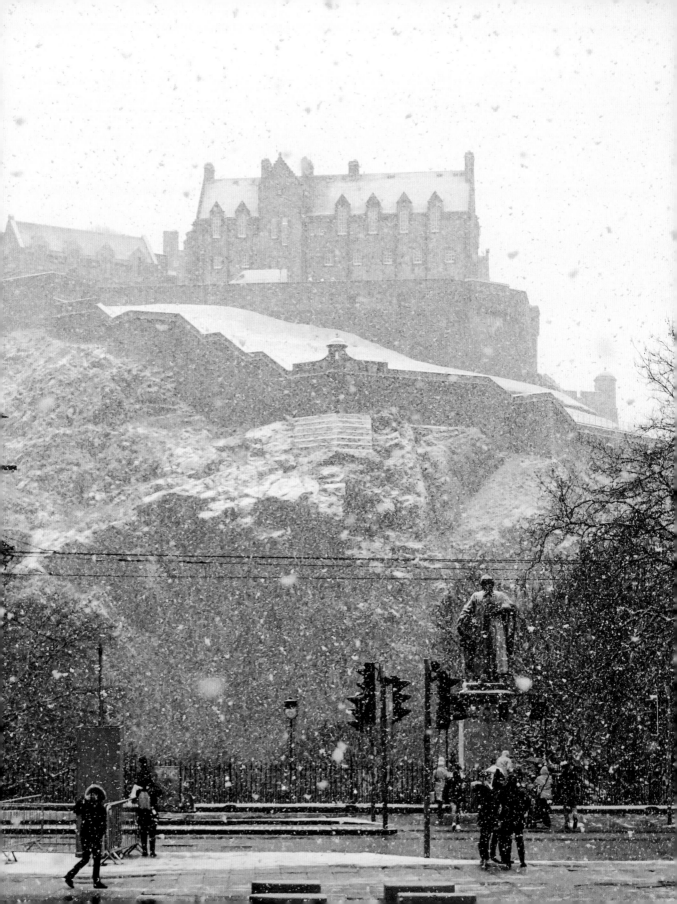

WINTER

'He who marvels at the beauty of the world in summer will find equal cause for wonder and admiration in winter.' – **JOHN BURROUGHS**

After a short but blissful lull in autumn, the arrival of December is accompanied by a general buzz. Throngs of people bustle around the shops looking for Christmas presents, tourists and local Instagrammers huddle together admiring (and photographing) the twinkly lights that adorn so many buildings, and the sound of festive songs floats through the air from the Christmas markets. Whether you love it or prefer to avoid it, you can't deny that the city comes alive again after the sleepier post-festival months of autumn.

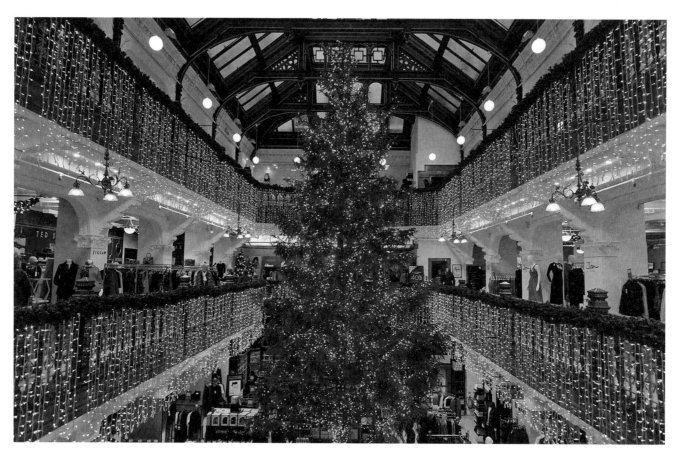

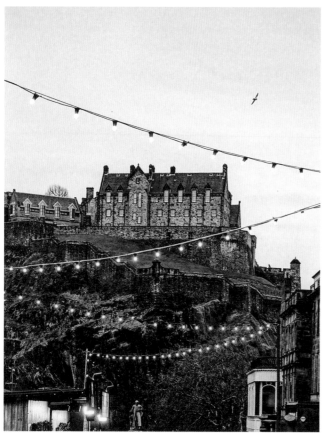

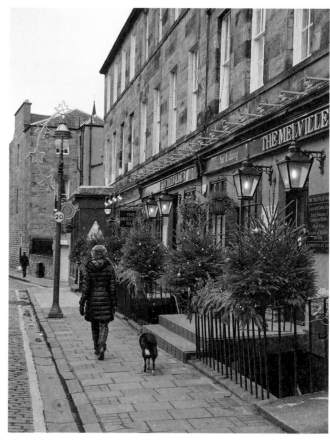

Festive Pockets of Pretty

For most of the year, we have nature to thank for dressing Edinburgh in pops of pink from the cherry blossoms or in the crimson reds of autumn. Then, as the trees lose their leaves and the colour seems to drain from the city, we rely on Christmas decorations and lights to combat the bleak weather and cold northerly winds. It also provides us with a plethora of photo opportunities. So, wrap up warm and grab your camera, here are a few of my festive favourite spots to visit.

OLD COLLEGE'S CHRISTMAS TREE

Old College is simply stunning all year round, but there's something about their annual Christmas tree, which sits proudly in the quad, that makes it all the more enchanting.

THE DOME

The Dome has been an Edinburgh Christmas icon for many years now and always creates a buzz when it dons its Christmas decorations. If you have time, be sure to pop inside too, where your senses will be assaulted by a concoction of festive scents, a giant Christmas tree and elaborate, extravagant decorations.

EDINBURGH'S WEST END CHRISTMAS DECORATIONS

One of my highlights of the festive season is the West End. It's a great place to escape the crowds while enjoying the West End's stylish

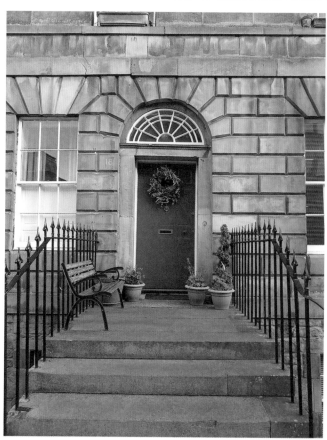

decorations. Various streets, including Alva and William Street, are adorned with garlands and mini Christmas trees – it's simply magical!

BOSWELL'S COURT & JOLLIE'S CLOSE, ROYAL MILE

Tucked away down Boswell's Court, you'll find an utterly picture-perfect festive scene. The cosy close invites you in with its old-fashioned lamps casting a warm glow and its Christmas tree glittering in the darkness. Don't forget to cross over the Royal Mile and peak into Jollie's Close for another festive surprise.

EDINBURGH'S CHRISTMAS MARKETS

These are a very Marmite subject – you either love them or hate them. That being said, I often find myself perched on the fence! I enjoy them as long as I visit during the week to avoid the crowds so I get to enjoy a leisurely browse and take as many photos as I like.

JENNER'S CHRISTMAS TREE

The arrival of Jenner's Christmas tree signifies the start of the festive celebrations and is an Edinburgh institution. The 40-foot tree stands proudly in what was once Scotland's oldest independent department store's grand hall. The tree is subject to local scrutiny and you might catch phrases like: 'Oh, it's looking much better this year, it was a little scrawny last year,' or 'Do you remember when it used to have a star?'

WINTER WREATH WATCH

I've always believed in finding joy in the smaller things in daily life, such as spotting an unusual door knocker, or the delicate arrival of snowdrops to assure us winter is almost over. So, when the festive season rolls around again, I can't help but feel excitement when I spot wreaths of all shapes and sizes adorning doors around Edinburgh. A few of my favourite places to go wreath hunting are Stockbridge, New Town and the Grange.

SNOWY DAYS

Unlike other countries who can expect heavy snow every winter and might perhaps dread it, Edinburgh is rarely covered in a thick blanket of snow. So, when it does snow (even a smattering), there's a sense of excitement in the city, as children head outdoors to build snowmen or students sled down the gentler slopes of Arthur's Seat. Or, if you're like me, you frantically message fellow Instagram friends and trudge through the cobbled streets together snapping countless snow-kissed photos.

Pockets continued . . .

And, even as another season draws to a chilly close, I know we'll all be looking forward to exploring Edinburgh afresh in the new year. There'll be unexpected gems to discover, old favourites to capture and plenty more pockets of pretty to share. Happy snapping!

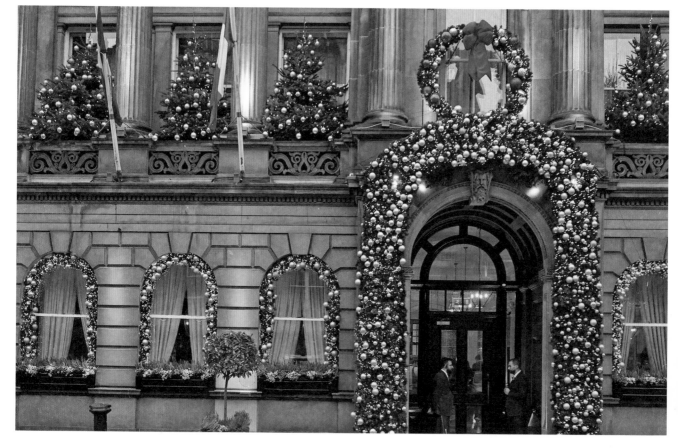

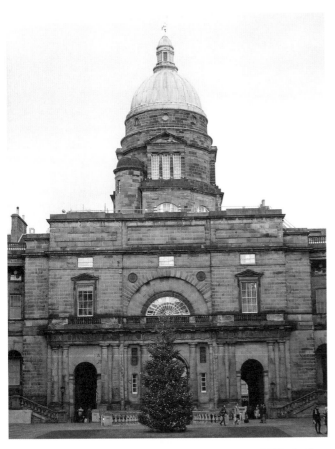

ABOUT
SHAWNA LAW

Self-proclaimed explorer and avid shutterbug, Shawna is the person behind Instagram account @ExploringEdinburgh. Despite having visited Edinburgh many times throughout her childhood, her love affair with the Scottish capital really began when she moved to the city to study.

As Shawna explored, she started documenting her discoveries on Instagram and what originated as a fun project developed into a major passion and a realisation that Andrew Carnegie's words are absolutely true: *'There is no habitation of human beings in this world so fine in its way as this, the capital of Scotland.'*

#PocketsofPretty @ExploringEdinburgh

THANK YOU

'May he give you the desire of your heart and make all your plans succeed.' – PSALM 20:4

There are many people I'd like to thank, but a good place to start is with Alison and the team at Black & White Publishing who I'm immensely grateful to for this amazing opportunity to produce something I thought would only ever be a distant dream. I'd like to thank Emma and Alice for polishing my ramblings into cohesive text, Tonje for designing a beautiful layout and putting up with my perfectionism, and Thomas for his all his advice and help.

I would like to thank my family, friends, and local church for their support, which kept me sane during the inevitably stressful moments.

I'm very grateful to all the independent business owners for their friendship and for giving up their time to be a part of my book.

I've met lovely friends through Instagram. I'd like to thank the talented @itsalexhamilton for my author portraits, and @Helen.C.Stark for her beautiful illustrations.

Last, but certainly not least, I had to move out of Edinburgh towards the end of the book's creation and I have to say a huge thanks to the Roulston family for being amazing friends and allowing me to stay in their home whenever I needed to.

I would like to leave you with a few of my favourite Edinburgh Instagram accounts.

@edienthusiast Ildi is a culture-loving expat who discovers Scotland in a Caterham (lovingly named Katie). Not only does she have a beautiful Instagram account, she's also an extremely lovely person with copious amounts of Edinburgh knowledge.

@scotlandwithfluffywolf Known affectionately as Sally the Samoyed. I dare you not to fall in love with Claire and Sally's delightful mix of adorable photos of Sally and their fun adventures around Scotland.

@gisforgeorgina Georgina shares magical photos of her explorations around Scotland and beyond, and always has me adding new places to my bucket list.

@myedinburgh Olli is a keen wanderer and I always enjoy following her Edinburgh explorations.